LAKE HOUSES

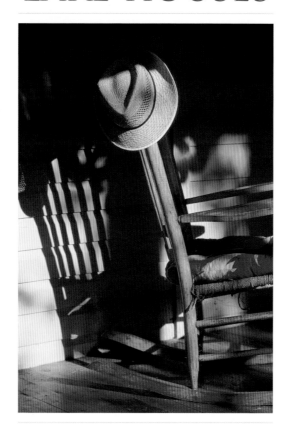

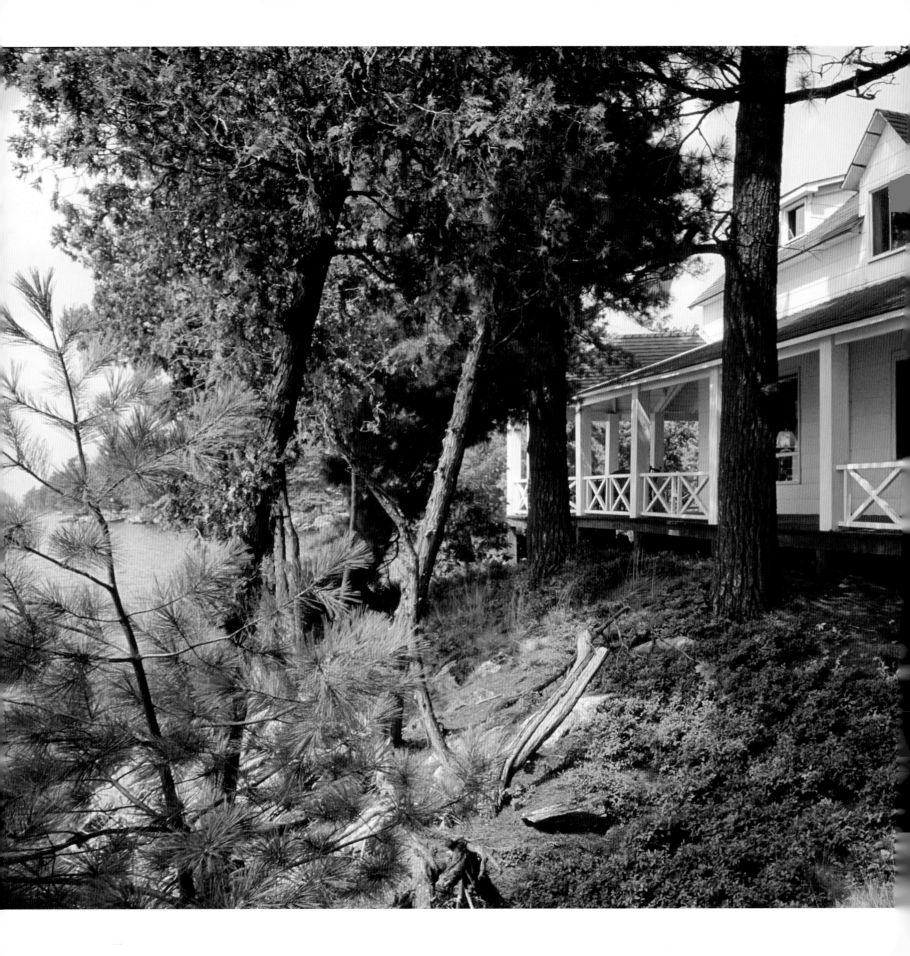

LAKE
HOUSES

John de Visser and Judy Ross

The BOSTON
MILLS PRESS

For our lake house on Mohawk Island and the family who love it
JUDY ROSS

To John and Madeline Fielding, for their great hospitality and friendship
JOHN DE VISSER

Copyright © 2008 John de Visser and Judy Ross

Published by Boston Mills Press, 2008
132 Main Street, Erin, Ontario, Canada N0B 1T0
Tel: 519-833-2407 Fax: 519-833-2195

In Canada:
Distributed by Firefly Books Ltd.
66 Leek Crescent
Richmond Hill, Ontario, Canada L4B 1H1

In the United States:
Distributed by Firefly Books (U.S.) Inc.
P.O. Box 1338, Ellicott Station
Buffalo, New York 14205

The publisher gratefully acknowledges for the financial support of our publishing program
the Canada Council, the Ontario Arts Council, and the Government of Canada
through the Book Publishing Industry Development Program (BPIDP).

Library and Archives Canada Cataloguing in Publication

De Visser, John, 1930–
Lake houses / John de Visser and Judy Ross.
ISBN 978-1-55046-483-2 (bound)

1. Vacation homes. 2. Vacation homes — Pictorial works.
I. Ross, Judy, 1942– II. Title.
NA7574.D49 2008 728.7'2 C2008-901403-0

Publisher Cataloging-in-Publication Data (U.S.)
De Visser, John.
Lake houses / John De Visser & Judy Ross.
[224] p. : col. photos. ; cm.
Summary: Photographs of and essays on the architecture and interior design of a variety of summer homes,
capturing the essential spirit of lake house life. Includes chapters on exteriors and outdoor living, dining rooms,
living rooms, kitchens, bathrooms, boathouses and docks, verandas and porches and the lake house garden.

ISBN: 978-1-55046-483-2
1. Architecture, Domestic — Canada — Pictorial works. 2. Vacation homes — Canada —
Pictorial works. I. Ross, Judy Thompson, 1942–. II. Title.
728.72/09713 dc22 NA7579.C2 .D415 2008

Design by Gillian Stead
Edited by Ruth Taylor

Printed in China

Perhaps the truth depends on a walk around the lake.

WALLACE STEVENS

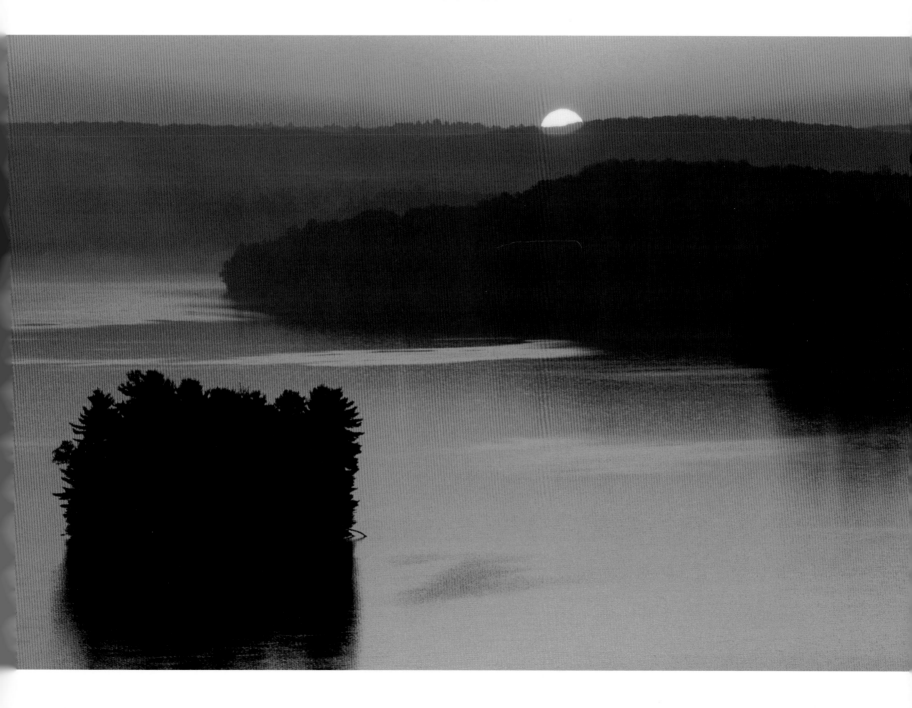

LAKE

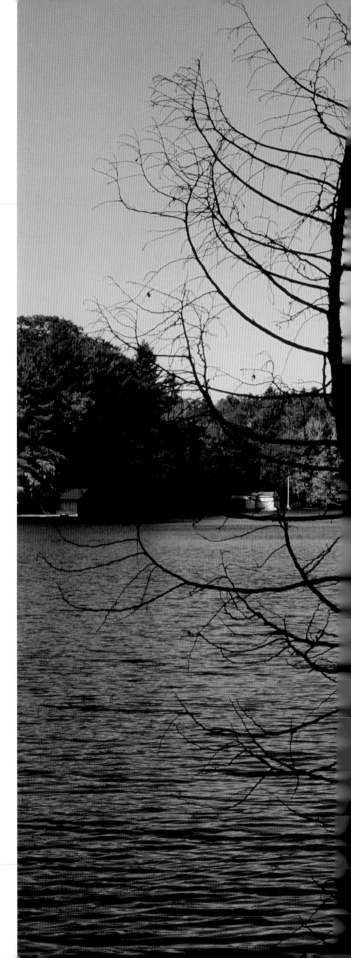

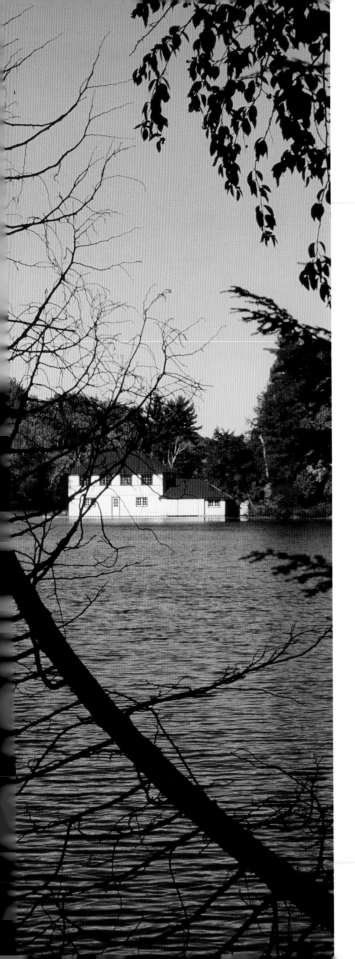

HOUSES

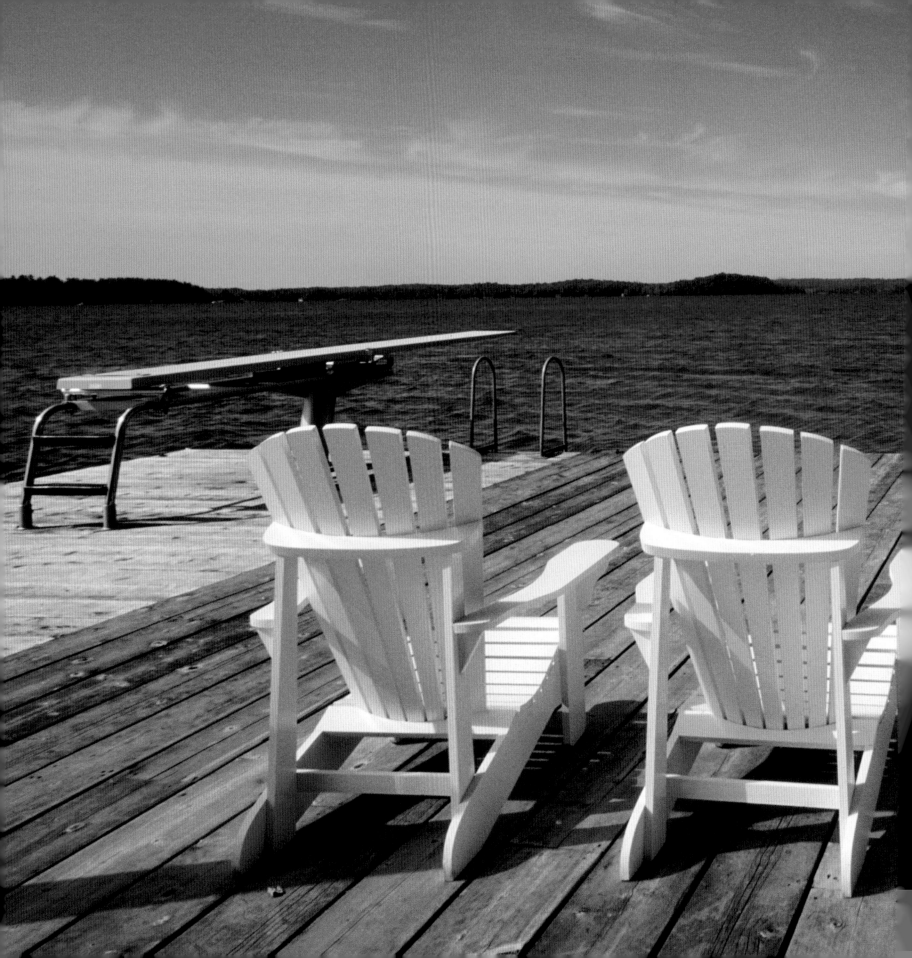

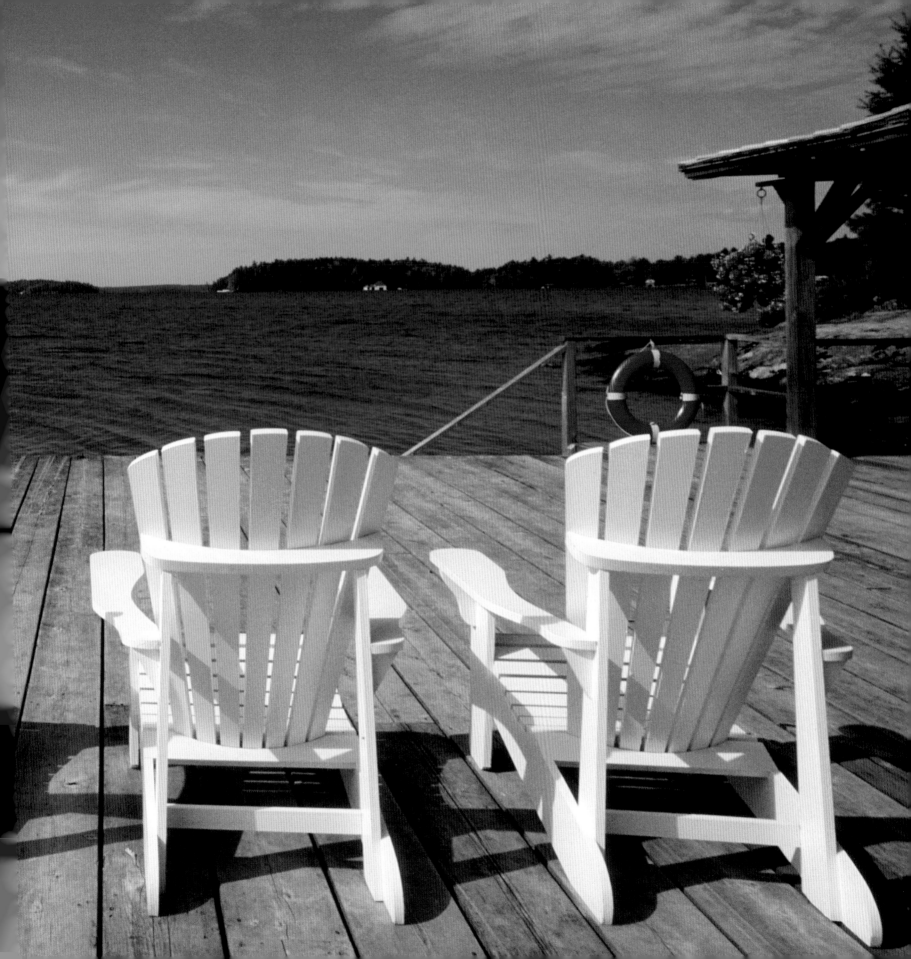

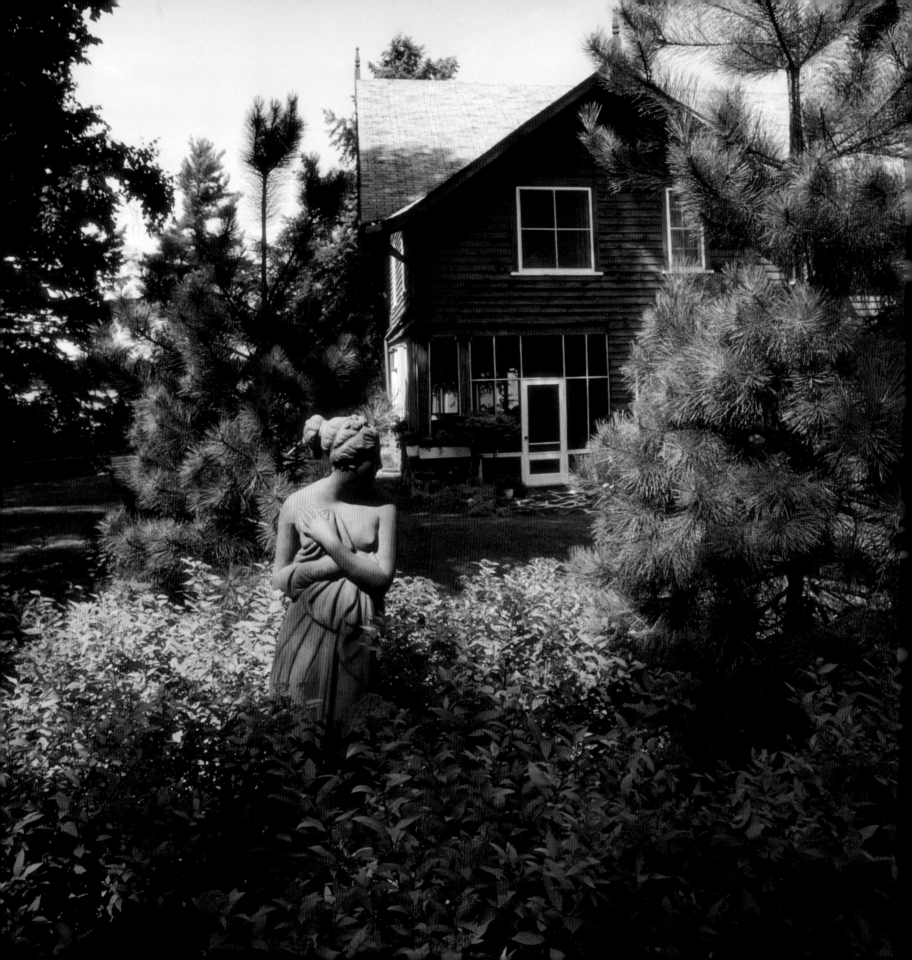

Where the Heart Is

The lake house. The mere words evoke images of sun-dappled woods and sparkling waters, breezy screened verandas and the promise of lazy afternoons. Often our most treasured retreat, the lake house has become a metaphor for relaxation, escapism and family kinship. Above all, it's the place where we can cast off our city shoes and worries, sink into an old porch rocker and be ourselves. Perhaps when Henry James said that the most beautiful words in the English language were "summer afternoon," he was envisioning a lazy day at a lakeside home.

In many parts of North America, summers at the lake house are an enduring institution, a part of our natural gravitation to the outdoors. Whether it's to the seashore, the bay, the lake or the river, the common element of this summer migration is the need to be near water. A need that's perpetuated by the children who spend summers jumping off wooden docks, learning to mimic the call of the loons, and being lulled to sleep by water lapping on the shore.

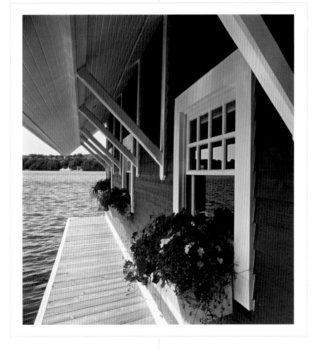

Lake house communities began to evolve before the turn of the last century. The allure of pine-scented woods and crystal-clear lakes was discovered by men of leisure who ventured far from their city homes to hunt and fish, fell in love with the land and staked claims to shore-front properties and islands. Before long they built houses. Some were grand stone mansions with servant wings and wide staircases. Others were more modest cabins built of wood and shingles. Many of these still exist today, summer homes to the descendants of these adventurous pioneers.

At the heart of lake house living is the family experience. No matter how widely dispersed or fragmented our families become, the lake house is the homing point to which we all return. As the enduring family touchstone, it represents the way we wish life could always be. Held within its wooden walls are memories of childhood summers, starry nights, and the kind of companionable gatherings that only happen on lamplit screened porches in the cool of a summer evening. What we hope to

(opposite) A terra-cotta statue adds interest to the garden of a summerhouse built in 1904.
Successive owners have been careful to preserve the vast two-story house and keep the property beautifully maintained.

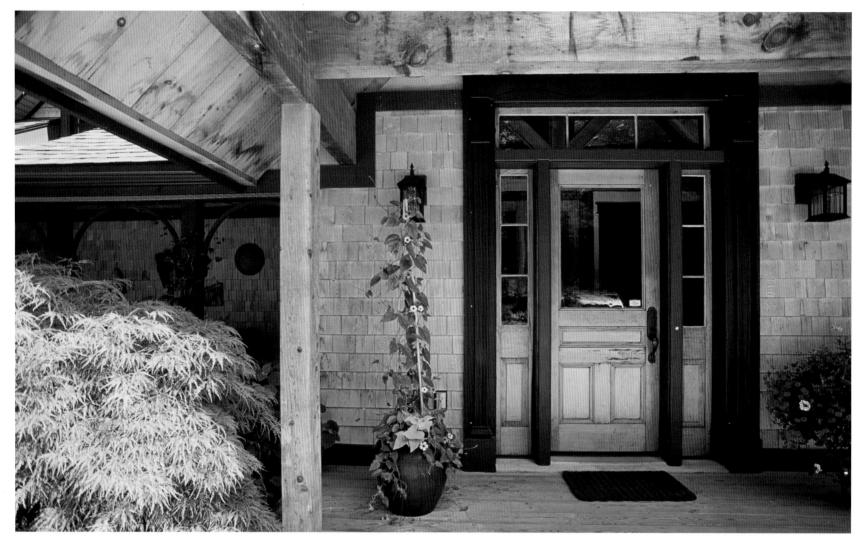

(above and opposite) A vintage door and old beams are among the salvaged materials used in building this waterfront home. From the road it looks like a cottage in the woods. From the lake it has the contemporary appeal of glass walls and expansive decking.

capture in this book, as much as the architecture and interior design of a variety of summer homes, is that essential spirit of lake house life.

With this in mind, we visited homes on lakes and rivers, on islands and beaches. We found many people who are following the trend of retiring to their summer places, so the cabin of old is becoming a more sophisticated dwelling with all the amenities of urban life. We met families who spent vast amounts of money on their showcase places and ones who are proudly hanging on as the fifth generation to summer at the family lake house, determined that nothing will change. Although vastly different in style and dimension, the common elements of these houses are intriguing. They are all built on water and have glorious views; they are all treasured as retreats from other lives; and they are all owned by people who say, "My lake house is where my heart is."

(following pages) A bird's-eye view of a quiet autumn day on Lake Rosseau in Muskoka, Ontario, brings to mind the words of Henry David Thoreau: "Even the tamest island has a distinct character, unique, a place apart, existing in a state of grace outside the world."

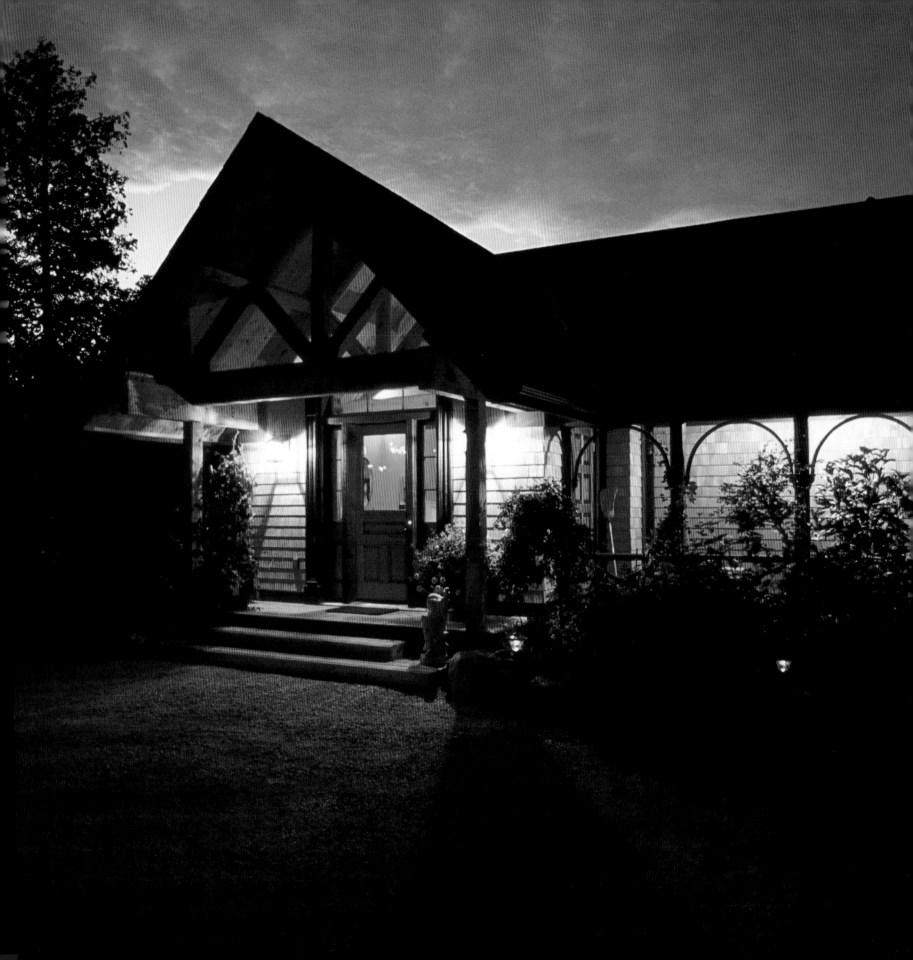

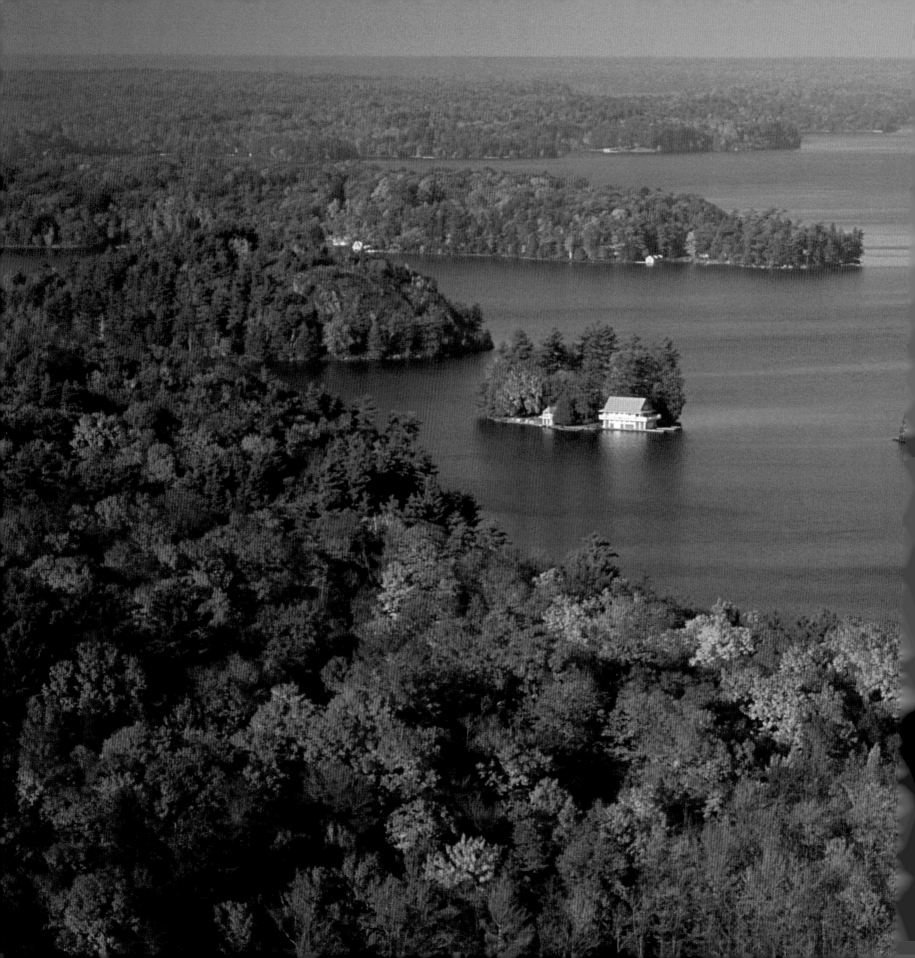

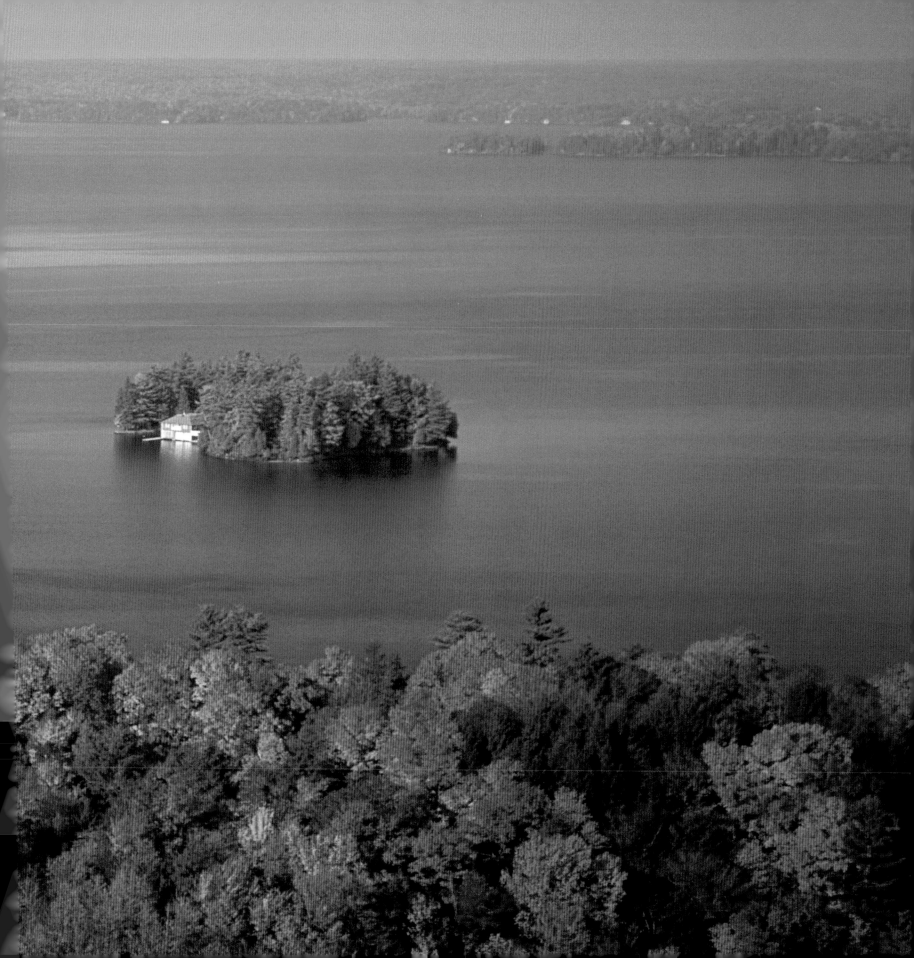

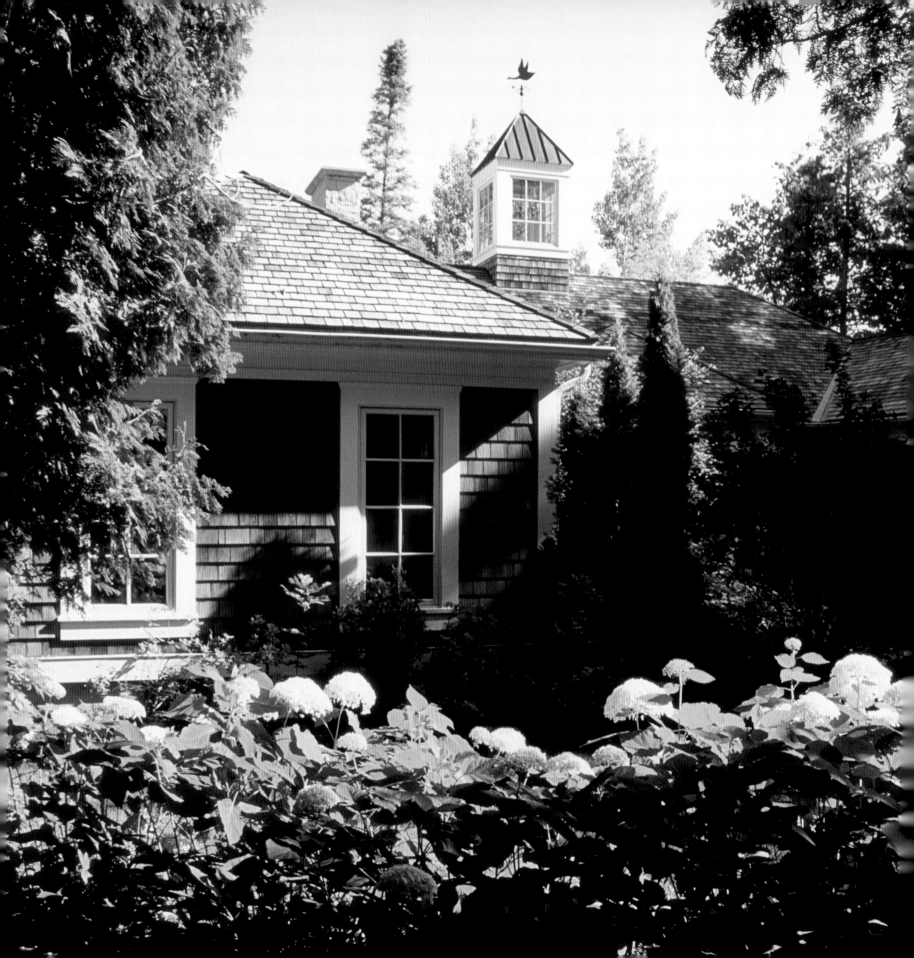

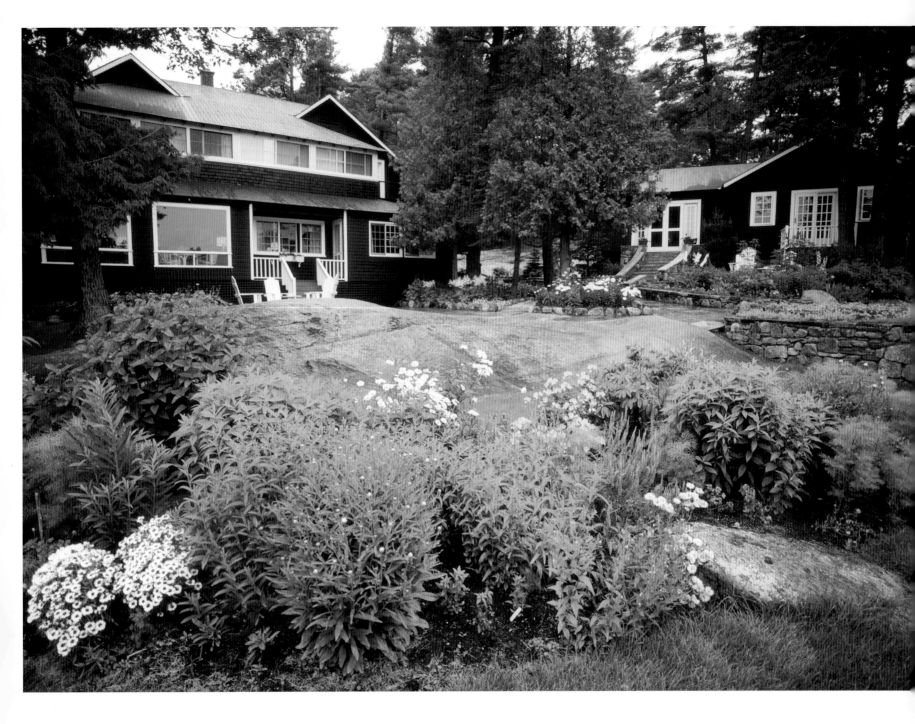

(above) Perennial gardens fill every pocket of soil in the rocky ground of this summer estate.
Over the years rocks from the property were used to create raised beds.

(opposite) A lake house designed in the New England shingle style boasts a belvedere that is lit at night as a beacon to passing boats.
Hydrangeas grow in abundance around the house.

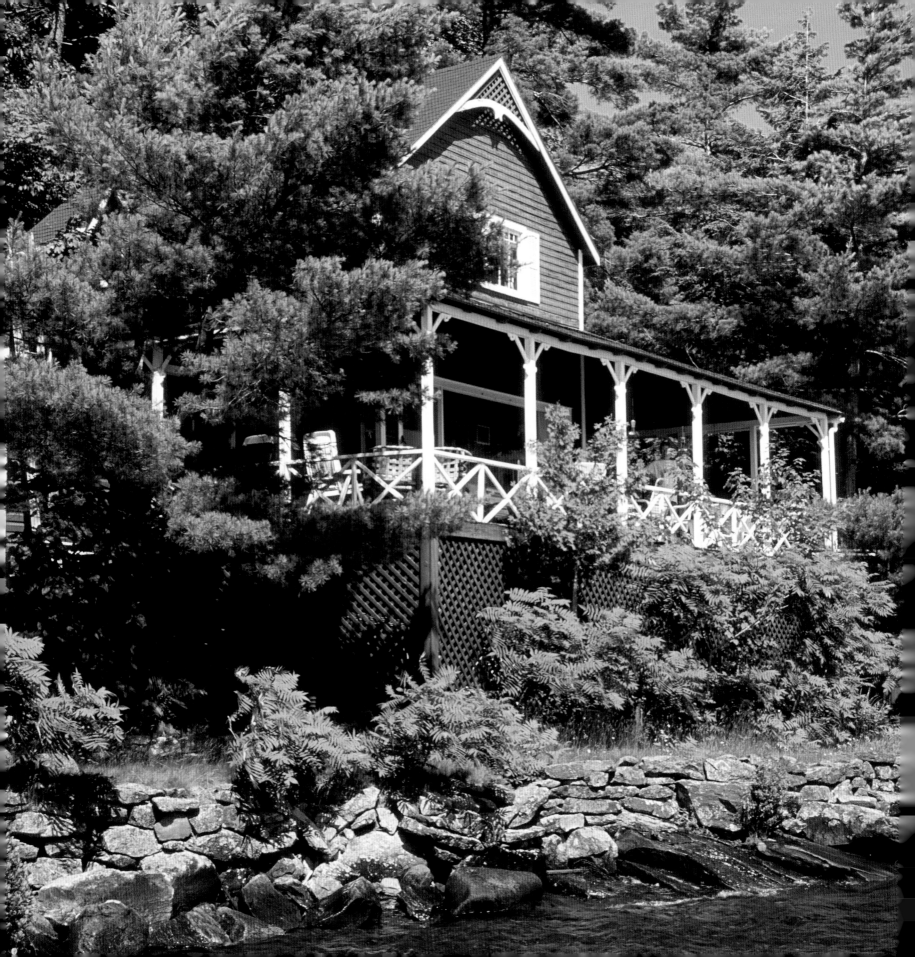

Home Away from Home

Whether tucked beneath a canopy of evergreens or jutting off a rocky promontory, these summer homes are focal points for family gatherings, places to languish on hot summer days. Some are grand, some humble, some new, some old, but all originate as rural escapes. They are places where we come face-to-face with nature. Many date back to the 19th century, when cities were first perceived as unwholesome places and men of vision took their families to the "pure, fresh air" of the countryside for the summer. The concept of cottaging had begun.

The concept continues today, as we still feel the need to escape, not so much from unwholesome cities as from the demands of everyday life. We look to our weekend homes as places where the closeness of water will soothe our days — where we can lie quietly and listen to the wind singing in the pines. And there will be time, lots of time, to sit outside at night beneath the star-filled sky.

Our places range from airy beach houses to cozy log cabins on clear mountain lakes — and all are essentially retreats. They are places where we remember and recreate the feeling of childhood summers. Recalls one owner who spent every summer as a child at a lakeside cabin, "You never forget

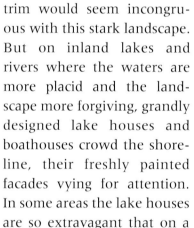

the freedom of running around unrestricted and half-naked on hot summer days."

The varied style of these summer places is somewhat dictated by location. On the Great Lakes, where island communities come together every summer, there's a weather-beaten solidity to the cabins that withstand gale-force winds and long shuttered winters. Decorative touches like flower planters and gingerbread trim would seem incongruous with this stark landscape. But on inland lakes and rivers where the waters are more placid and the landscape more forgiving, grandly designed lake houses and boathouses crowd the shoreline, their freshly painted facades vying for attention. In some areas the lake houses are so extravagant that on a daily basis, boat cruises full of tourists glide by them to get a peek. Like the summerhouses of Newport, Rhode Island, these gracious mansions are called cottages even though they have servant wings and separate carriage houses.

Architect-designed structures are increasingly the norm, often built with walls of glass to take full advantage of the view. But for most of us, the cottage is more in keeping with the dictionary definition, a "small, simple house," a cozy nest to which we return summer after summer.

(opposite) Traditional cottages feature wraparound verandas with plenty of shady spots to sit and enjoy the lake views. Here, gingerbread detail adds to the old-fashioned charm.

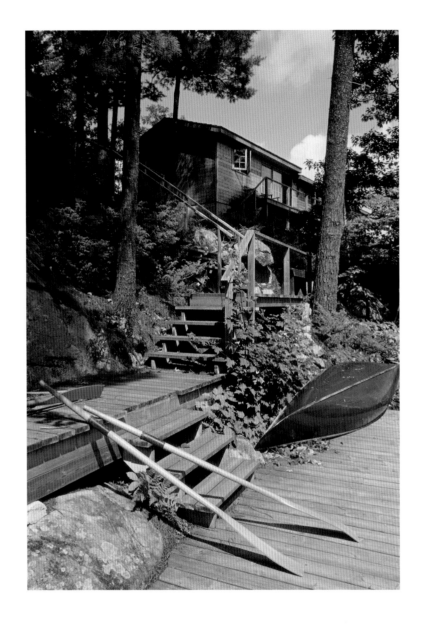

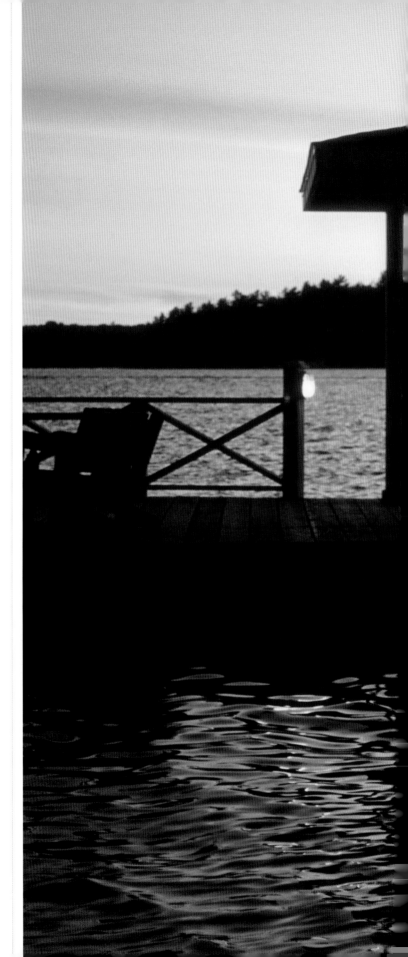

(above) A simple cedar-clad structure straddles the granite shoreline. "This place is the one material possession I feel strongly about," comments the proud owner, who prefers to putter about the lake in a canoe or rowboat.

(right) Watching the sunset from the covered dock is a daily ritual at this lake house.

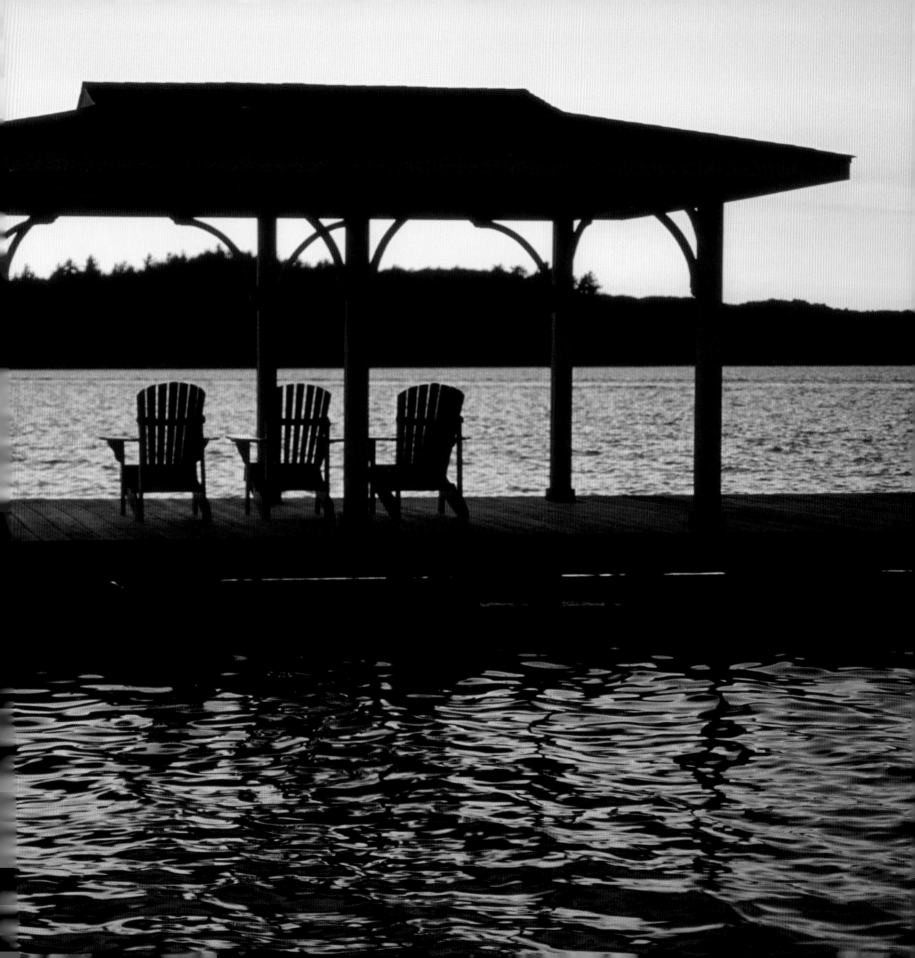

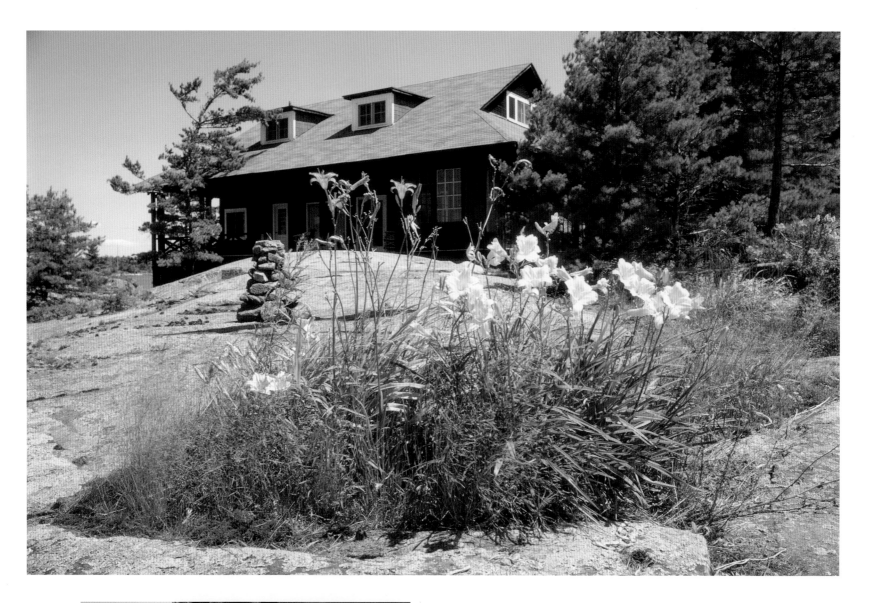

(above) Lilies sprout from the Precambrian rock where little else will grow. Many houses in this windswept region were built a century ago and have barely changed.

(left) Rock foundations show the simplicity of the building style. They haven't budged in over a hundred years.

(opposite) Vintage porch furniture is freshened with summery fabrics in shades that reflect the lakeside location.

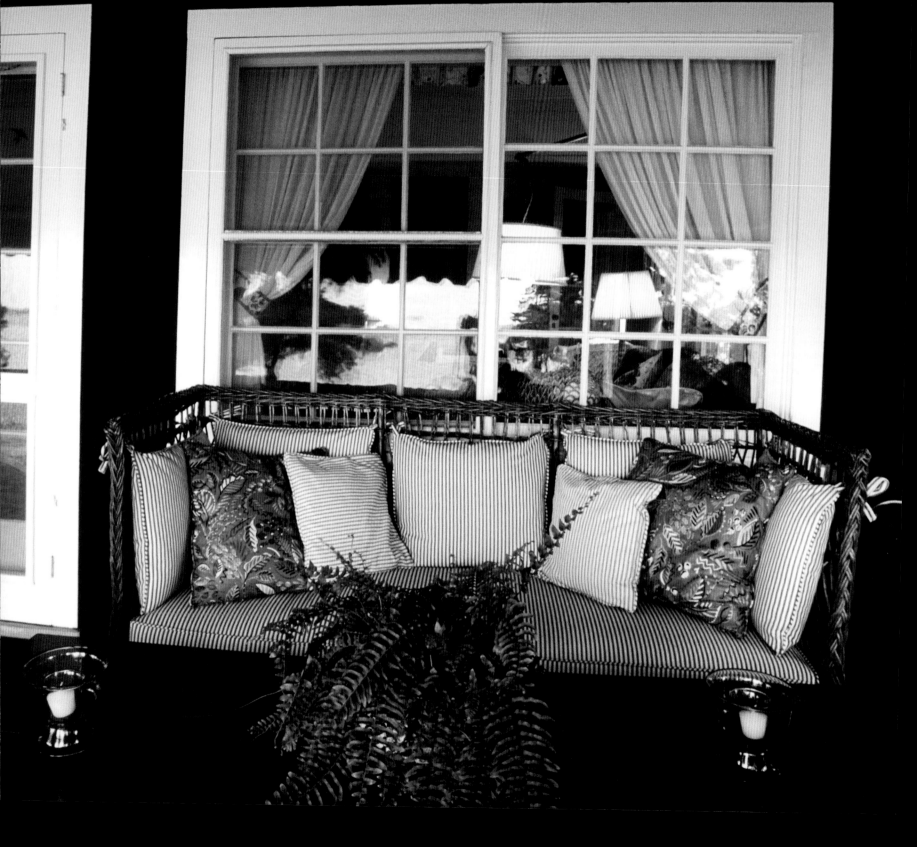

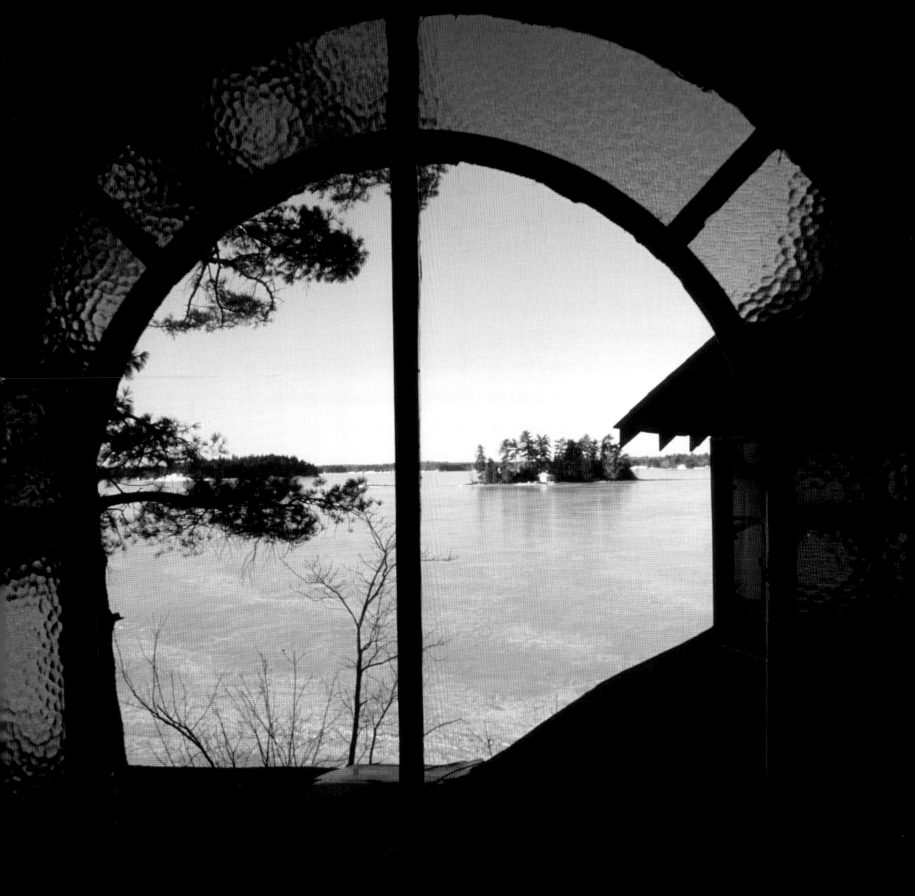

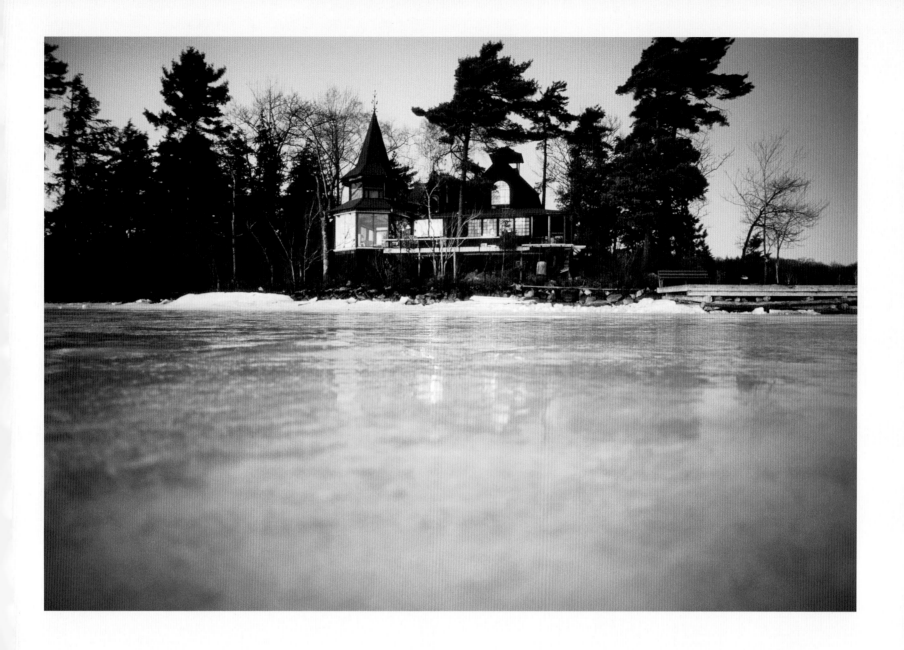

In winter I get up at night

And dress by yellow candle-light.

In summer, quite the other way,

I have to go to bed by day.

ROBERT LOUIS STEVENSON

(opposite and above) Winter at the island can be a game of waiting until it is safe to cross the ice. This family enjoys the lake house in every season, especially in winter, the quiet time when only a few other houselights can be seen at night.

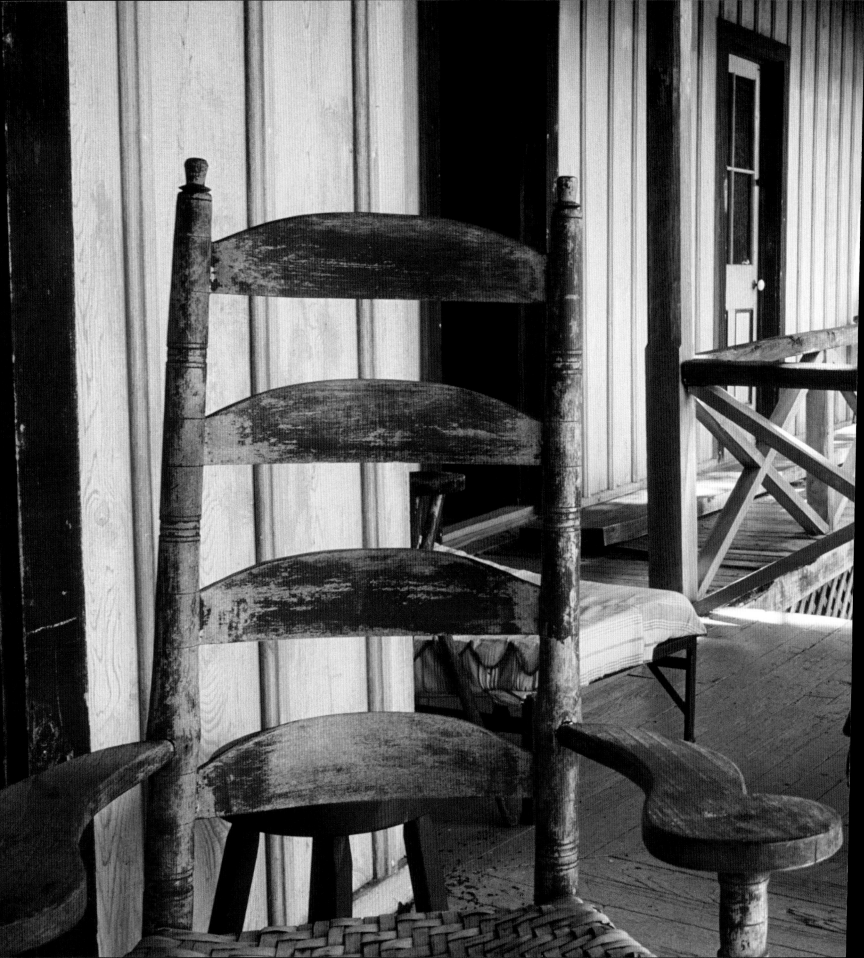

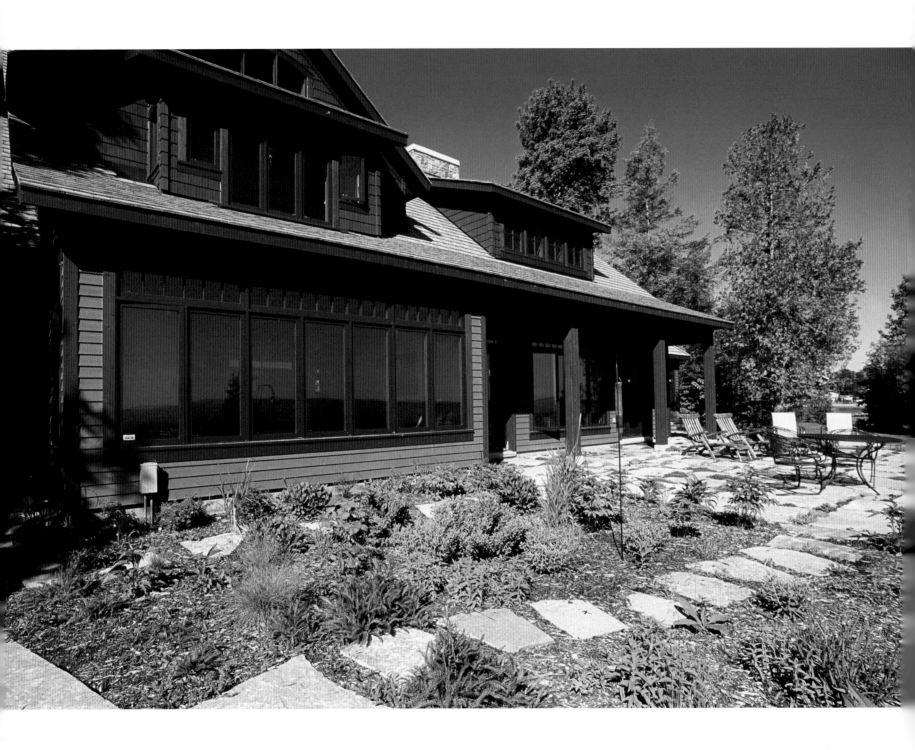

Gardens are just being established at this newly built home designed in the Arts and Crafts style with shed dormers and posts and beams. Flat slabs of rock lead to the entranceway, which faces the water.

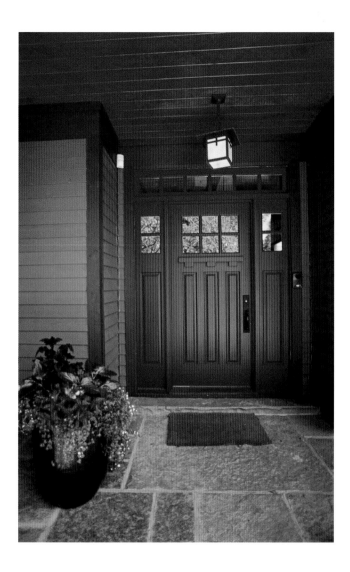

(above) The doorway features the clean, symmetrical lines typical of the architecture influenced by this art movement.

(right) Although built decades earlier (in 1882), there is a similar design ethic in this classic lake house. Wraparound verandas and separate sleeping quarters are linked by a common roof. "I love the Oriental simplicity of the design," says the owner. "It makes it so private and peaceful."

Then followed that
beautiful season ...
Summer ...
Filled was the air with
a dreamy and magical
light; and the landscape
Lay as if new created
in all the freshness
of childhood.

HENRY WADSWORTH LONGFELLOW

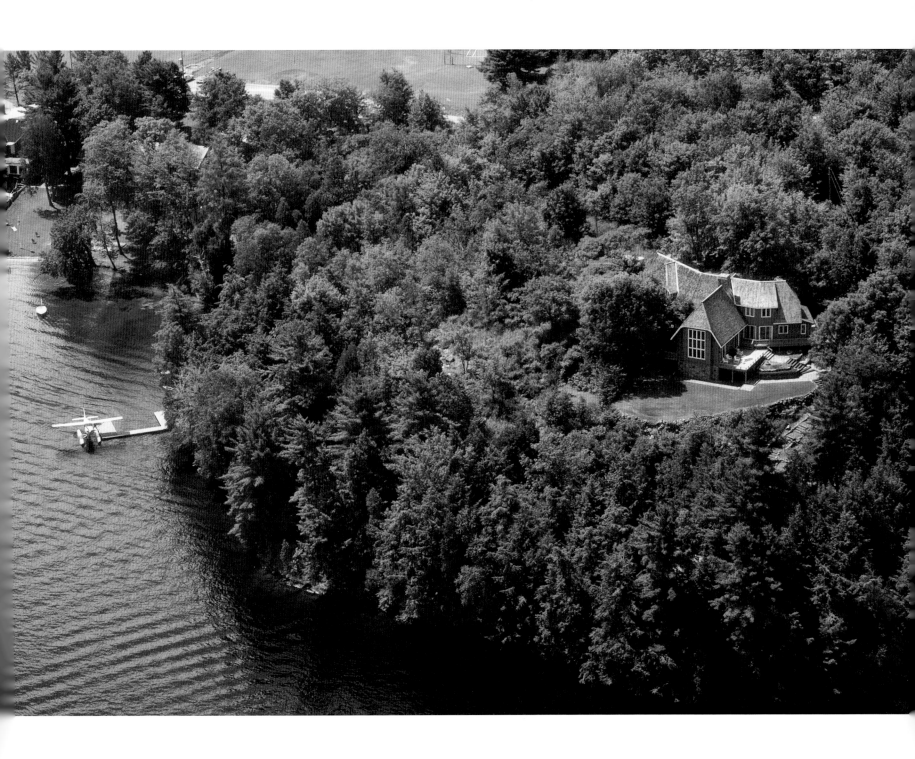

A floatplane provides easy access to this country estate, hidden from the lake by a thicket of trees.

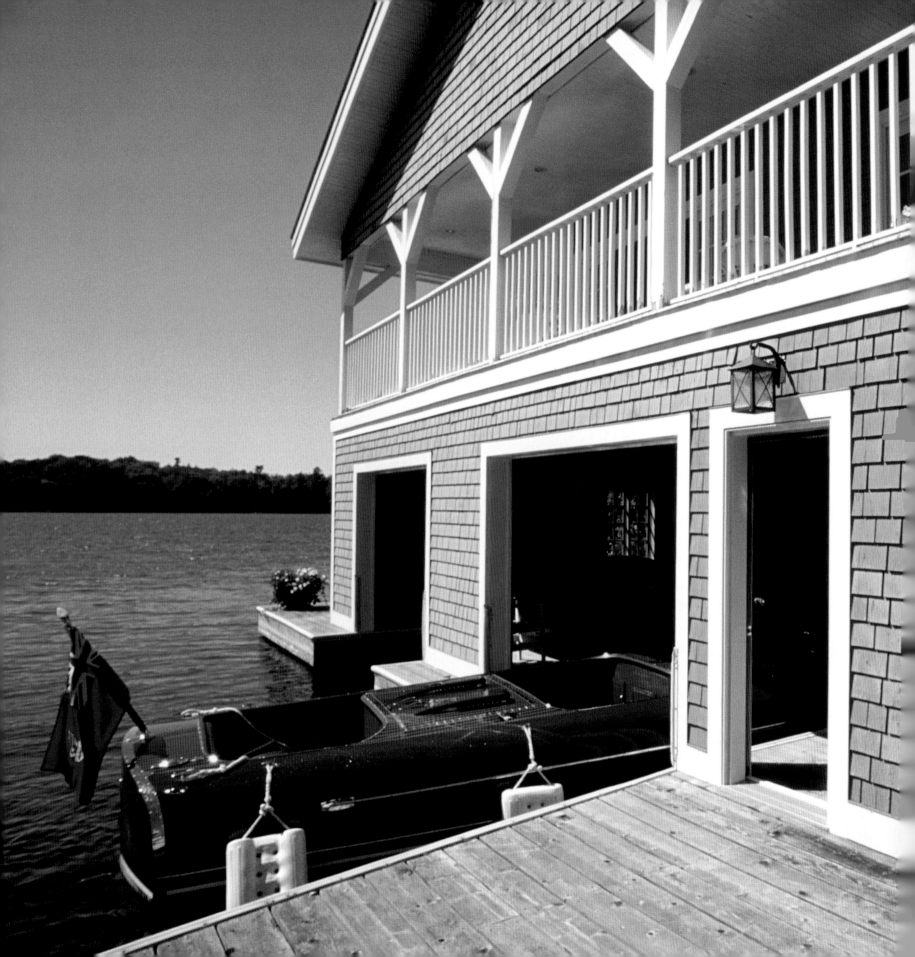

2

Boathouses

On many lakes where houses lie hidden in the woods, the most visible structure is a boathouse at the water's edge. The origin of these whimsical-looking buildings dates back to pioneer times when settlers with lakefront properties built wooden sheds for their canoes and rowboats. Sometime later the dry boathouse appeared. Still primitive in design, it had a ramp that sloped into the water to ease the launching of nonmotorized craft.

The boathouse continued to evolve as new forms of motor power were introduced and pleasure boating became part of the summer experience. The finest vintage boathouses are grand old buildings that date back to the 1800s, when wealthy families needed such structures to shelter their private steam yachts. By the early 1900s, with the advent of gas engines and the popularity of the mahogany launch for recreational boating, boathouses grew to include as many as eight slips at the water level and expansive living quarters up above.

In the Adirondacks, where sprawling log cabin summer retreats were built during the early 20th century, the boathouse was an essential component of these so-called great camps. Made of rough-hewn timbers, ornamental railings, peeled cedar and twig filigree, they became showcases of Adirondack style, often the only visible element of these private upscale enclaves.

To best appreciate the grandeur of a boathouse, step inside to see the boats that are sheltered there. Bobbing majestically in their slips are beautiful watercraft, the legacies of North America's fine boatbuilders. Back in the 1930s, custom boatbuilding was in its heyday. Handcrafted launches were much in demand and featured the finest mahogany, interiors crafted of premium leather, and ornate fittings made of brass and chrome. Many such boats still ply the lakes — some are well-loved originals, others are restored beauties that were rescued from oblivion. Whatever their provenance they make ideal occupants of these elegant shoreline structures.

Boathouse style ranges from the rustic luxury of the Adirondacks to the Victorian lavishness of gables, cupolas, turrets and balustrades seen on lakes in the Muskoka region of Ontario. In more rugged settings boathouses are merely utilitarian garages for boats, tending to Shaker simplicity, with clean lines and board-and-batten siding. Maintaining these old treasures, built with their foundations underwater, is an ongoing challenge. As one boathouse owner relates, "I'm always relieved to arrive at the lake and find the boathouse hasn't sloped off into the water."

(opposite) The owner had Nantucket style in mind when building this boathouse. As a result there's a seaside spareness to the design, with its blue-gray shingles and jaunty white trim.

33

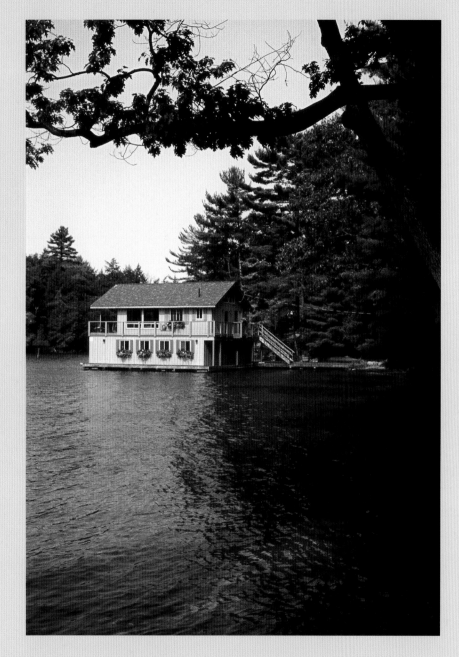

(above) Window boxes filled with annuals brighten the boathouse exterior.

(right) On a busy midsummer day, the white wakes of speedboats slice through the lake.

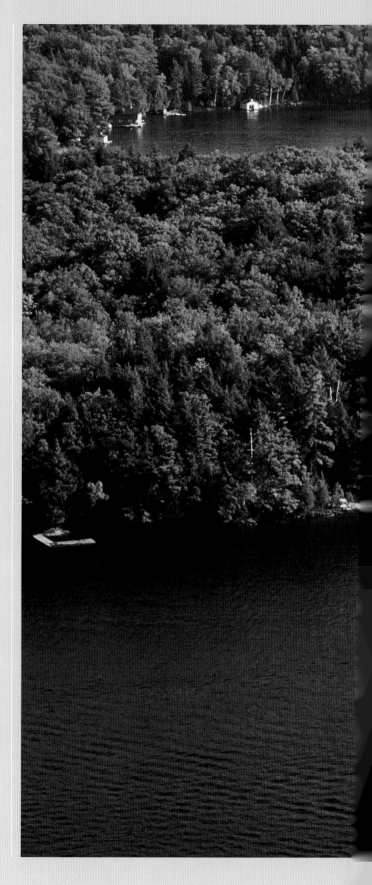

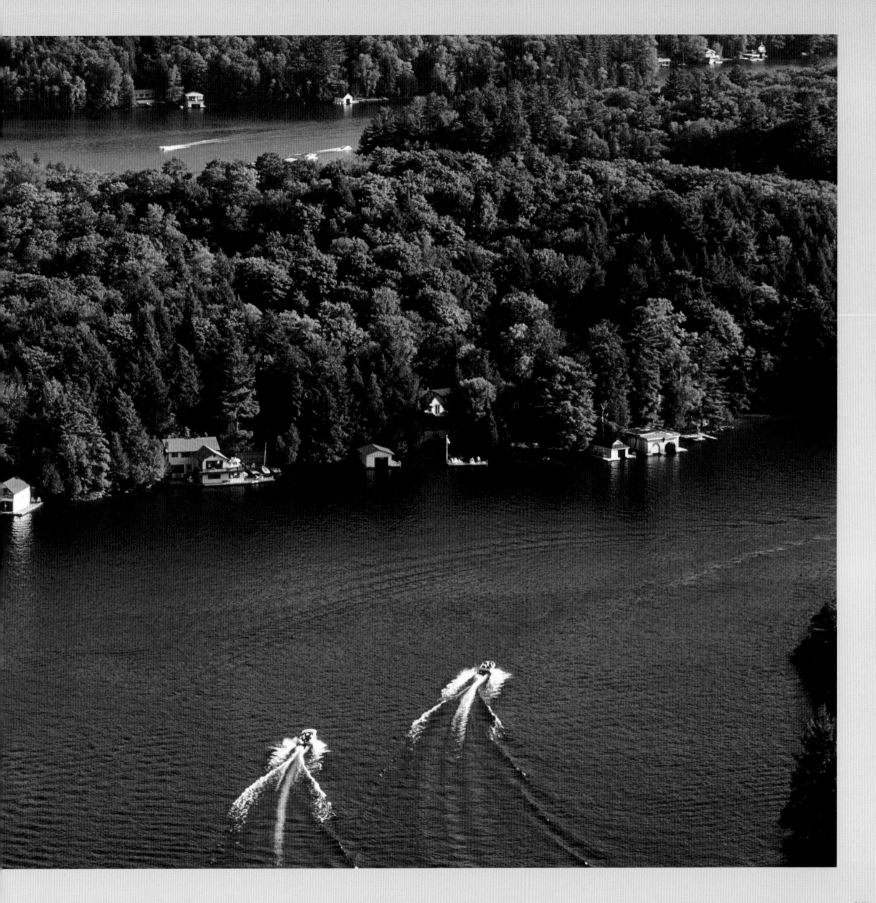

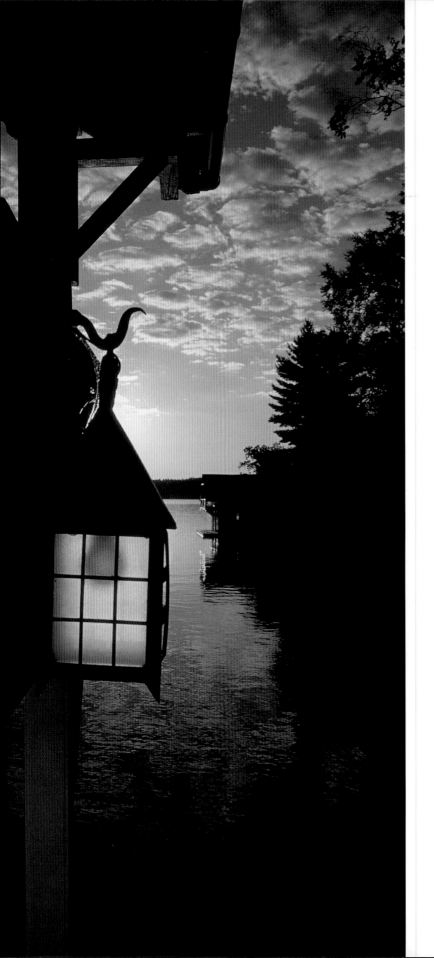

The soft light of a coach
lantern guides boaters
home in the twilight.

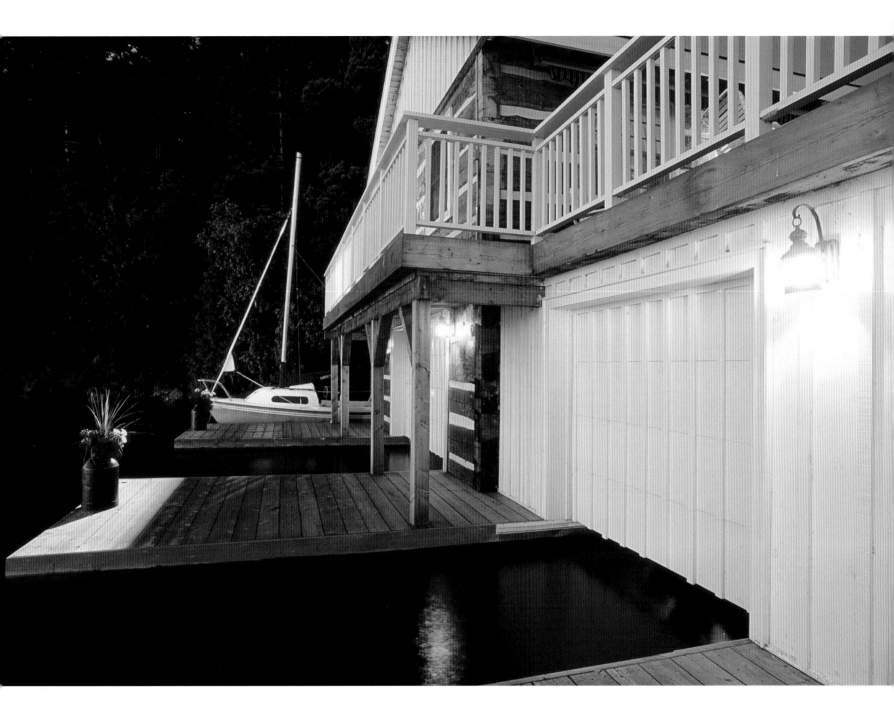

(above) The owners of this boathouse, conscious of preserving the night sky, keep lighting to a minimum. In lake country, one of many joys is being able to see the stars.

(following pages) This large boathouse, built to replicate the island's original buildings, has vast living quarters above and plenty of boat slips for antique launches. The owner, whose summer compound comprises 21 beds, says, "We call it our summer hotel."

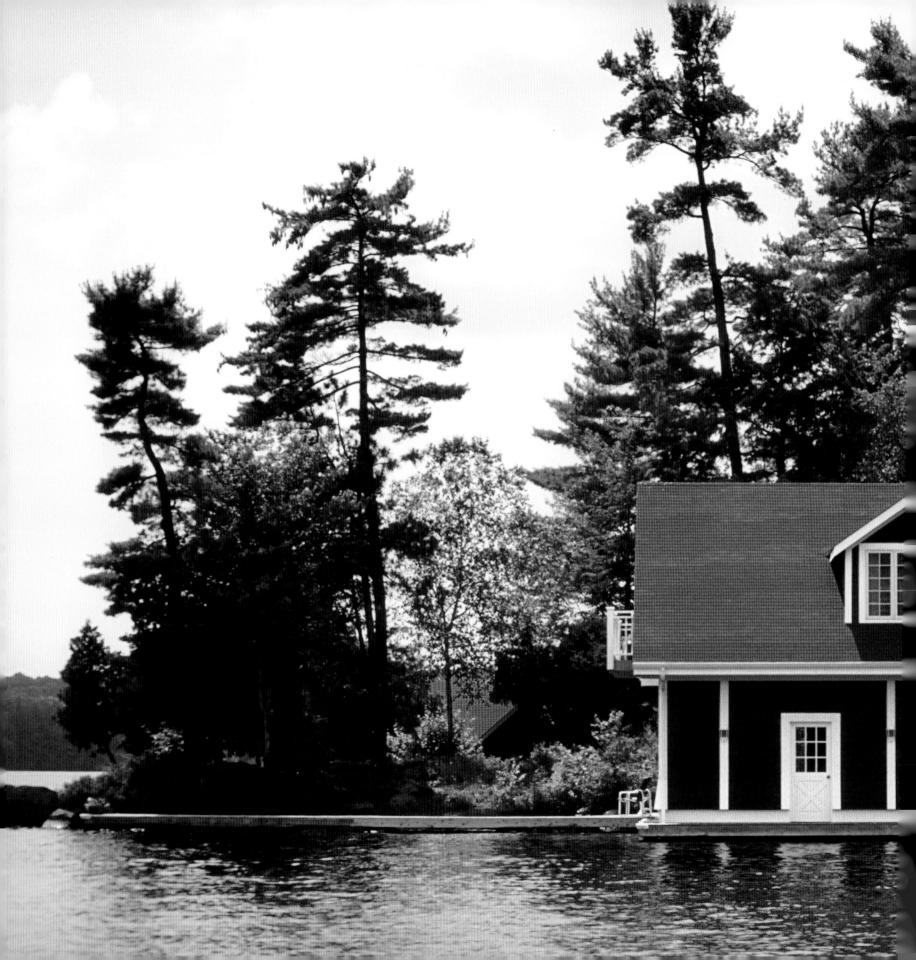

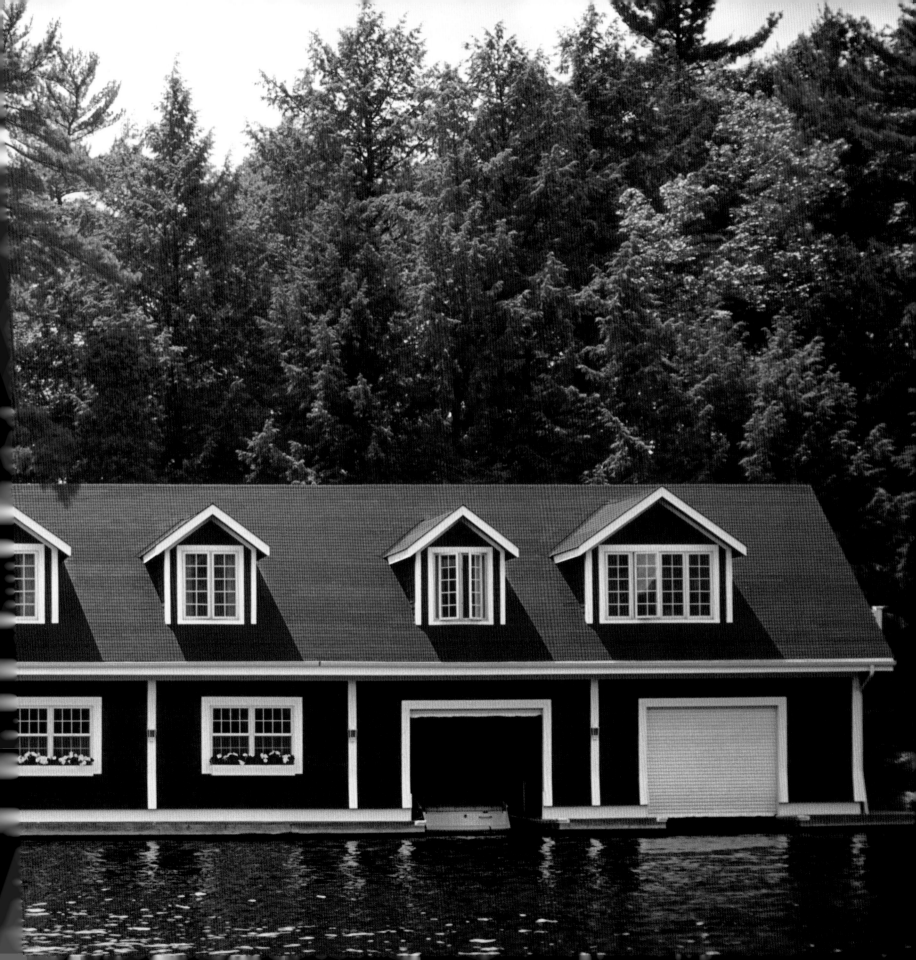

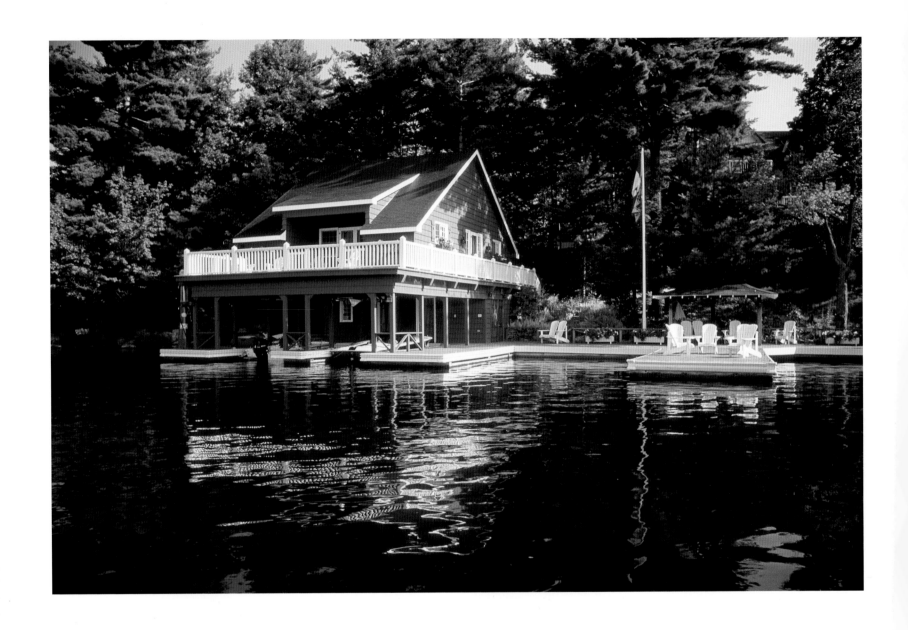

A family compound (originally a resort), with several buildings spread about the property.
This boathouse has a built-in bar at the dock level and a self-contained guesthouse up above.

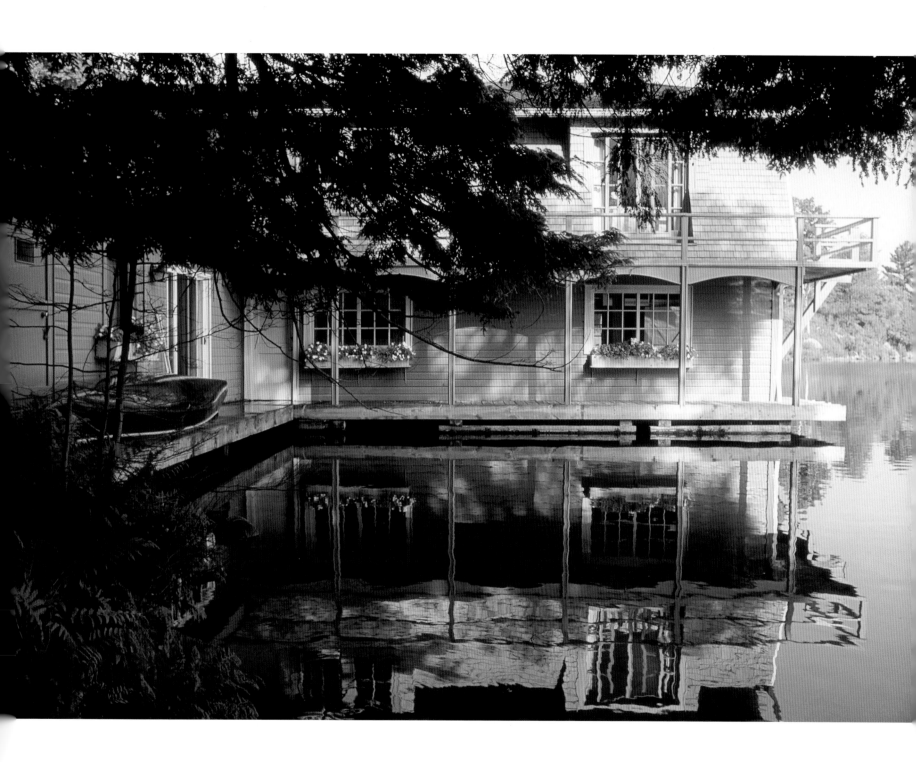

In a quiet cove, the placid water surrounding this boathouse offers up lovely reflections.

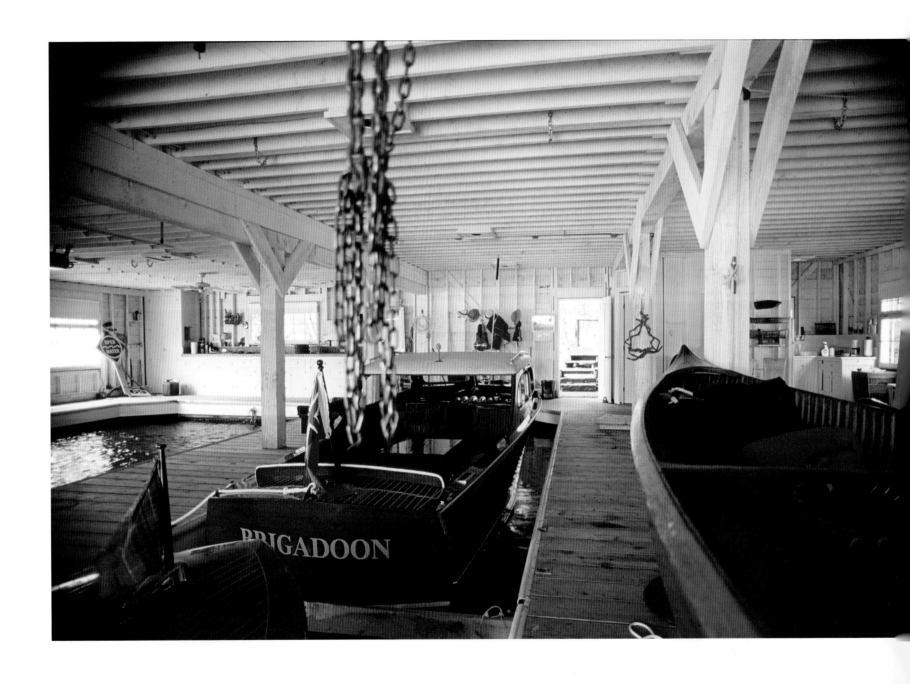

Brigadoon is the name of both the island and this mahogany boat, which is a 1941 Maccraft built originally as a Great Lakes patrol boat. The interior walls and beams were rejuvenated with many coats of white paint.

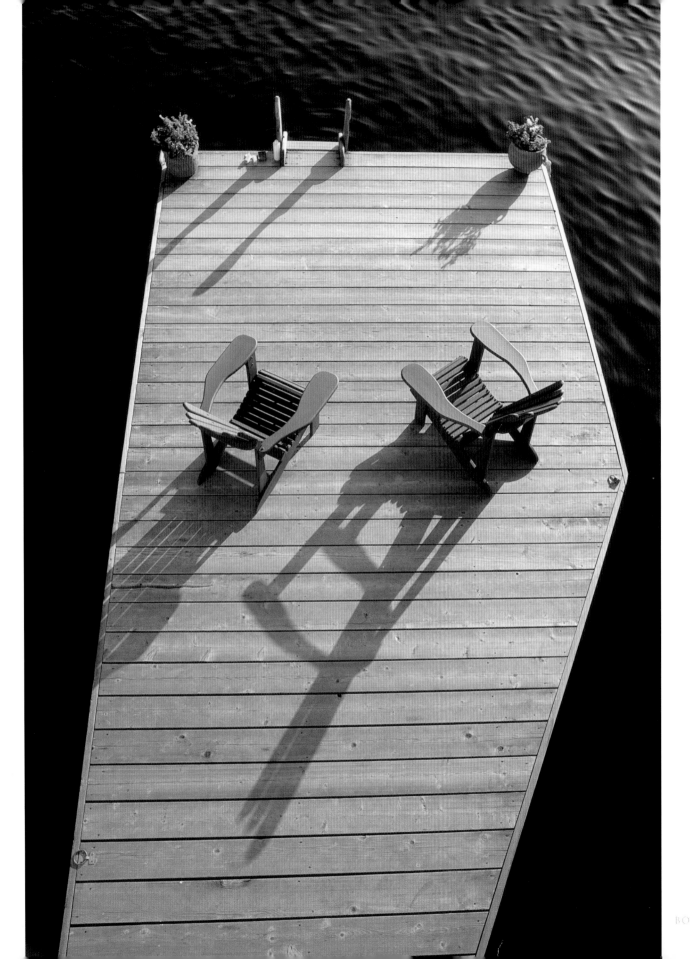

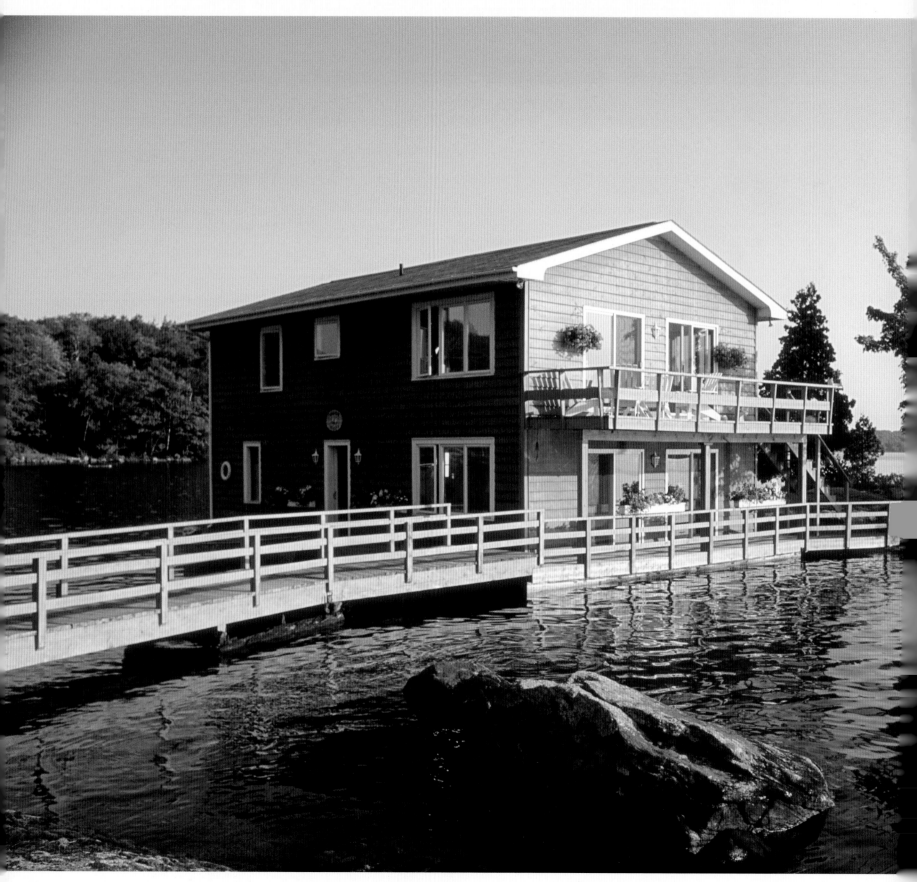

And home sings me
of sweet things.
My life there
has its own wings.

KARLA BONOFF

A wooden bridge connects this boathouse to a larger island and
the cottage. The small island is just big enough for a hammock
slung between two birch trees.

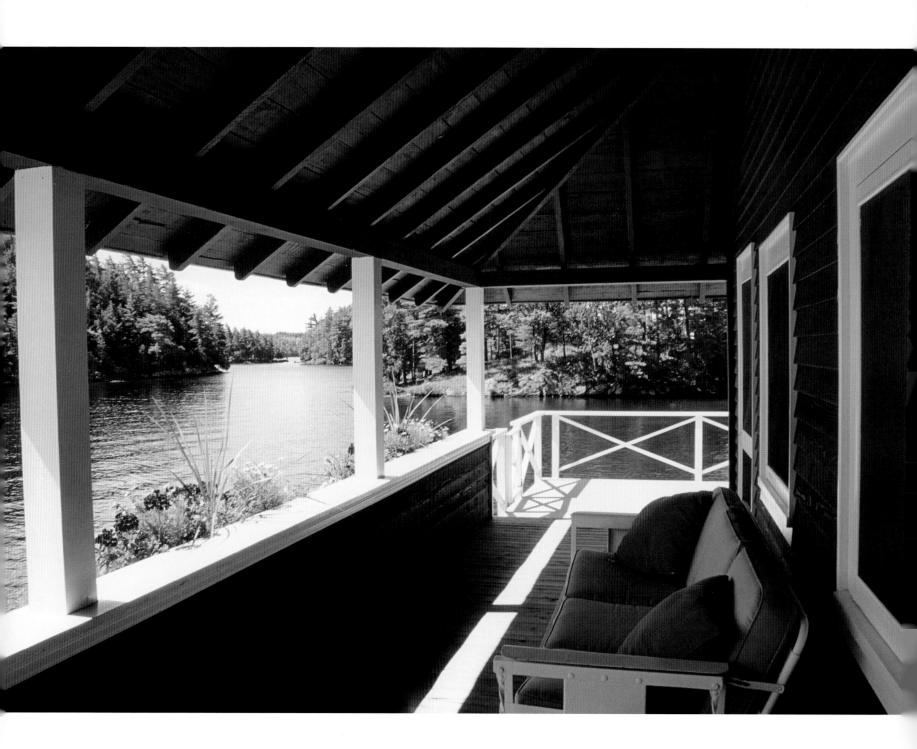

A cluster of islands viewed from the shaded comfort of a covered porch.

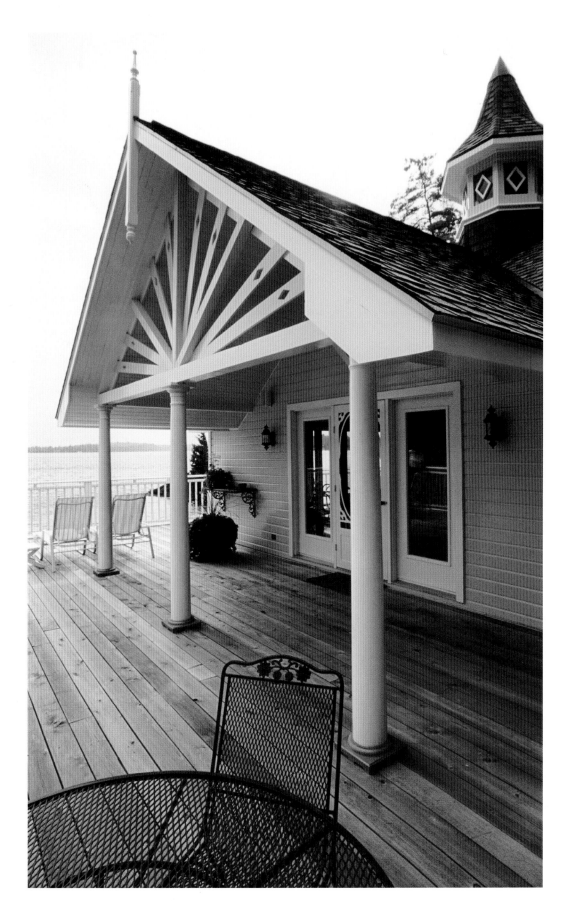

(left) Behind the diamond-shaped windows of the rooftop cupola is a cube of mirrors. When the sun heats the windows, the cube moves to create a glinting effect that can be seen from across the lake.

(following pages) The older boathouse on the right was built in the 1920s. A newer building on the left blends with the vintage design of the original. The owners had the second story insulated so they could come to the lake all year round. This was never an option in the 1920s.

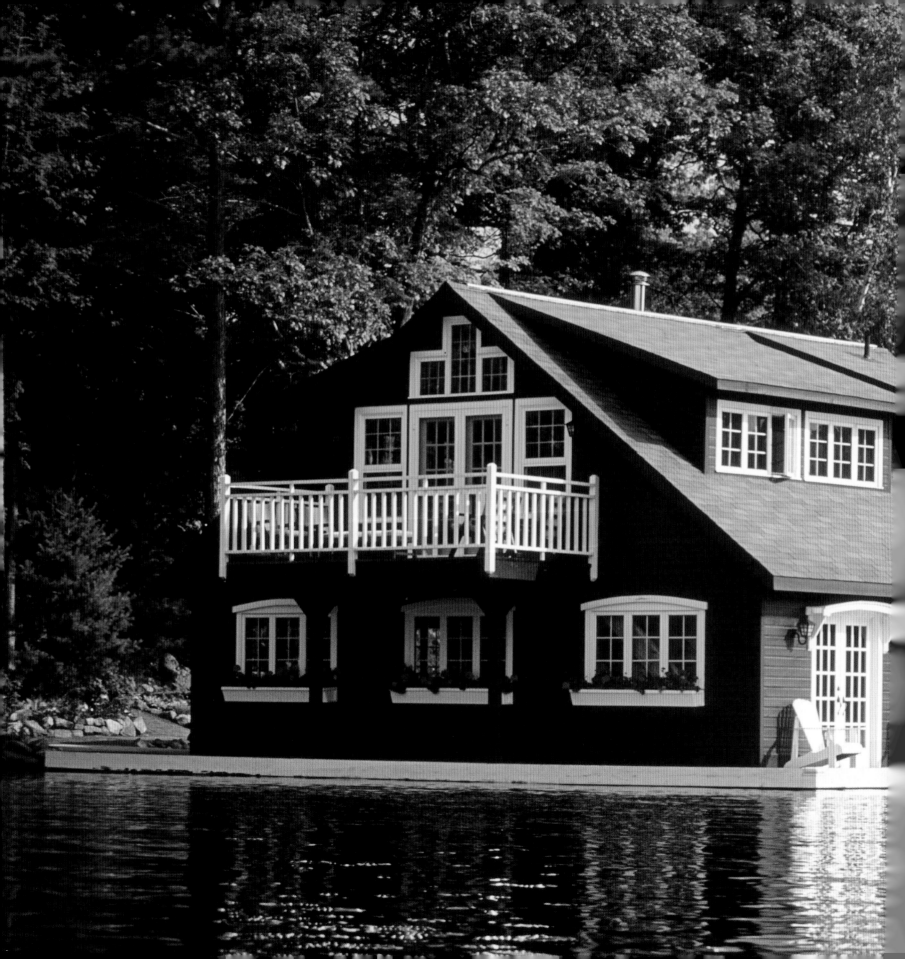

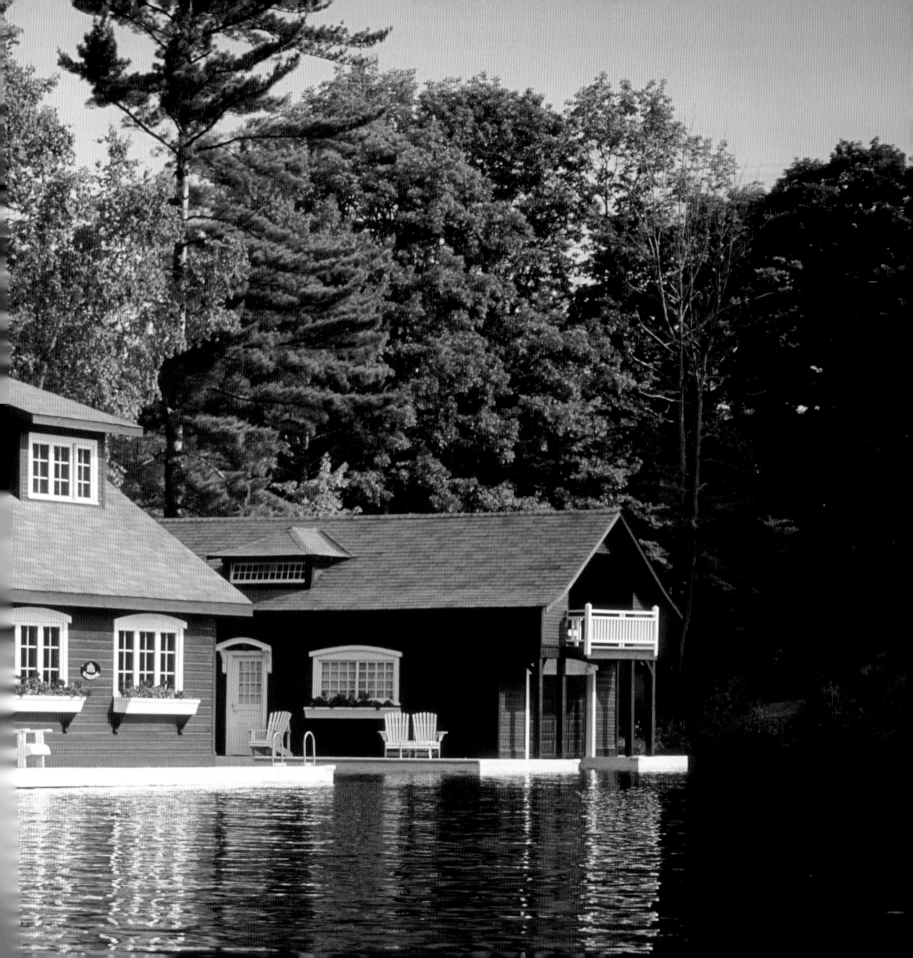

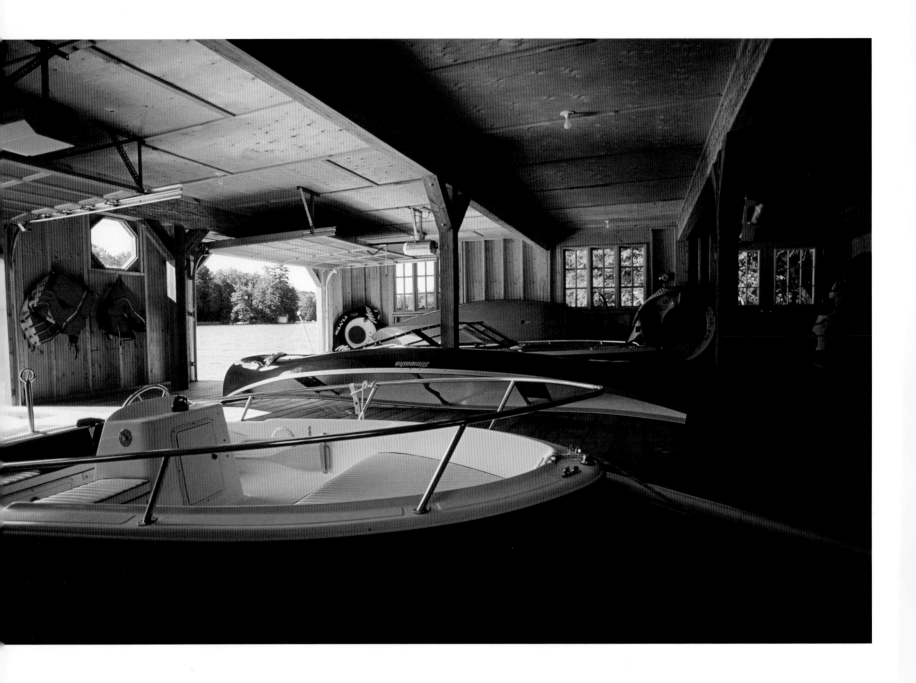

(above) Boats bobbing in their slips at a waterfront retreat named Montana Lago (from the Spanish for Mountain Lake).
The owners named it in fun because the house is perched high on a cliff top.

(opposite) Behind the boathouse are cedar stairs that wind up the hill to the main house.

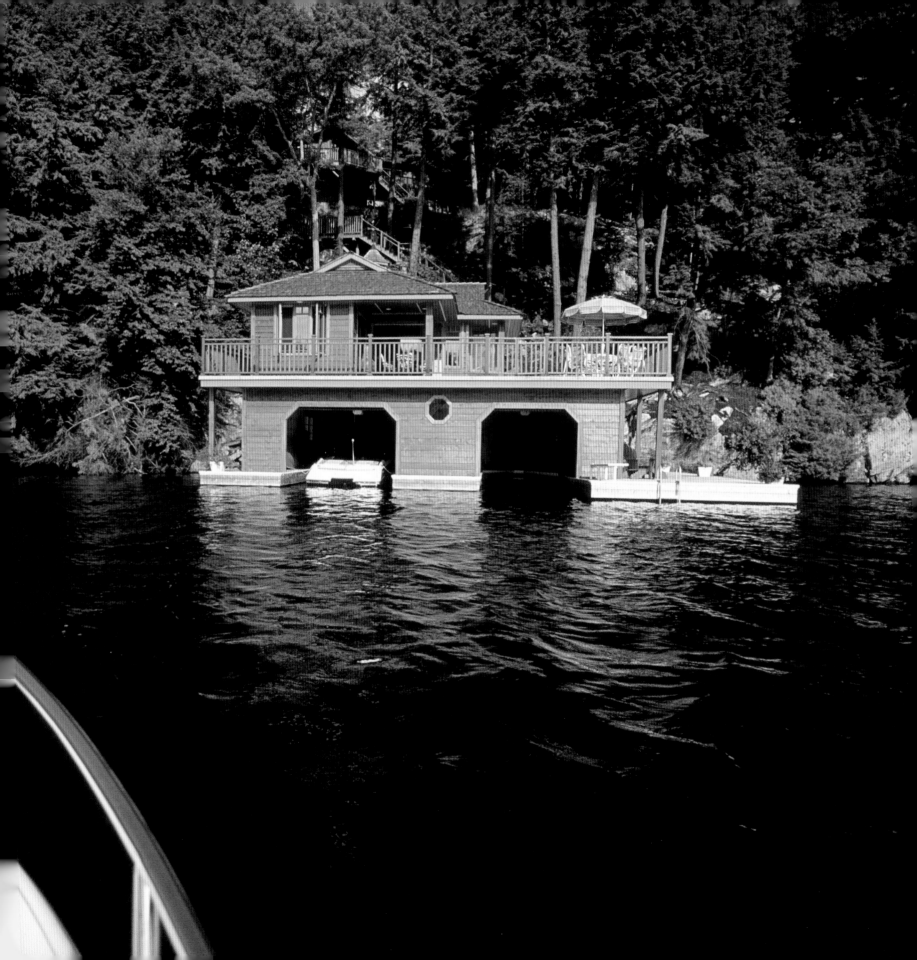

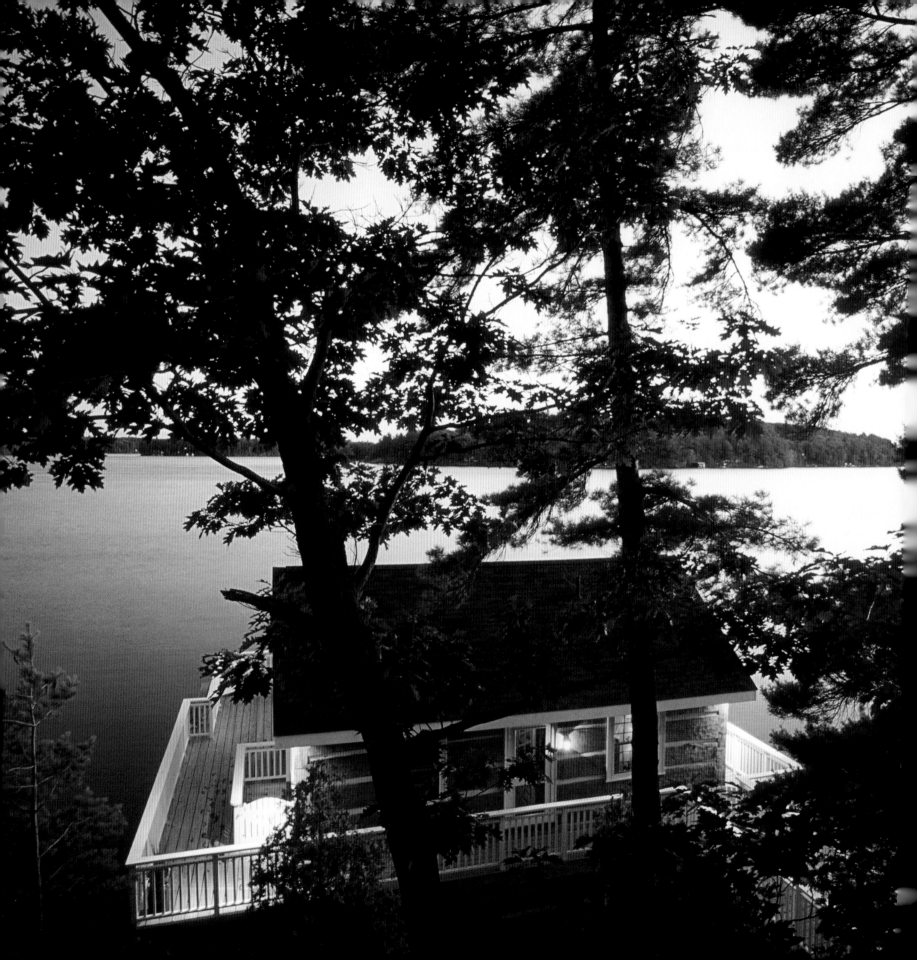

Living Above the Boats

Despite romantic notions about living upstairs in a boathouse, the second floor of most historic boathouses consisted of basic bare-walled staff quarters intended for the family servants. If the staff was housed elsewhere, then the space served a more exotic function — as a ballroom in the big-band heyday of the twenties, or a ball-hockey floor when dancing went out of fashion. But, like attics in city homes, these quarters are now being reborn, swept clean of cobwebs and restored to their cozy gabled origins.

Although most lake communities now restrict the size of livable space allowed in a boathouse, some of the grand old ones have upper stories with more square footage than an average lake house. And newly built ones show creative use of limited interior space. Making up for the small interiors are sprawling decks that surround the living area and offer sun, shade and cool lake breezes all through the day.

Anyone who lives in a boathouse in the summer knows that being wrapped in blue lake is different from living fixed to the ground on the shore. There

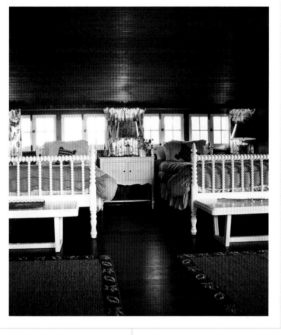

is a feeling of buoyancy in the daytime and at night, the lulling sensation of water lapping beneath you as you sleep. It is like being on a large vessel that is permanently anchored in the same snug harbor.

Summer days and nights are ruled by the lake's many moods — by the rhythms of the water, the cycles of the sun and moon, the closeness of the night sky. The light is special too. It glints off the water on even the dullest days. Dawn comes in with its pale and shimmery waves of yellow, and at twilight, the afterglow of sunset bathes the lake in shades of pink.

"We built our boathouse to use the upstairs as guest quarters," claims one owner, "but when it was finished, we spent one night there listening to the water and loved it so much we moved into it ourselves." Other people plan the boathouse for the older children, but when the time comes, they retreat there themselves and leave the house up the hill to their adult offspring. Boathouse dwellers speak wistfully of the lulling quality of life above the water, the shiplike sensation and the wonderful wraparound views.

(opposite) All is calm on the lake after the sun goes down.

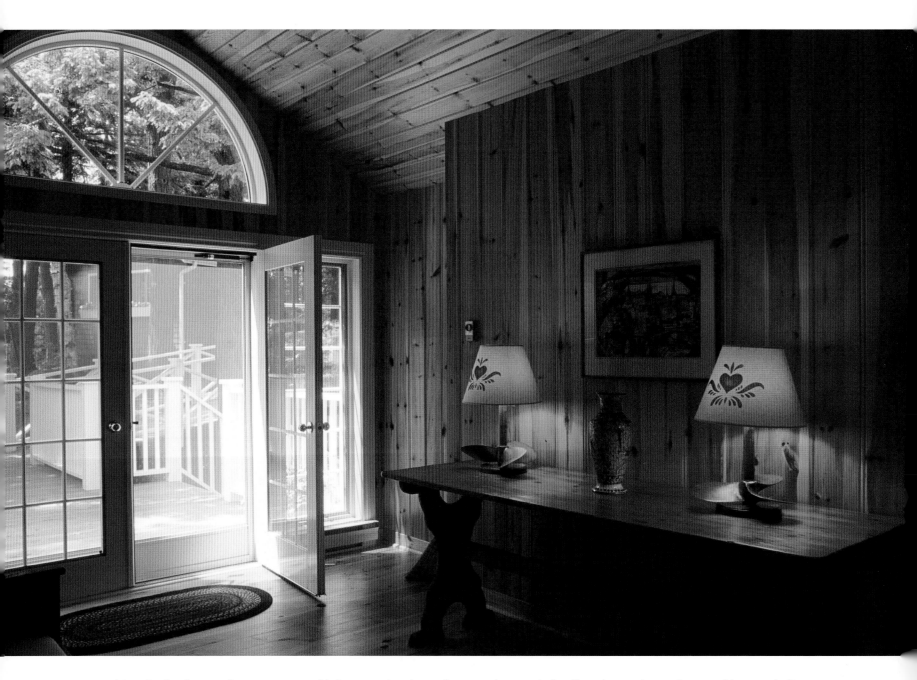

(above) The dormered entranceway to this immense boathouse features pine-paneled walls and an antique refectory table. Long hallways separate the living spaces, providing privacy for guests.

(opposite) Golden rays of light illuminate the lake at dusk. The new owners built the boathouse to match the island's turreted Victorian house, which had been in the same family for five generations.

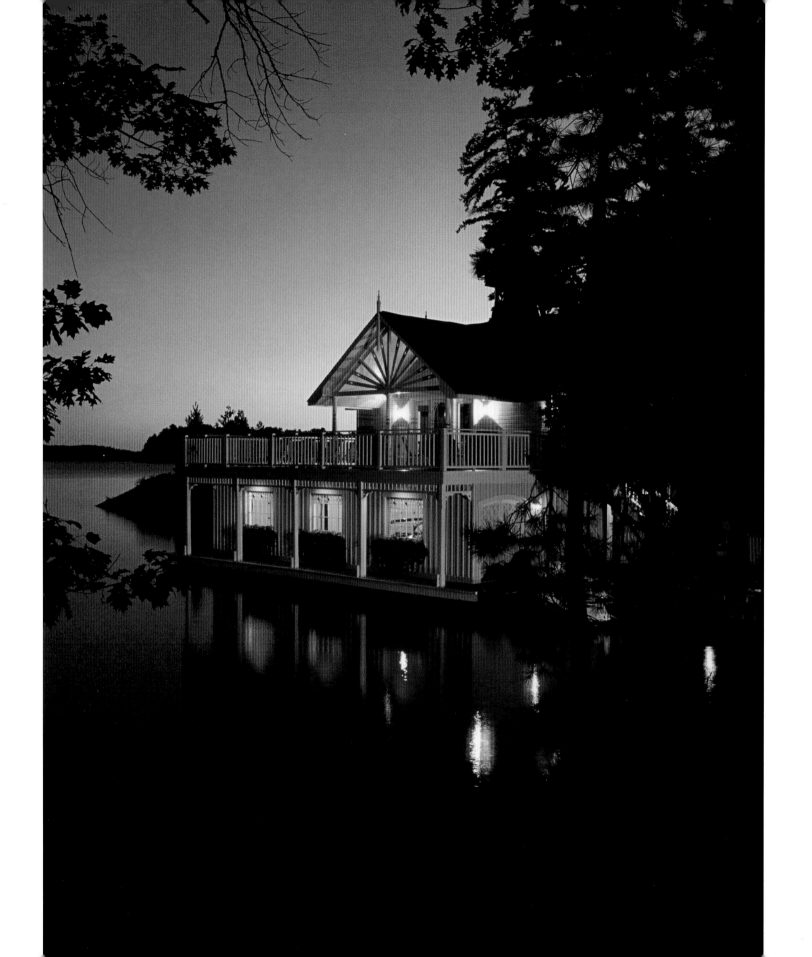

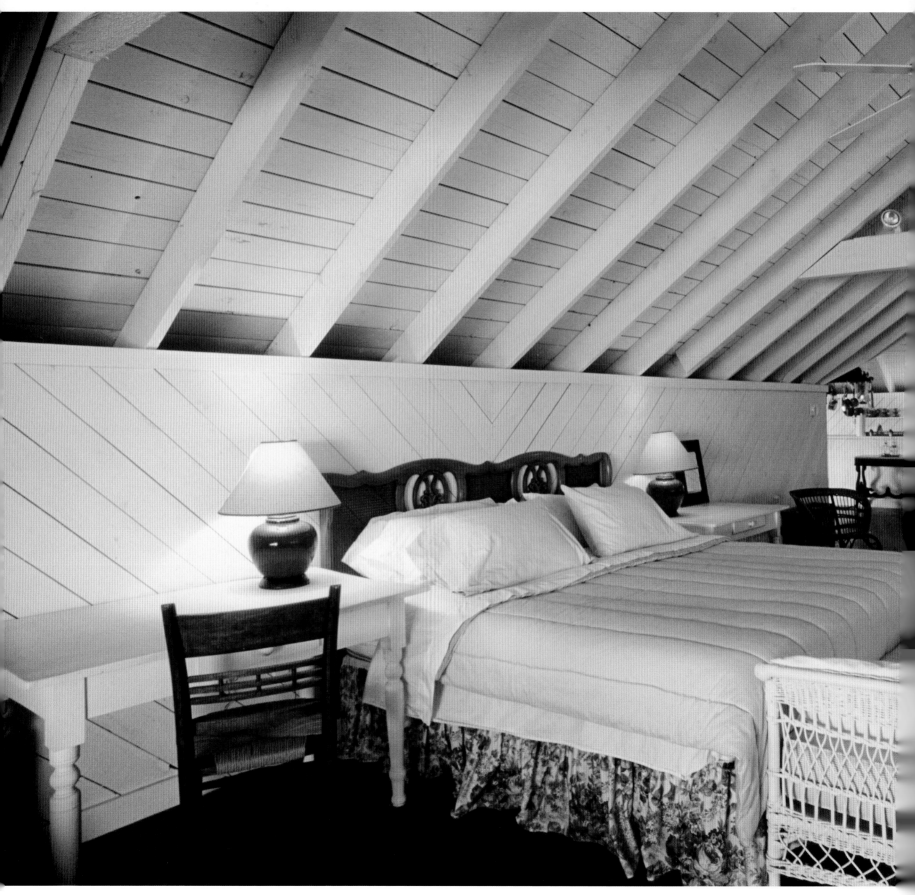

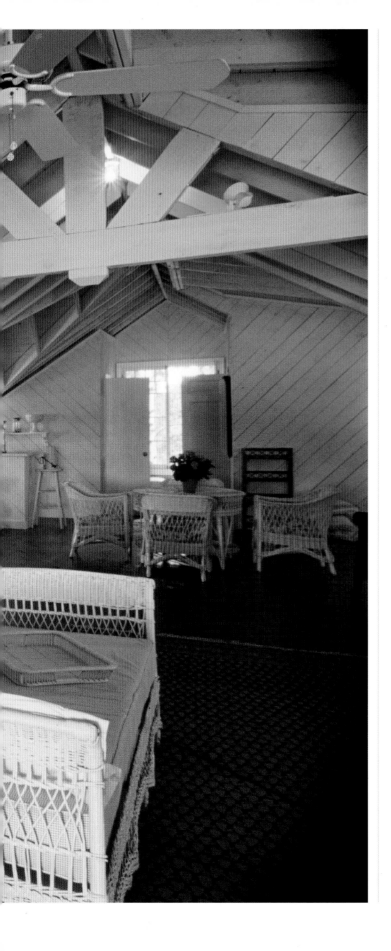

Sleep that knits up the
ravelled sleave of care,
The death of each day's life,
sore labour's bath,
Balm of hurt minds,
great nature's second course,
Chief nourisher in life's feast.

WILLIAM SHAKESPEARE

Exposed rafters and beams were given a coat of white paint, and the floor-boards coated in glossy forest green in this open-concept boathouse. The V-pattern wall planking adds a nautical touch to the airy space.

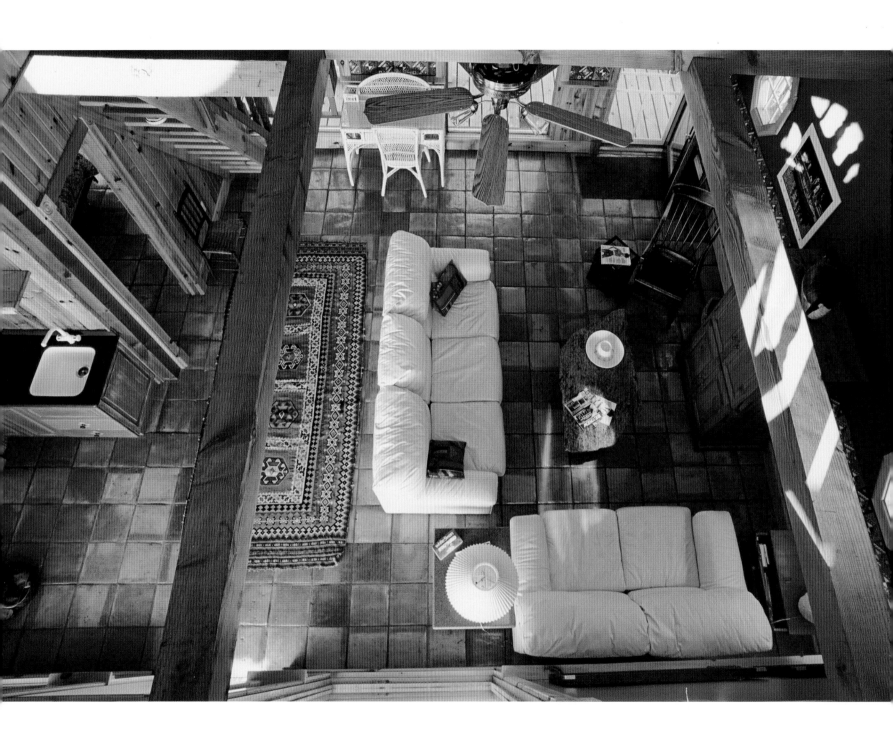

A Mexican tile floor and leather sofas make for easy living in this casual boathouse. Stairs lead to a loft tucked beneath the steeply gabled roof. The owners designed the exterior in the style of a railway station and called it Charing Cross after the one in London, England.

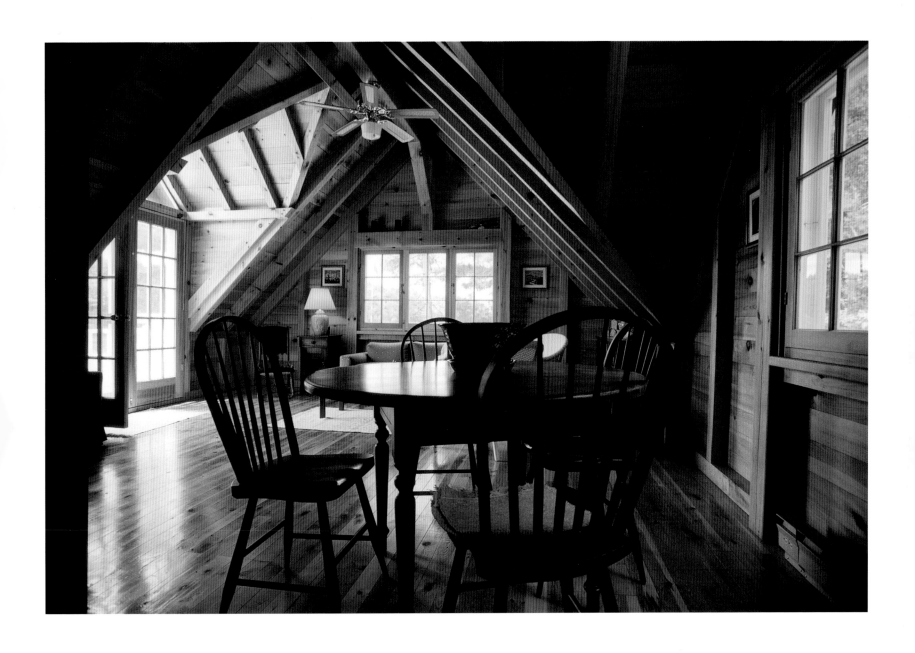

Milk-painted furniture in sage green and warm pine floors create a mellow mood reminiscent of summers long ago.
French doors open to a balcony overlooking the lake.

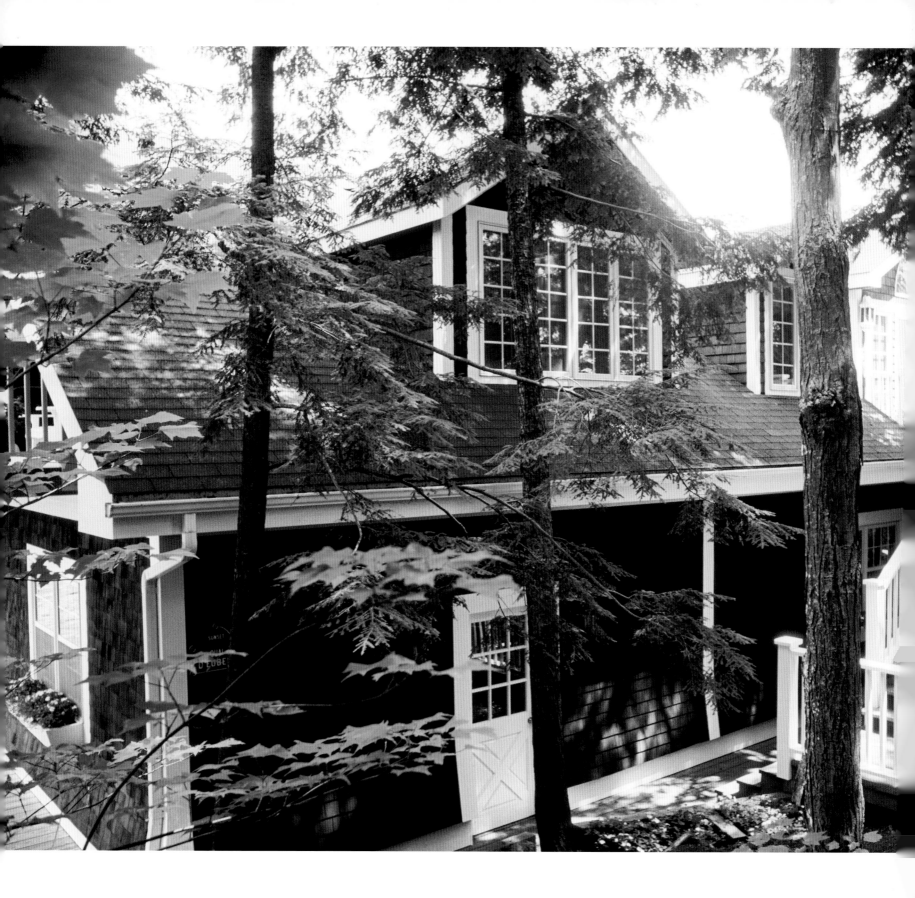

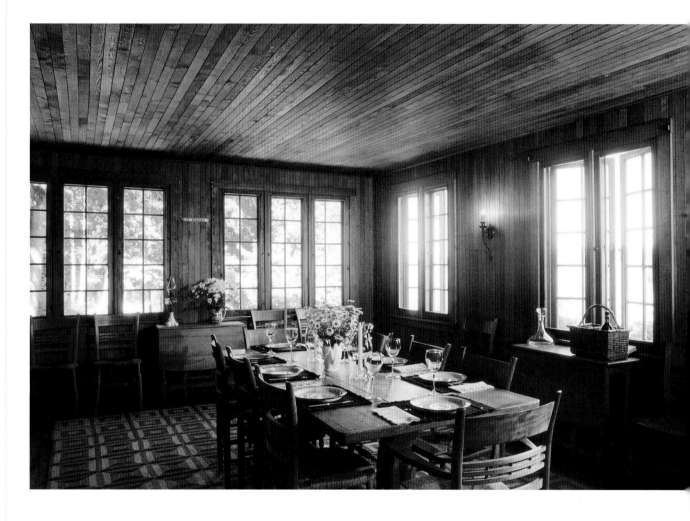

(above) Plenty of windows offer water views from almost every seat in the dining room of this vintage summerhouse.

(left) Multiple gables show the size of this waterfront house. Architectural details are outlined by crisp white trim, a pleasing contrast to the deep chocolate brown cladding.

(following pages) Flagstone paths built into the granite shoreline lead up to the main house from this gracefully restored boathouse. The owners, who come from Switzerland for the summer, admit, "We sometimes go down to sleep there just to be close to the lake at night."

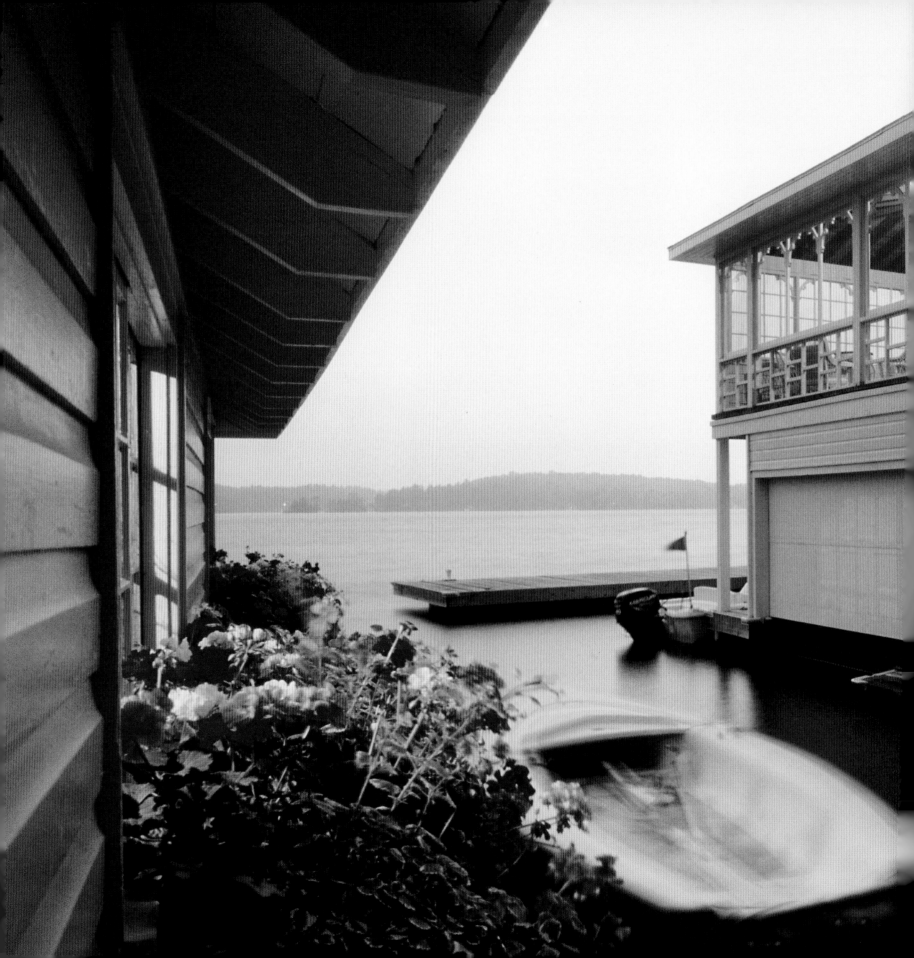

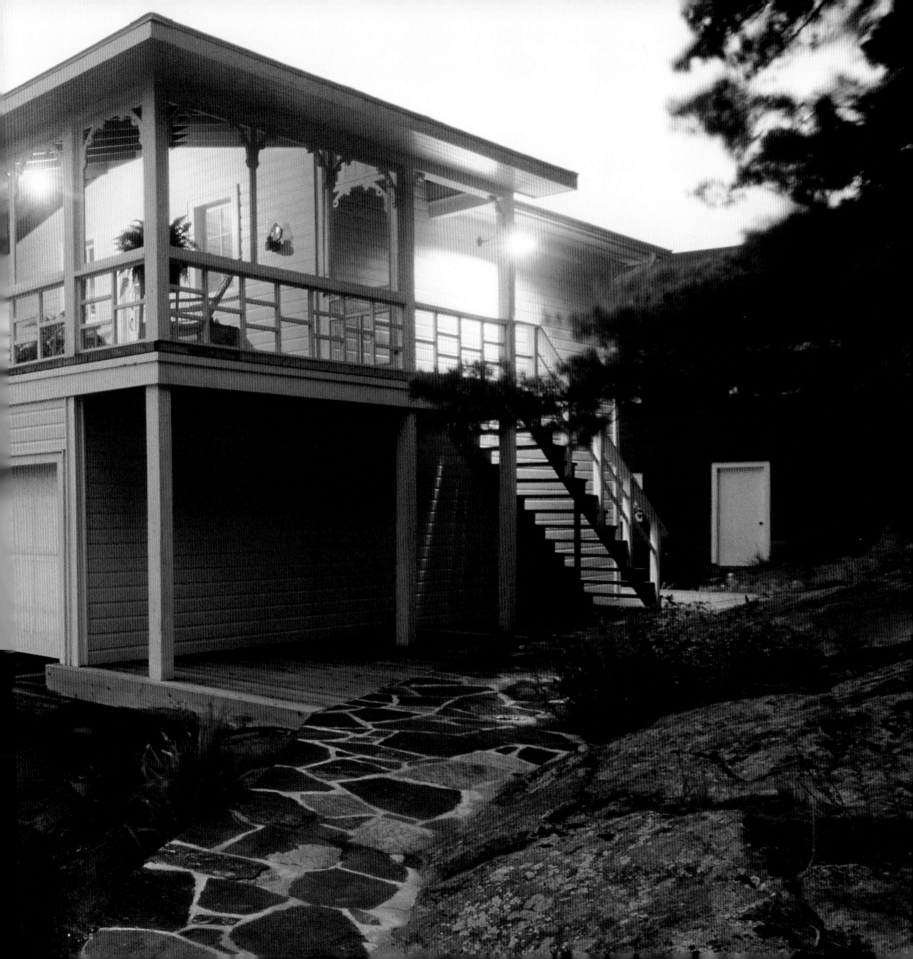

In summer, the song sings itself.

WILLIAM CARLOS WILLIAMS

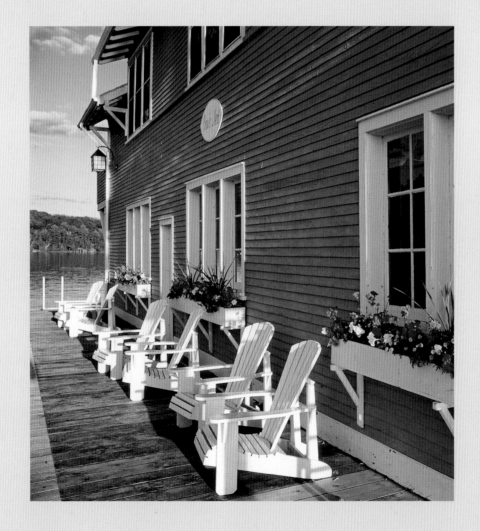

A collection of buildings, both old and new, form this lake compound. The main boathouse dates to the early 1900s, whereas the dockside cabin is a more recent addition. The owner, a publisher, often lends the cabin to visiting writers who find inspiration by the water.

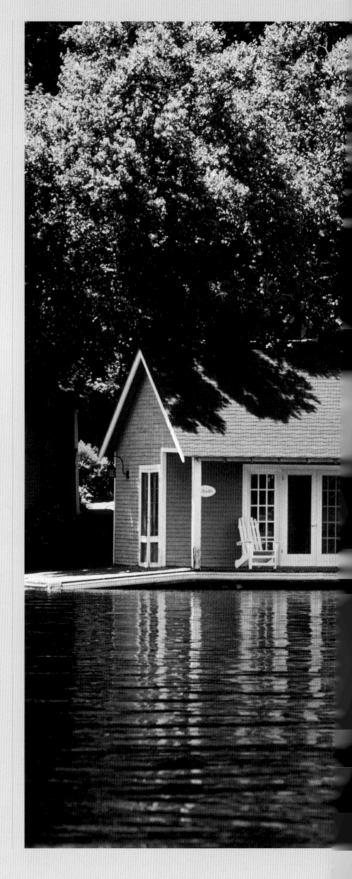

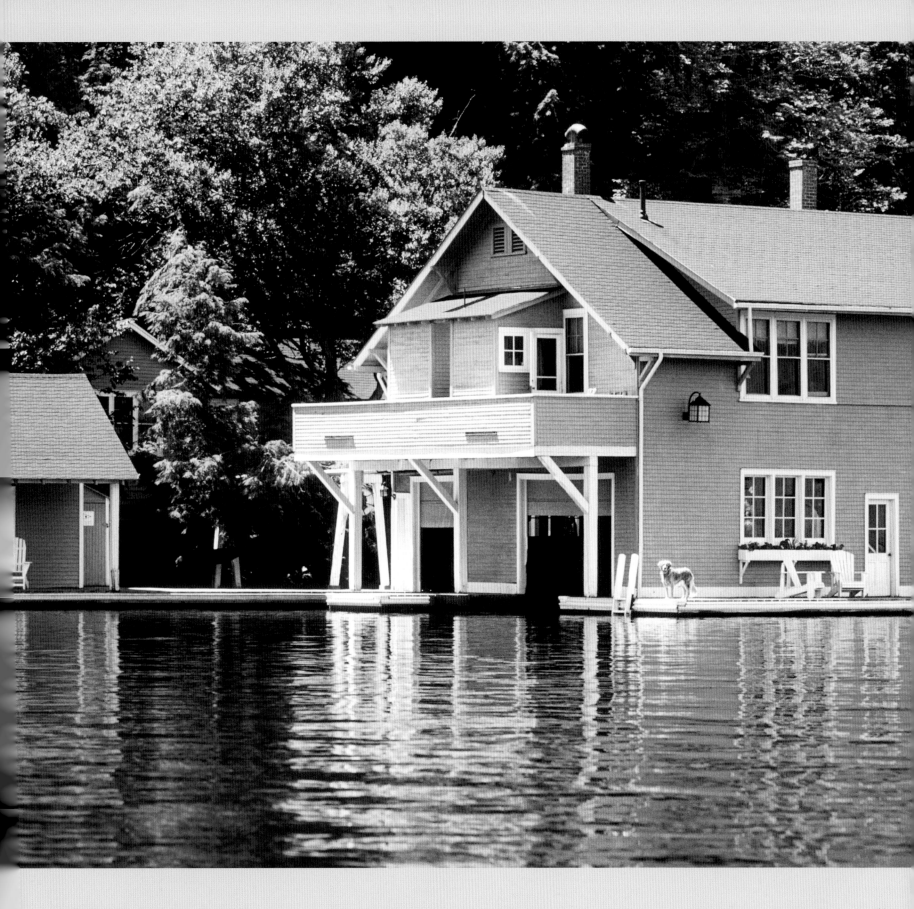

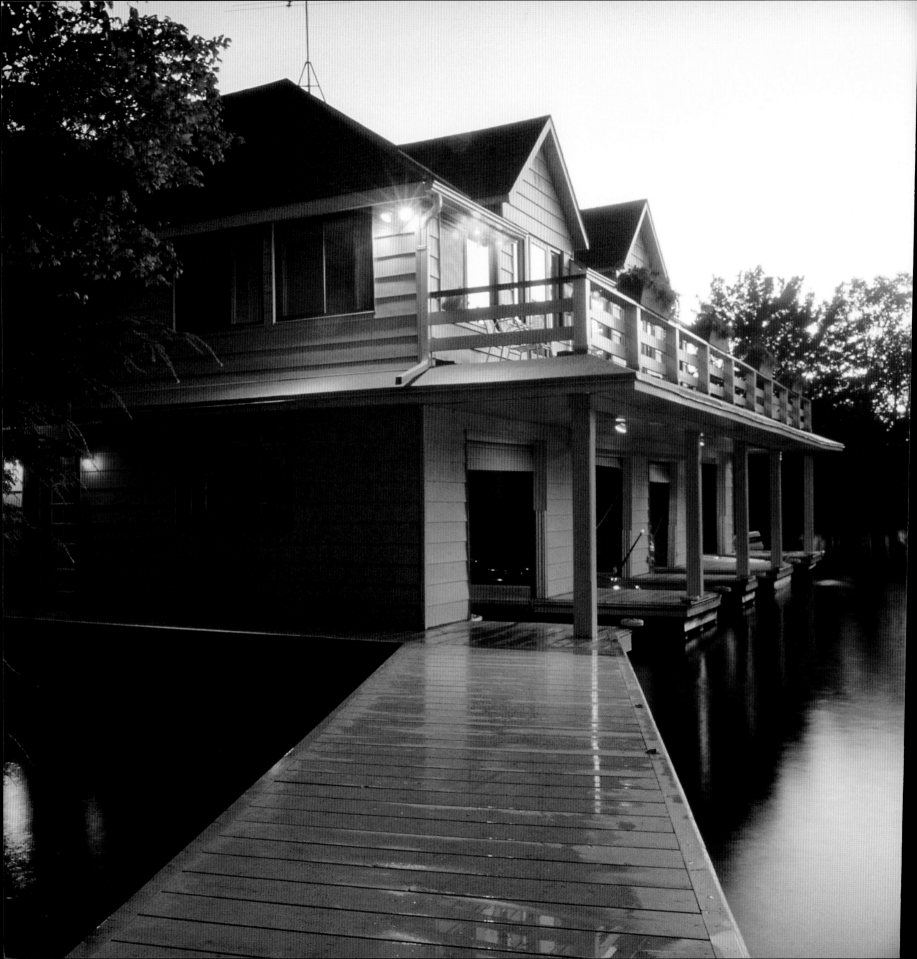

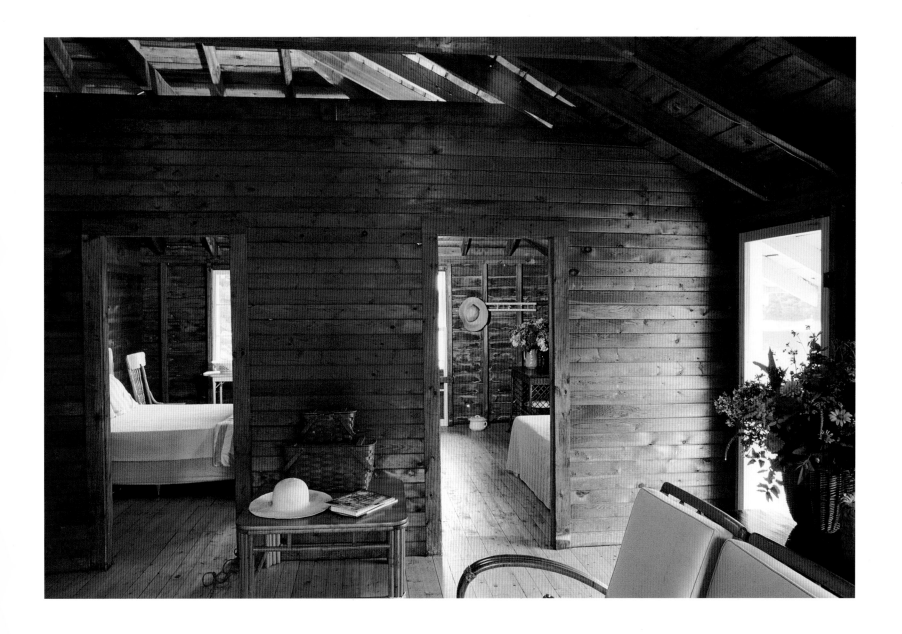

(above) This 1895 boathouse was once part of a summer resort hotel and served as a dormitory for the musicians who entertained the guests. Some of their names are still scribbled on the old cedar walls. Keeping the place as unchanged as possible is the current owners' goal.

(opposite) Four boat slips offer storage for the owner's mahogany launches. The living quarters have expanded over the years to become a spacious family home. The owner loves living on the water: "It makes for very casual summer living," she says.

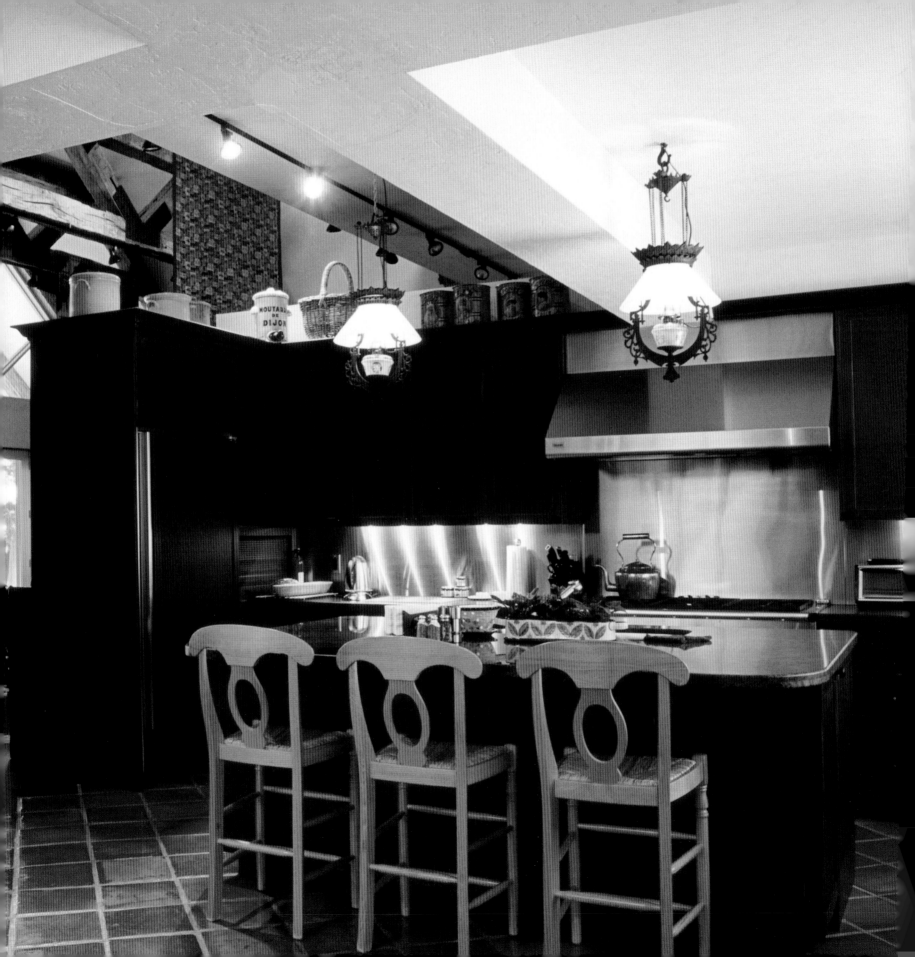

The Cook's Domain

If the cook in charge considers summertime an opportunity to create imaginative meals, the kitchen will likely be a cheerful room with everything in its place — homemade jams and pickles on pantry shelves, freshly picked vegetables in quart baskets, herb pots on a windowsill and the smell of coffee cake baking in the oven. On the other hand, if the cook prefers to spend time down at the dock, the kitchen may operate as a kind of haphazard take-out restaurant where the only rule is "close the refrigerator door."

Either way, in most lake houses the kitchen tends to be the hub. Keeping outdoor appetites satisfied and the larder filled are ongoing tasks. In contemporary open-plan kitchens, the cook can stir the stew and still take part in family games. And today's lavishly designed retreats can have kitchens that would be the envy of a professional chef, industrial-size appliances, granite countertops and every gadget imaginable.

To make the most of the short summer season, lake houses are moving the cooking outdoors.

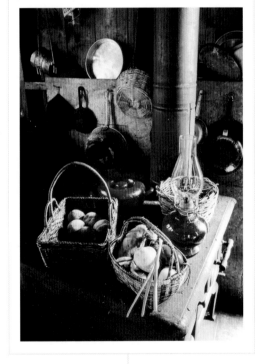

Summer kitchens, complete with stove, sink, refrigerator and a screened-in dining area, take the heat out of the house. Outdoor barbecues have gone way beyond the basic charcoal hibachi and are now large enough to grill a lamb on a rotating spit. Often built of rock collected on the property so as to blend into the natural setting, they become a companionable center of attraction at the dinner hour. Outdoor fire pits built into the deck are perfect for roasting marshmallows and keeping conversations going long into the cool summer nights.

But in traditional back-of-the-house country kitchens, where propane powers the appliances and a hand pump draws water from the lake, keeping things the way they always were is more important. As one cook explains while removing hot loaves of oatmeal bread from her woodstove, "I don't want to hear the whir of a food processor or the dinging of a microwave oven at my lake house. I like the quiet of an old-fashioned kitchen."

(opposite) Antique lanterns and cabinets painted a midnight blue give this kitchen its charming character.
The lake house has undergone seven renovations, adding rooms here and there over many years.
"We try to tie it all together," says the owner, "with dark-stained floors and Mexican tiles."

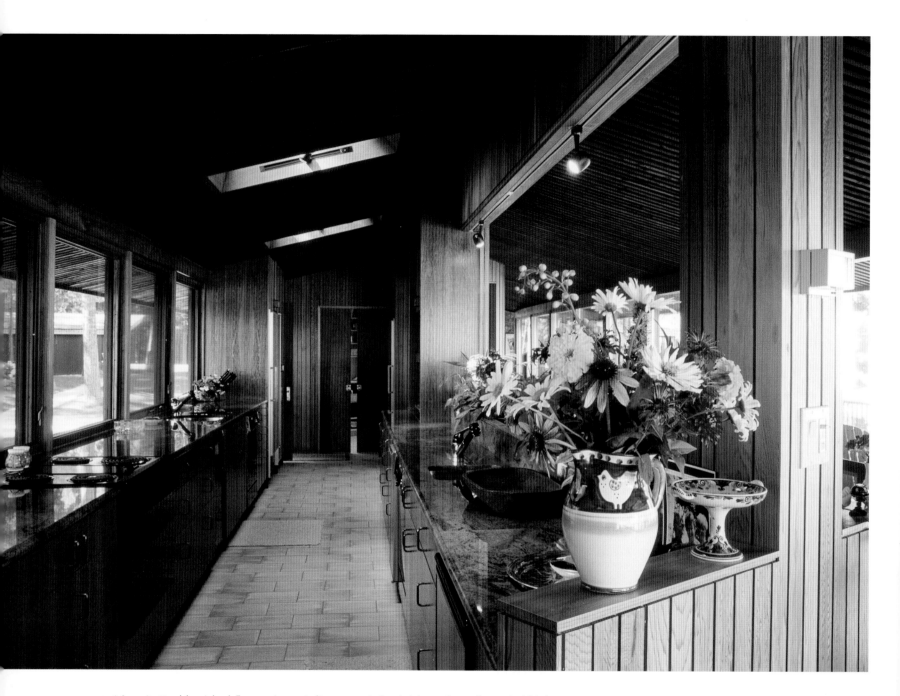

(above) Freshly picked flowers in an Italian ceramic jug brighten the galley-styled kitchen.

(opposite) More Italian ceramics are on display in this old-fashioned kitchen. "Open shelving is the best solution for summer living," suggests the owner. "Guests can find things more easily."

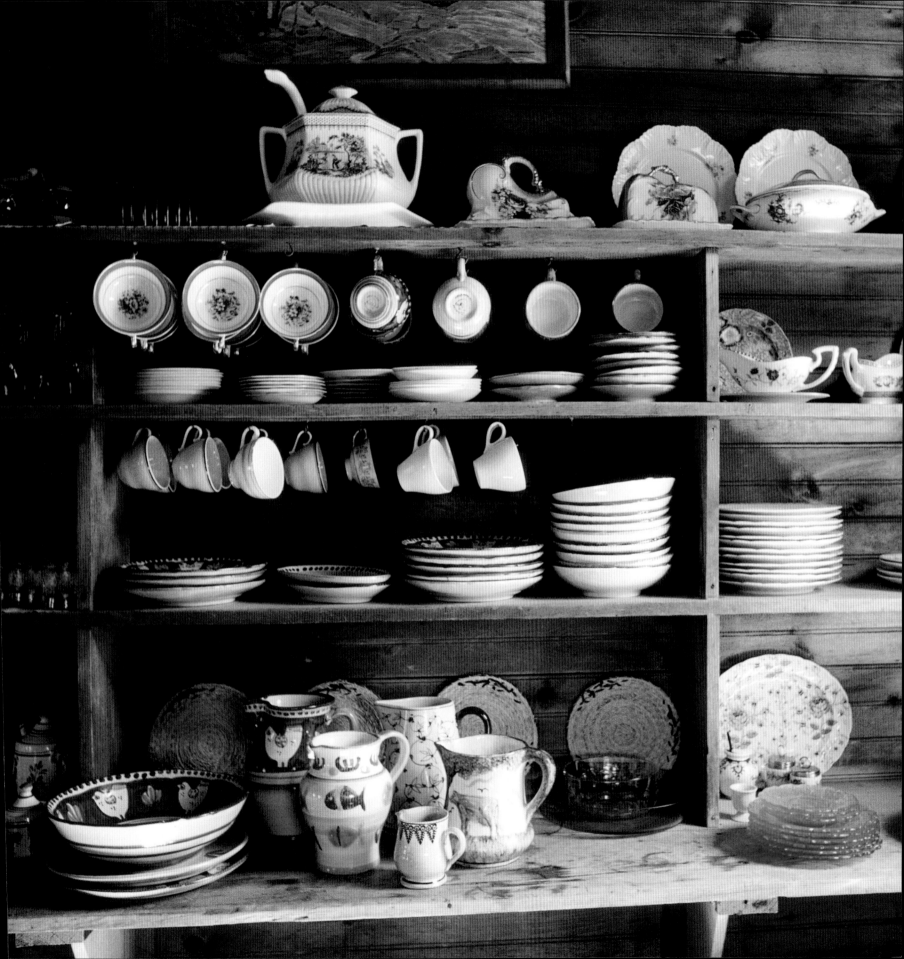

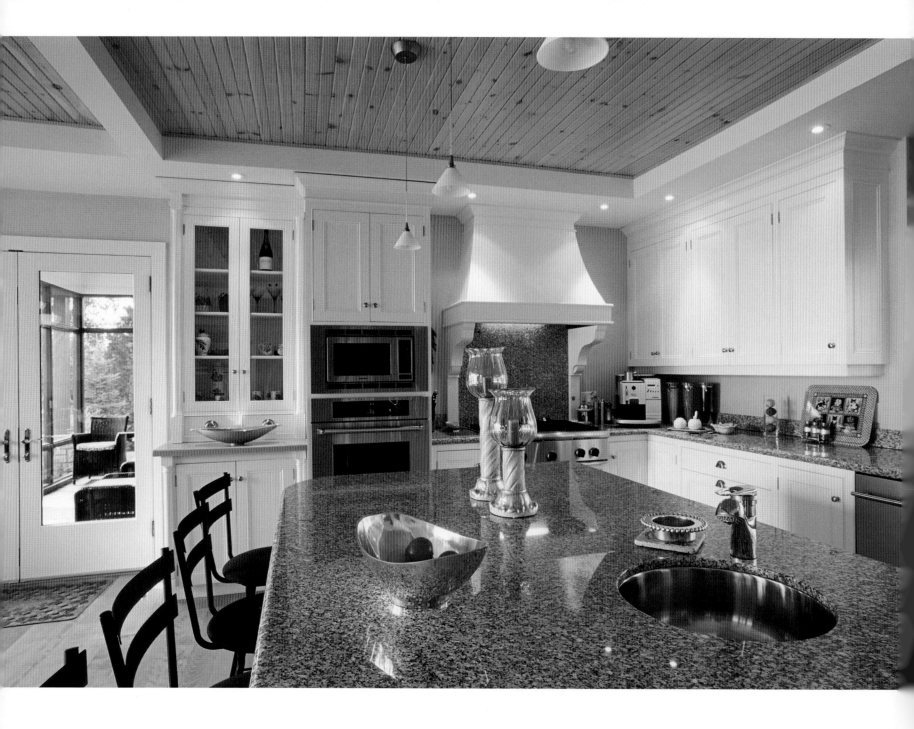

The kitchen in this architect-designed lake house was built for vintage appeal but still features all the modern conveniences. The door opens to a sun-filled screen porch.

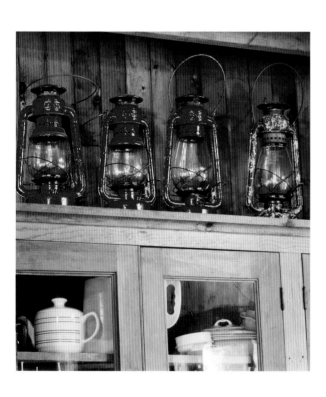

(above) Kerosene lamps are a sign of the age of the cottage, built before electricity came to the lake.

(right) The family at this lake house thrives on an old-time, relaxed summer existence. Bread is baked in the wood stove, and a kettle on top is kept warm, ready for afternoon tea.

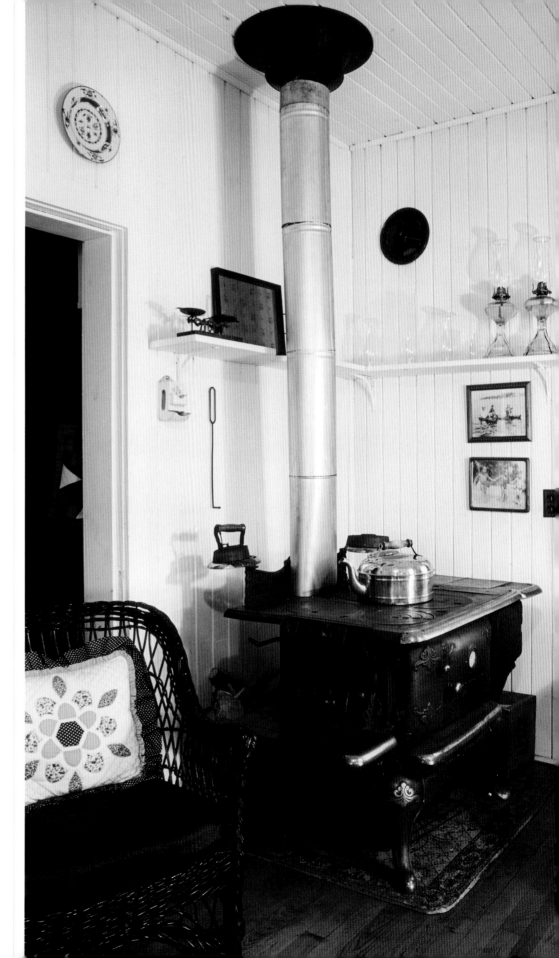

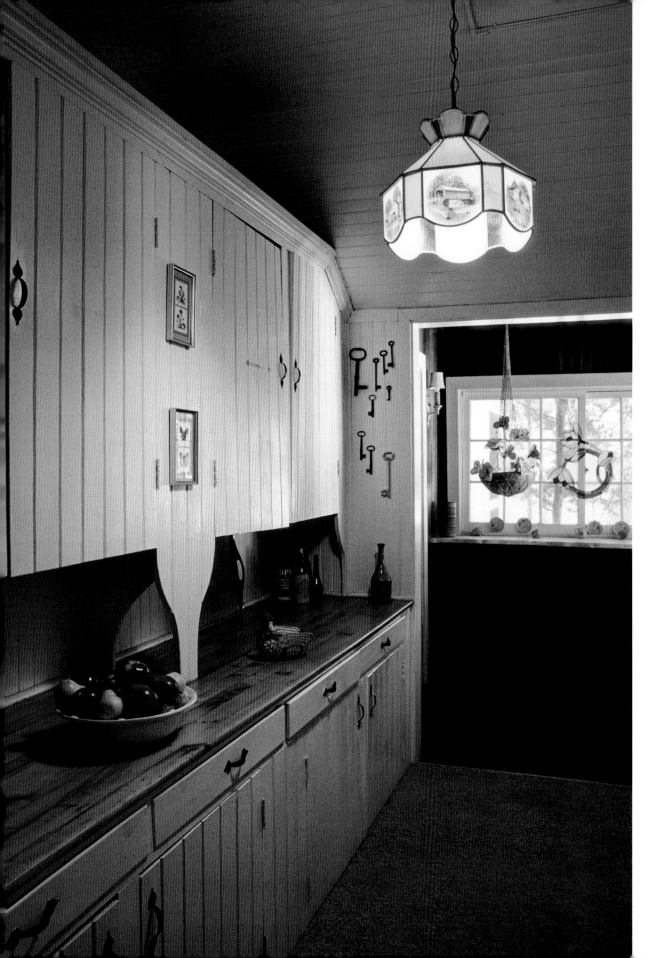

The pantry, with its worn wooden counters, was once the servants' domain in this rambling lake home. Today, it provides useful storage for a large family.

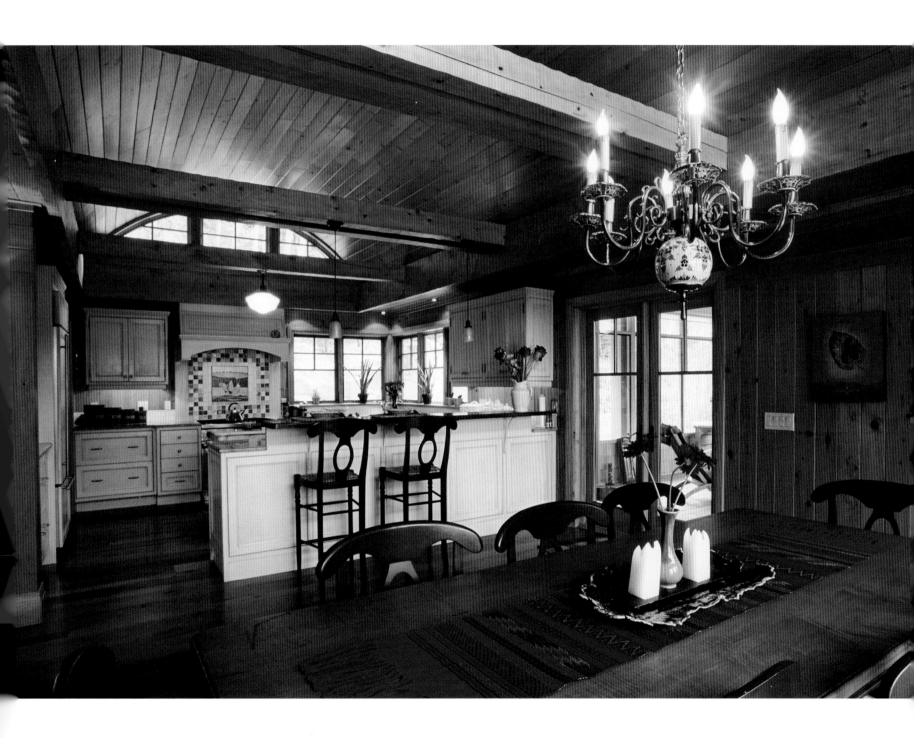

Details like the eyebrow window add architectural interest to this lake house, where friends and family gather around the kitchen island for simple, no-fuss meals. The kitchen opens to a sunroom with plank flooring and a ceiling-high stone fireplace.

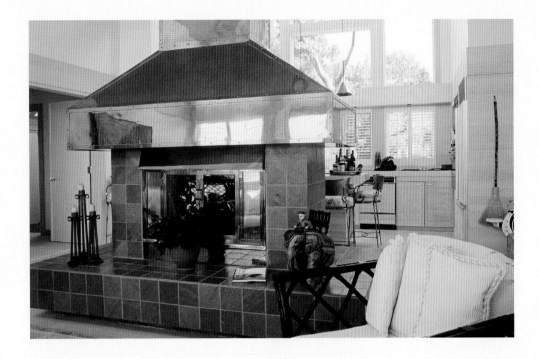

The owners designed this 2,000-square-foot space as a luxurious year-round guesthouse. The well-equipped kitchen includes a copper fireplace with a raised green slate hearth. It opens to both the kitchen and the living room.

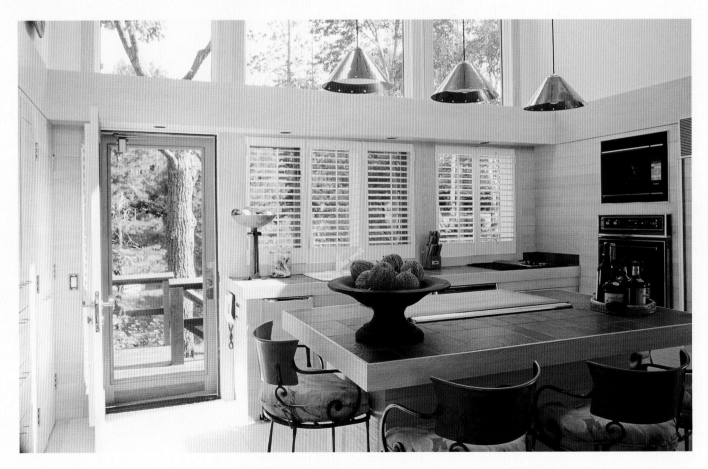

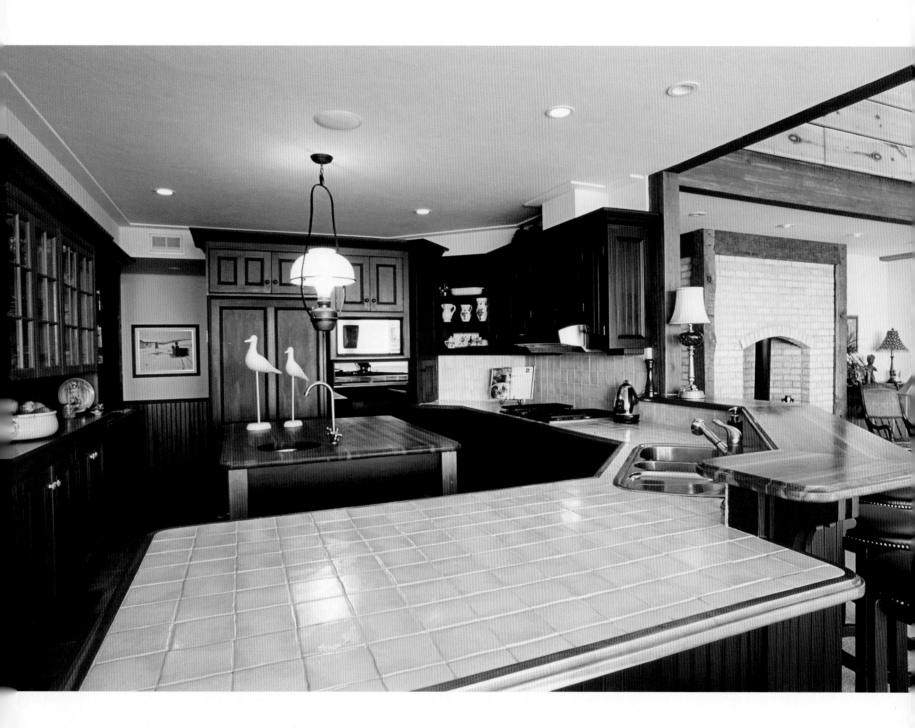

After a fire destroyed the original cottage on this property, it was rebuilt and enlarged to take advantage of the spectacular site.
Now the kitchen opens to the living area, where a wall of glass faces the water.

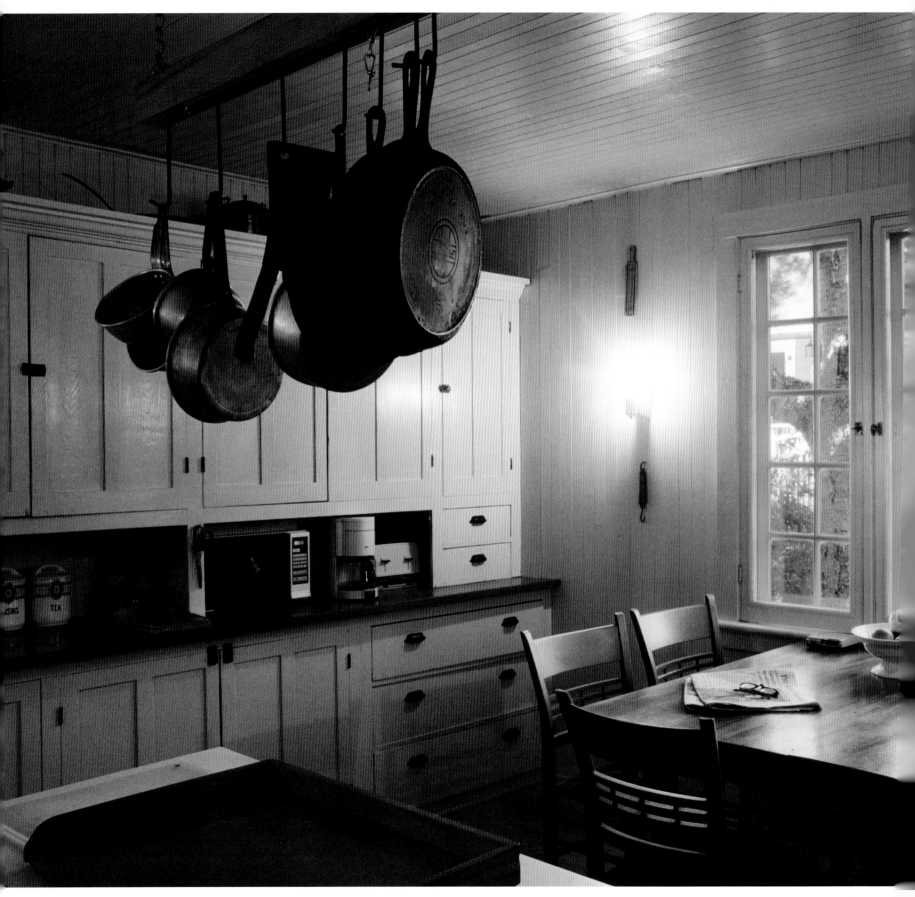

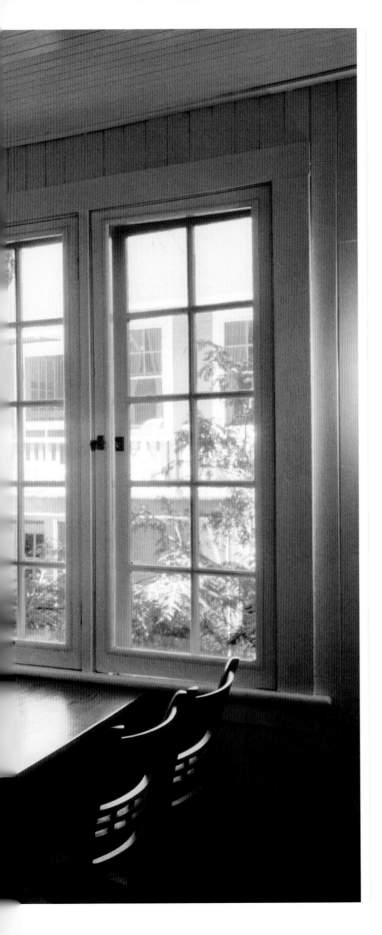

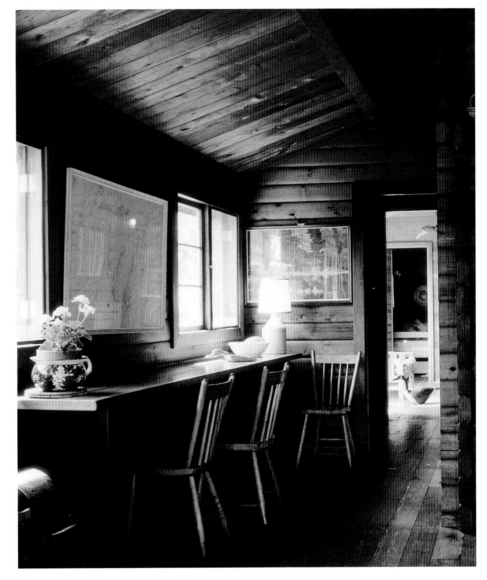

(above) Additional kitchen seating was installed along one wall of this cedar-lined house. "We keep shifting rooms around here," says the owner, a handyman always looking for summer projects, "but I've almost run out of rational additions."

(left) In this old lake house, the kitchen, pantry, summer porch and dining room are housed in one building. A ramp links it with the boathouse (seen through the window), which has a living room and bedrooms in the upper story. "It's not the most practical layout," laughs the owner, "but we still love it."

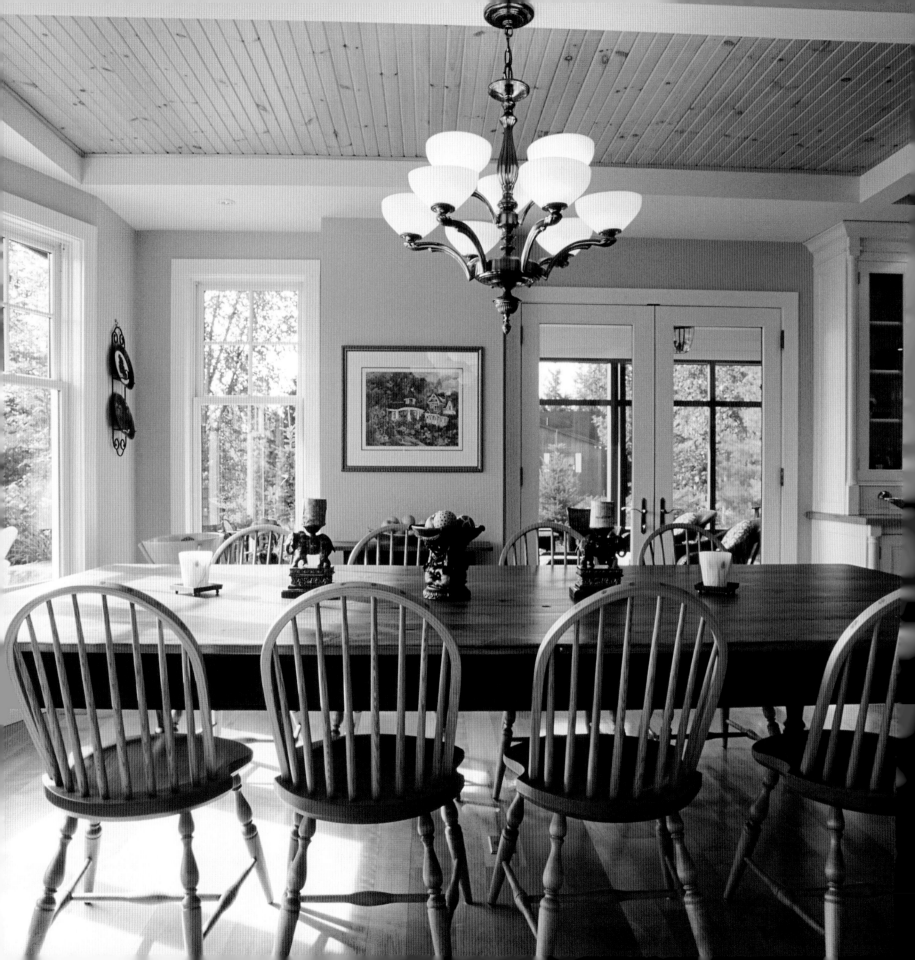

Family-Style Dining

A lake house dining table can never be too large. No matter how small the house, a great big table is needed when feeding hordes of weekend guests or playing board games on rainy days. It's the boisterous gatherings at these large tables that breed some of our best lake house memories. The dining table is much more than a place to eat. It's where children learn the house rules of Monopoly and Scrabble, and family traditions, like charades played on Aunt Jean's birthday, are passed on from generation to generation.

The ideal setting for these gatherings is an old-fashioned pine harvest table. Battered with dings and nicks, it makes for easy "no fuss" entertaining. Pair it with mismatched chairs and a selection of flea market chinaware, and you have captured the laid-back essence of lake house style.

Farm-style tables made from reclaimed barn boards offer ready-made rustic patina and can be custom built to accommodate the largest crowds. At one island house, the oversized dining table converts to a Ping-Pong table when the meal is finished. "It's sort of an all-purpose piece of furniture," quips the owner. At another vintage lake house where all ages gather for long and lively suppers, the creative owners hired an artist to paint their wooden dining-room chairs using primary colors in a different (and significant) design for each family member.

In elegant old summer mansions (built in the days of servants), there was always a formal dining room with a stone fireplace where the adults would be served meals, while the children sat at a separate nursery table attended by nannies. Today, the separate dining room has pretty much vanished, and lake houses have "great rooms" instead that combine living room, dining room and kitchen in one airy open space.

In areas like Muskoka in Canada and the lakes in Upper New York State and Michigan, cottaging was already established by the late 1800s. In the off-season the area's boatbuilders and caretakers built furniture. Influenced by the Arts and Crafts movement made popular by Gustav Stickley, they used white oak to create sturdy, durable dining-room tables and chairs. Called mission furniture it was almost indestructible and still exists in many vintage dining rooms.

The most important element in lake house dining, apart from plenty of good food, is comfy seating to keep people relaxed. With candles flickering on the table, soft music in the background and the moon rising across the lake, these gatherings will be remembered long after summer is over.

(above) PLacemats made by natives years ago out of birchbark and porcupine quills are treasured at this lake house. (opposite) High ceilings and extra-tall windows allow plenty of light to filter into this dining room. At night, candles are lit on the long harvest table for a romantic mood.

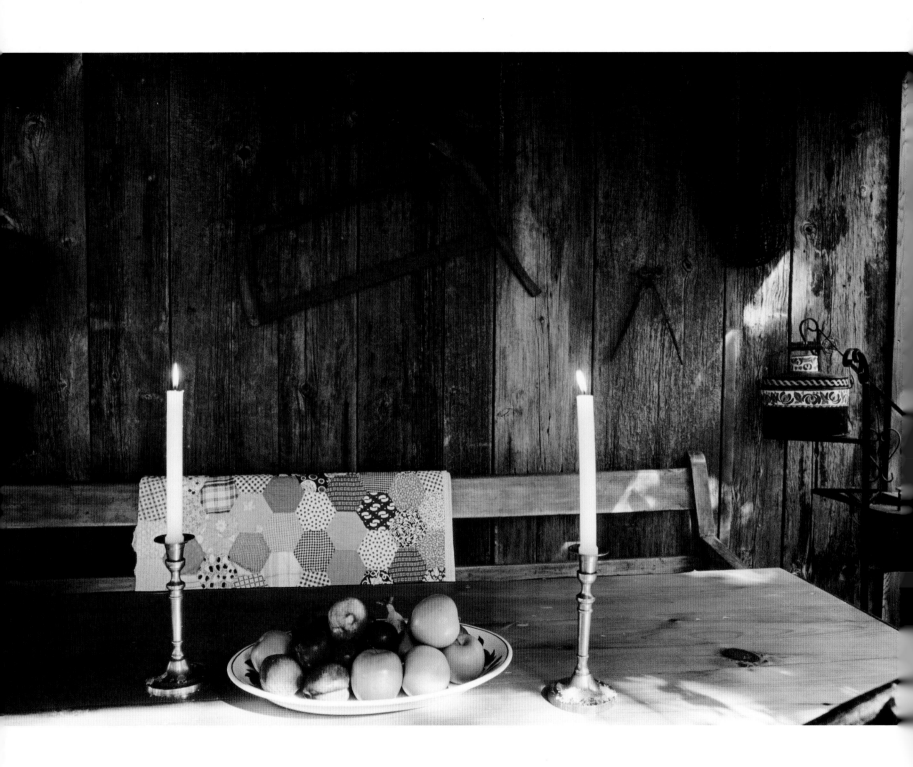

The homespun look of barnwood, pine and a hand-sewn quilt form the backdrop in this screen-porch dining area.

It was an aesthetic
experience to live
within those walls.

EVELYN WAUGH

In this dining room, walls of glass open to a lake view, and the restrained decor allows nature to dominate. "I love it here in the late afternoon," says the owner, "when sunlight dapples the floor."

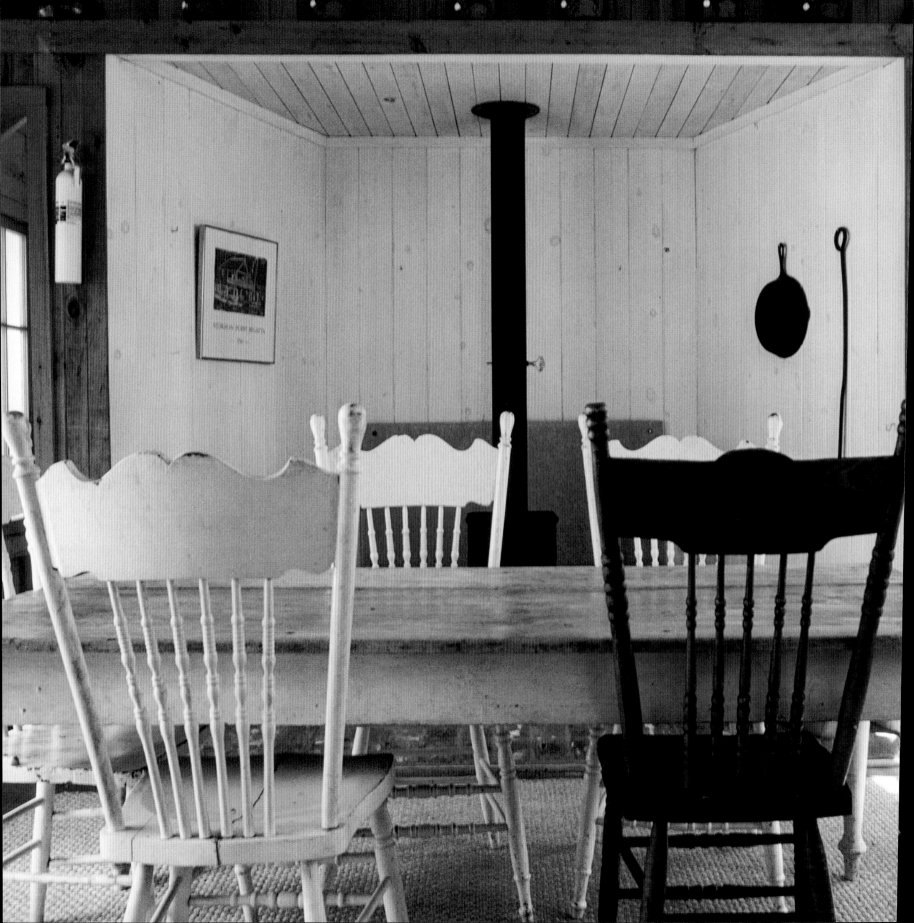

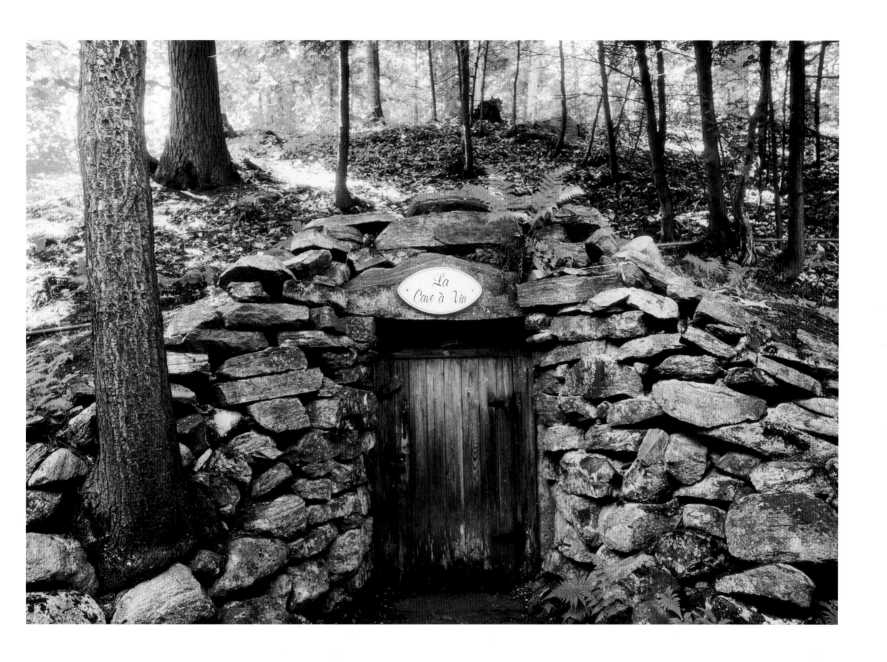

(above) The outdoor cold cellar, a common feature in olden days, was used to store meat and dairy products before refrigeration.
The current owners of this century estate have found a new function for the dark, cool place.

(opposite) Mismatched old wooden chairs add rustic charm to this vintage dining room.
A potbellied stove, blackened from years of use, is fired up on cool summer nights.

Plenty of summery colors (including a vivid David Hockney print) brighten the dark, weathered interior of the dining area. The chairs were designed and painted by an artist friend, one for each member of the family.

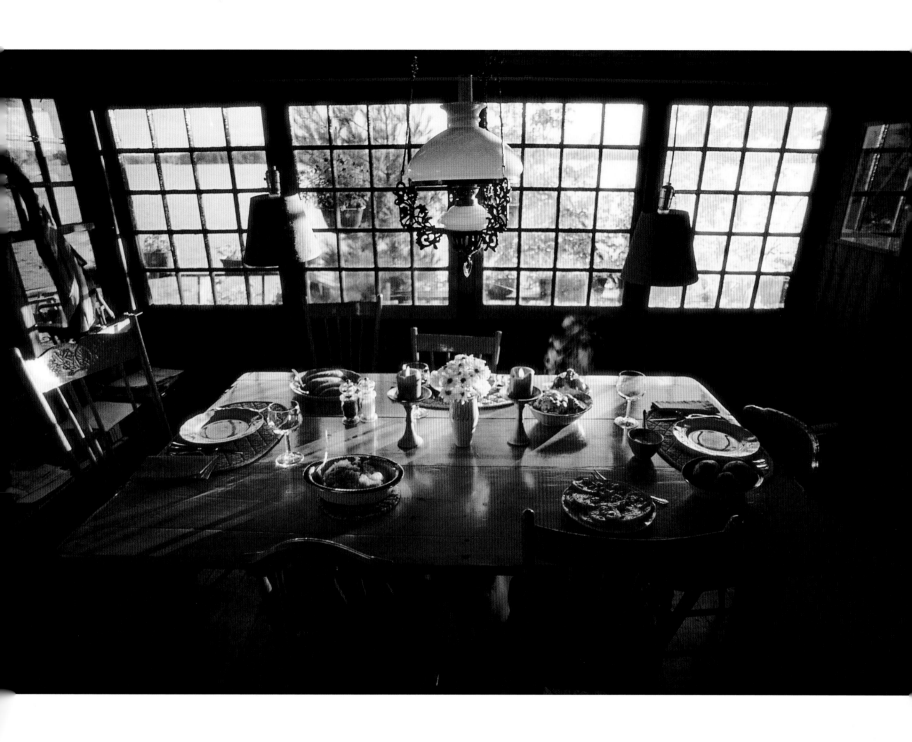

Candles, flowers, food and plenty of wine. Add a sparkling view of the lake and can summer dining get any better?

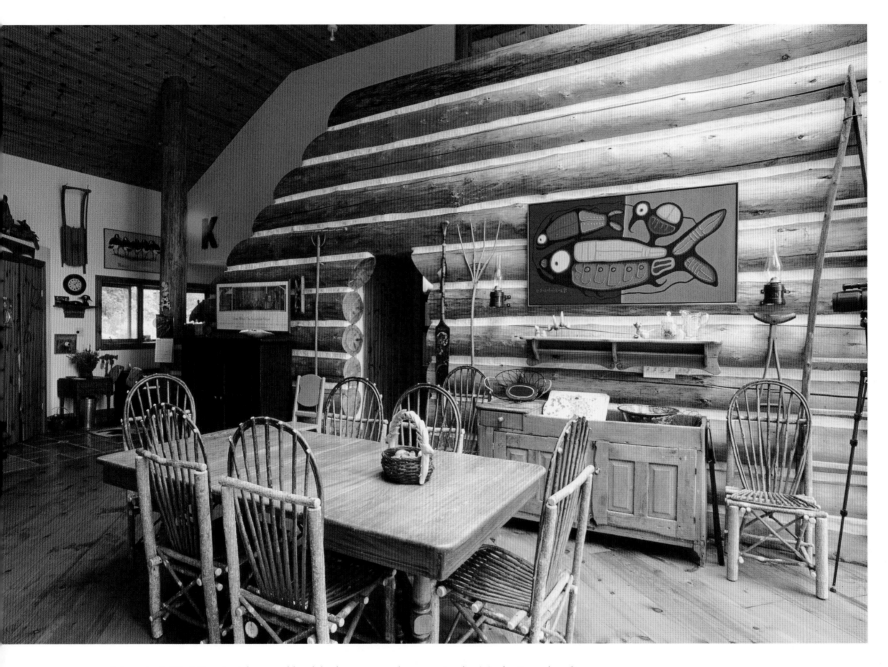

(above) A West Coast–style round-log lake house pays homage to aboriginal arts and crafts.
The twig dining-room chairs were made locally from cedar and willow. The painting is by the late Native artist Norval Morrisseau.

(opposite) In the days when the wealthy built grand stone and shingle estates like this, families moved to the lake for the summer with their staff. The adults were served dinner by the fire, and the children were cared for at a separate nursery table in the kitchen.

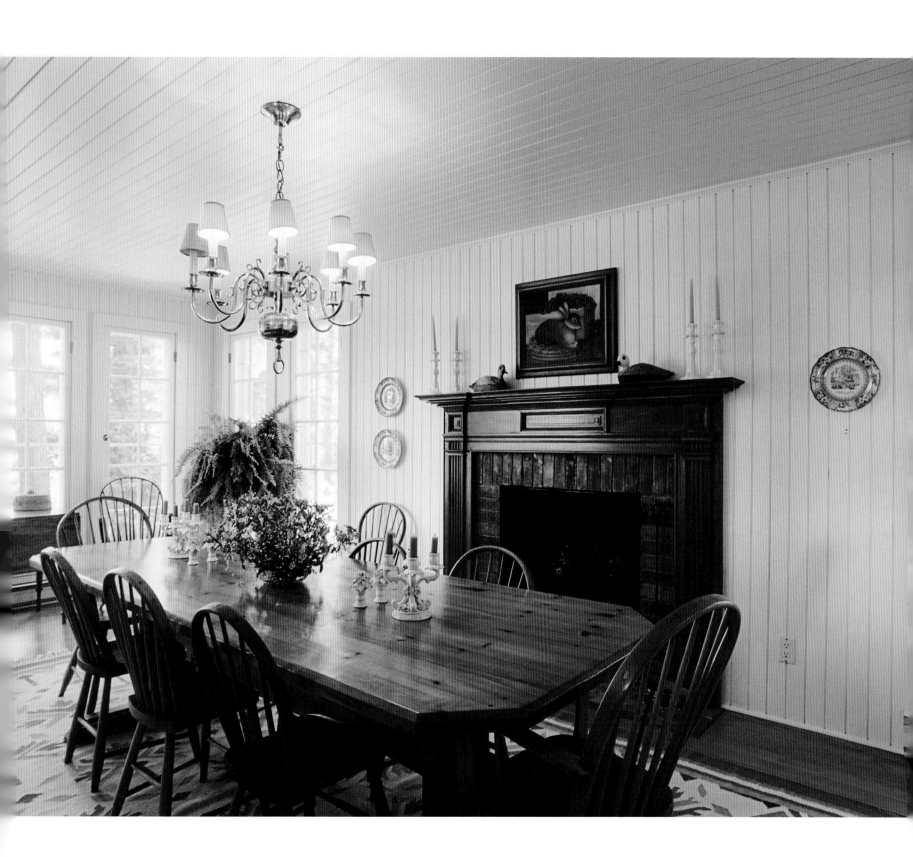

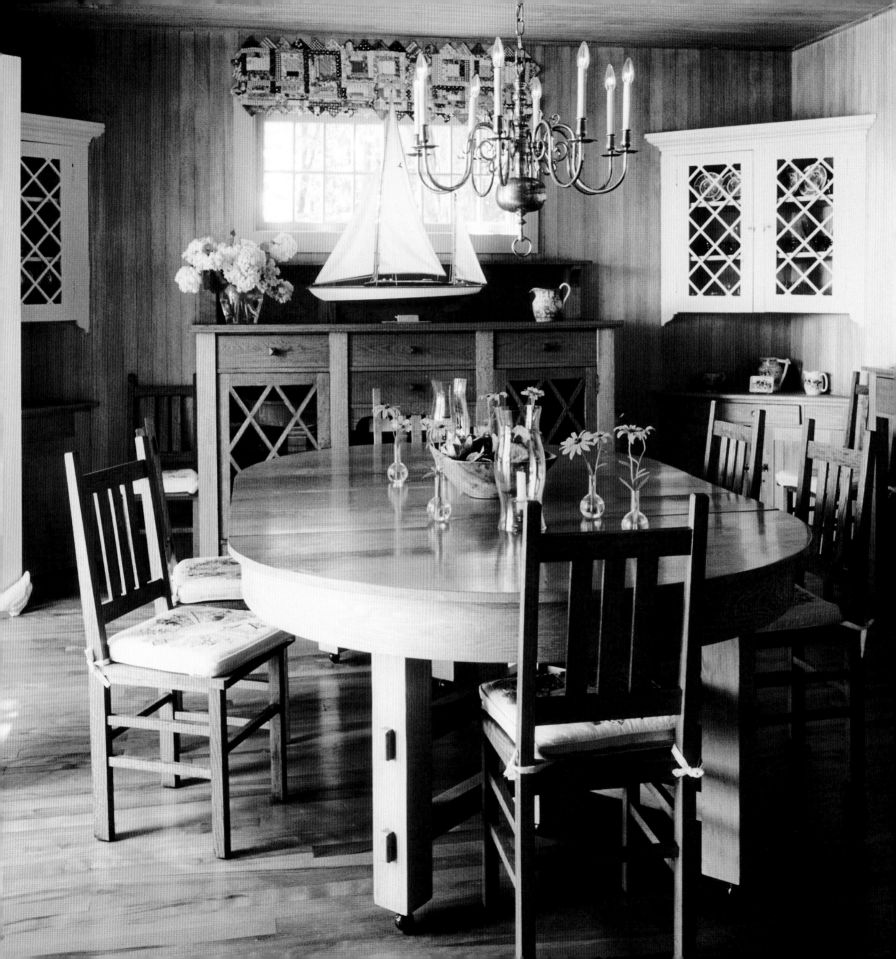

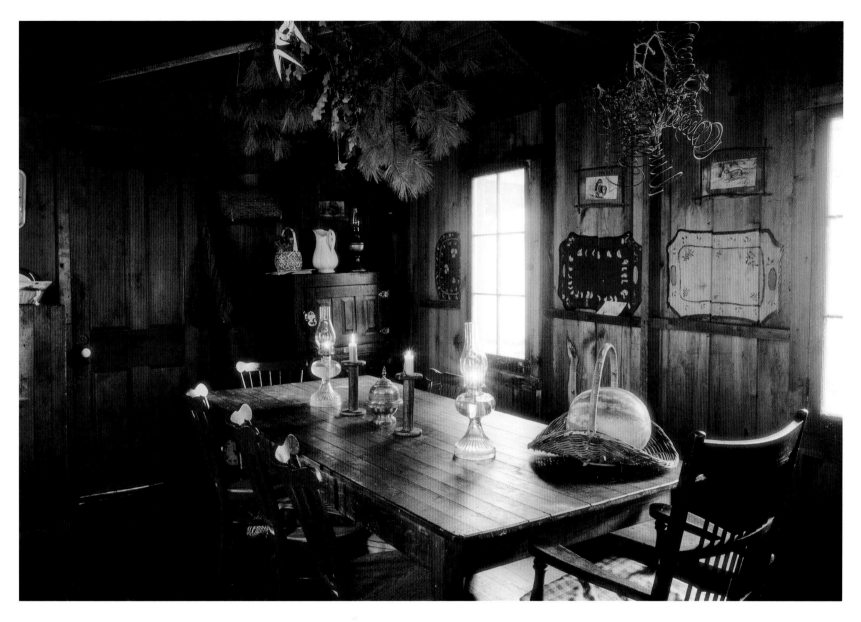

(above) The eccentric dining room of a lake house called Windhaven is dark and gloomy just the way the owner likes it. Hanging over the table (made from floorboards) is a cluster of rusty bedsprings, and all around the room are hand-painted trays. "I like the idea of living here just as it was," she says. "I don't believe in changing things."

(left) A vintage quilt was cut up to make cushions for the oak chairs in the dining room. The original windows were all small and high, like the one shown here. The owners replaced them with French doors on one wall facing the lake. "Everyone stays around the table longer now that we can see the lake," claims the owner of this 100-year-old house.

Very hot and still the air was,

Very smooth the gliding river,

Motionless the sleeping shadows.

HENRY WADSWORTH LONGFELLOW

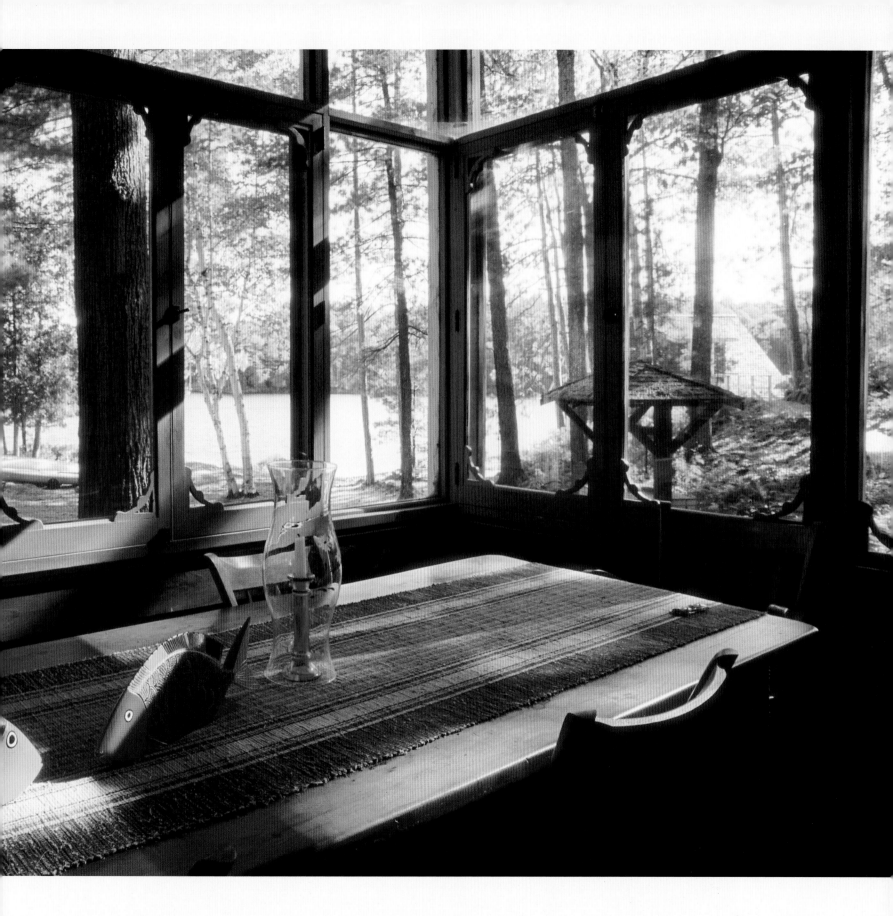

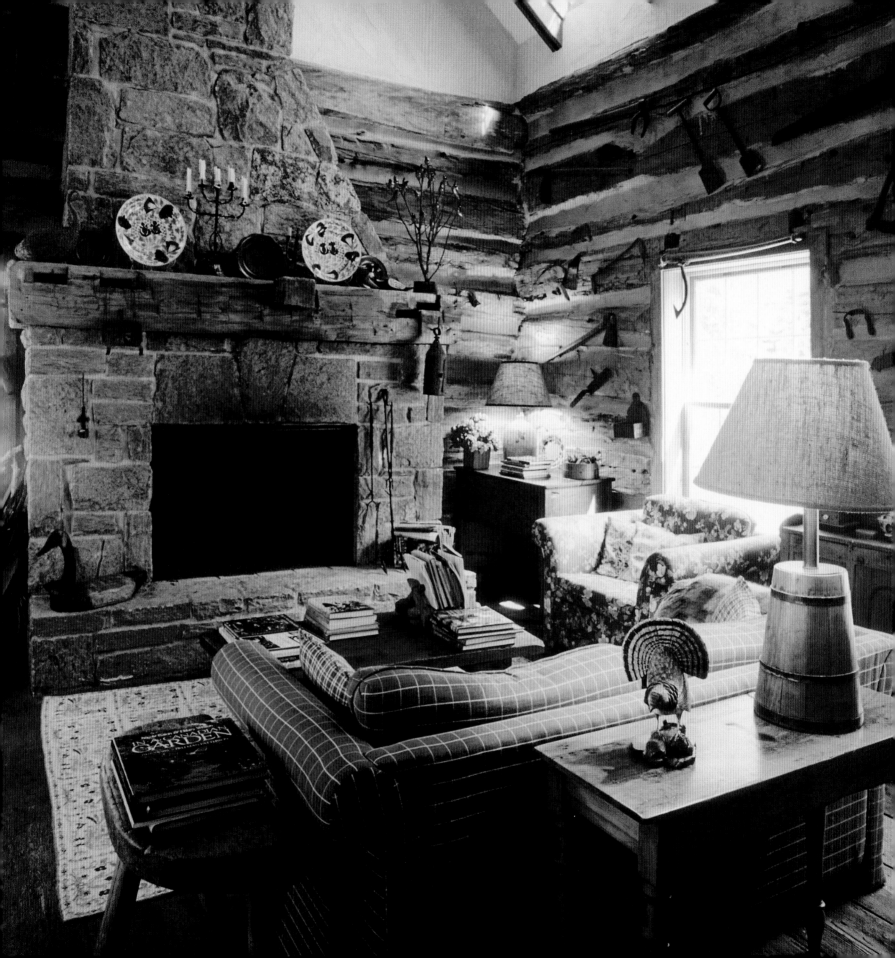

Curling Up Indoors

Summer is meant to be lived outdoors, picnicking on rocky points, lazing in hammocks, taking walks. But on days when the rains come and the north winds blow, we move indoors. Then, all we want is a deep squashy sofa, a cozy blanket and a good reading light.

This feet-up comfort is usually the first consideration for lake house sitting rooms. For some, the ideal is an easy-care kind of place where barefoot children can run through with dripping pails and everything sweeps clean in minutes. In these places there's a carefree approach to decor, with mismatched furniture and second-hand finds. Other people see the country house as a place to indulge their sense of style, and every nook is designer decorated. But comfort is paramount, whether the seat of choice is a creaky wicker rocking chair with faded chintz cushions or an elegant love seat upholstered in fine fabric.

In century-old sitting rooms, certain things are sure to appear: a large fireplace, usually built from stones collected on the property, small windows intended to keep out the summer sun, wood-paneled walls (often lined with regatta ribbons). As well there will be tattered photo albums, field guides and a guest book filled with long-forgotten names and somewhere, in some corner, a piano. Music was so important then that everyone was expected to play an instrument or sing a tune. Piano companies advertised in residents' association directories. In a 1902 Muskoka yearbook, the firm of Gourlay, Winter & Leeming ran an ad for piano rentals claiming, "The summer outing is robbed of half its charm if music is made impossible by want of a piano."

Pianos may be less common today, but music, and the time to sit and listen to it, is part of the reason we love our lake houses. The greatest luxury is an atmosphere that invites relaxation and provides time for simple pleasures. So we have music piped into living areas; we set up card tables with jigsaw puzzles; we pile the latest magazines on coffee tables — and make sure that reading lights are directed over comfy chairs.

On damp blowy days when we must move indoors, a fireplace crackling with burning logs becomes the welcoming focal point. We scan the bookcases looking for long-forgotten novels, pull our chairs up close to the fire and drift off to the sound of rain drumming on the roof.

(opposite) A pioneer log cabin is given new life as the living room of a lake house. After it was dismantled and moved to the site, the builder added four extra logs to the walls and installed gabled windows in the roof to add height and light. The fireplace mantel was an old barn beam purchased at a country auction.

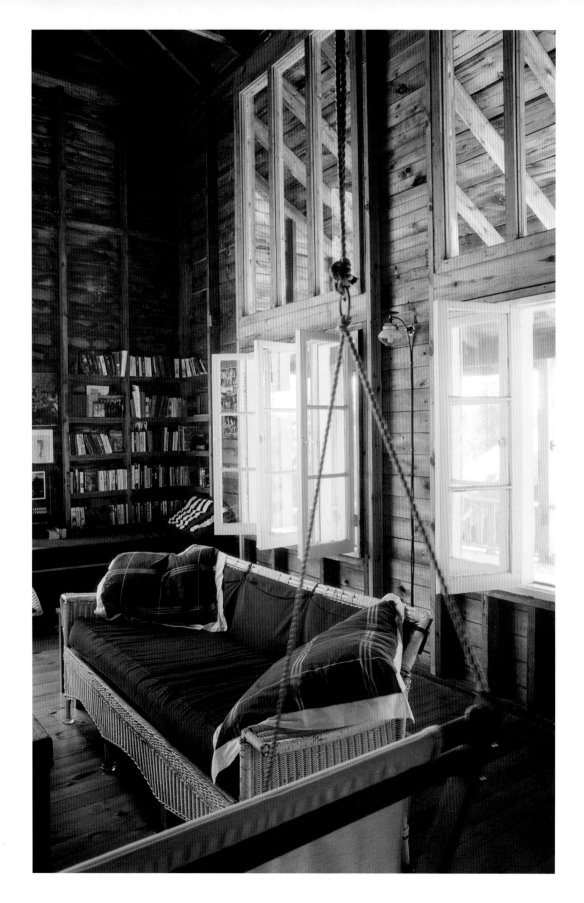

(left) Windows open to the lake breezes in this summer home where days are spent in a bathing suit. To bring more light into the dark wood-paneled living room, an architect friend suggested this easy solution. The ceiling was opened up to the rafters and a second set of windows mounted above the original ones.

(opposite) Everything is designed with easy care in mind at this family lake house. The white slipcovers can be washed, and the floors are prefinished Brazilian mahogany that can be swept clean. The rough-sawn pine walls are painted white for a summery look.

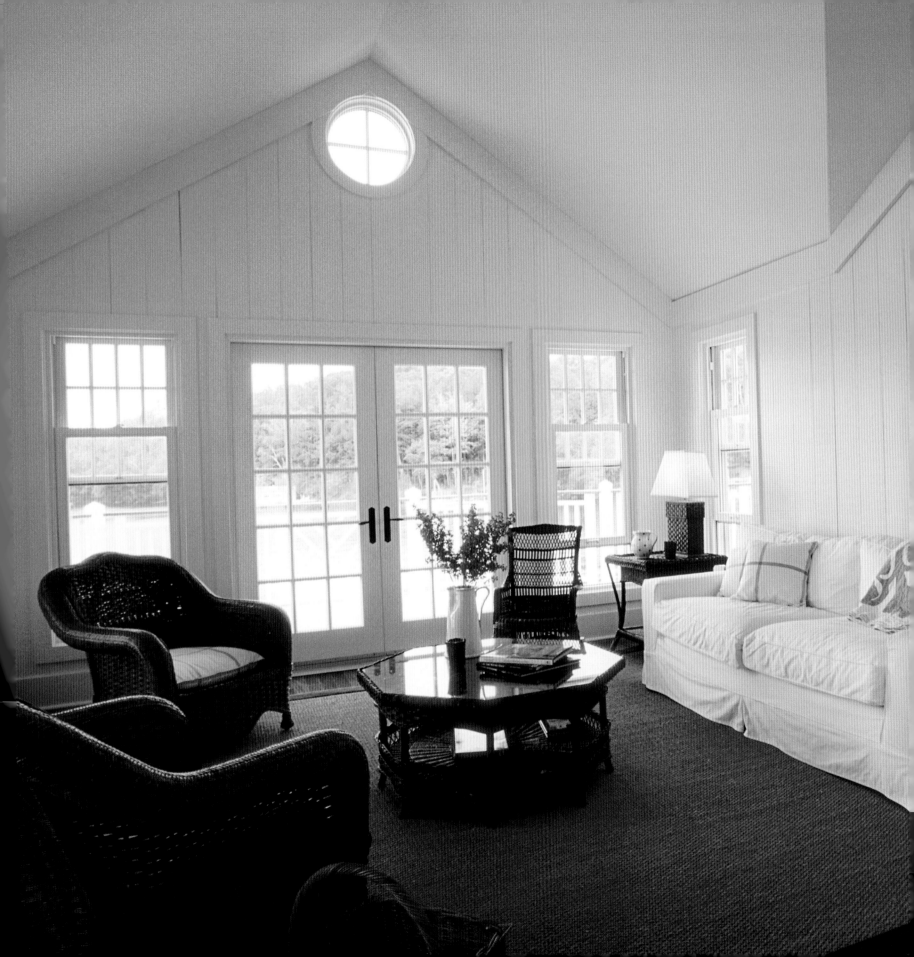

Have nothing in

your houses that

you do not know to

be useful or believe

to be beautiful.

WILLIAM MORRIS

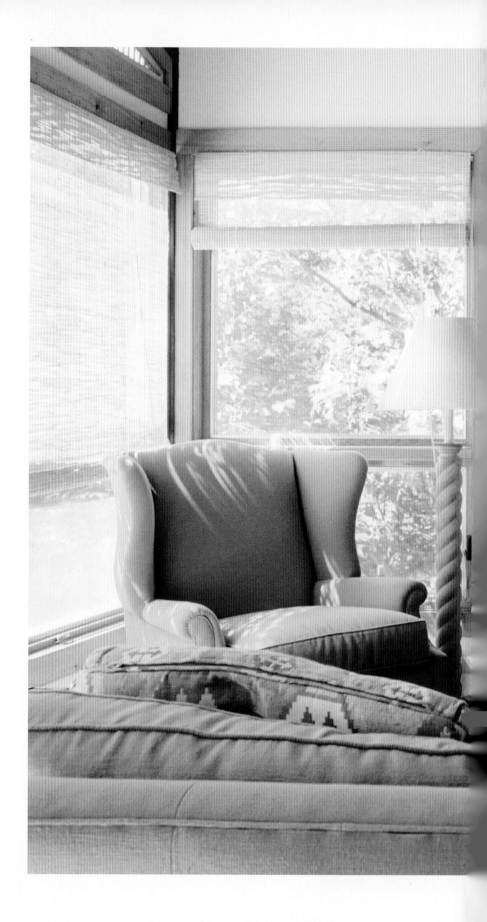

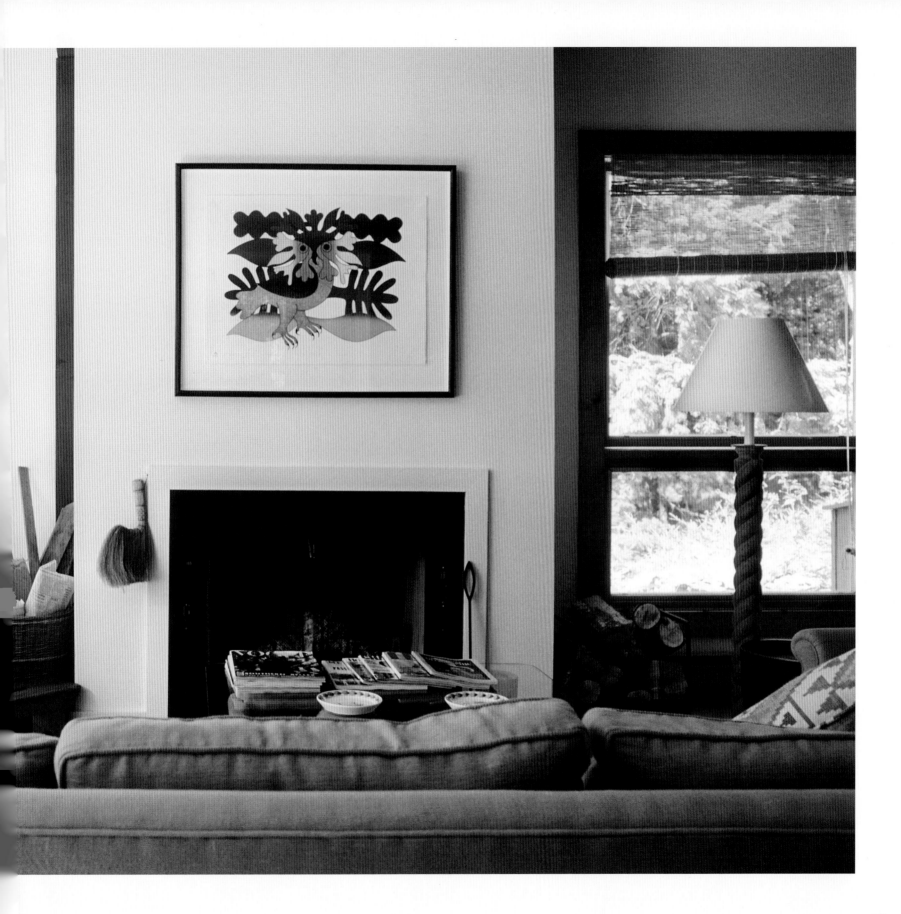

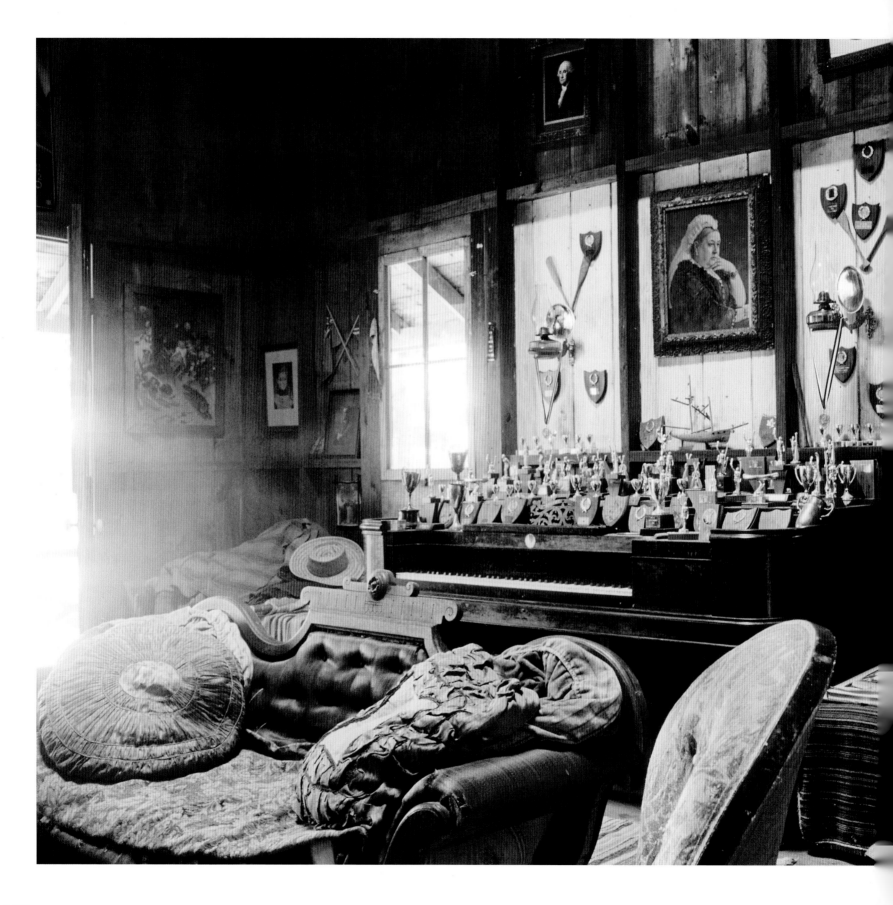

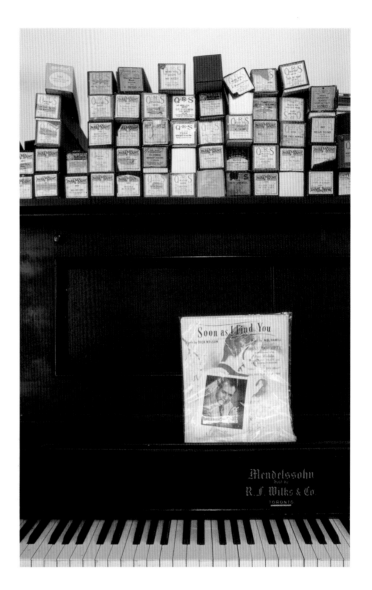

(above) A player piano was once the focal point of summer entertainment and is still a curiosity with the grandchildren in this family. Songs in their collection — played on rainy days — include "The Light of the Silvery Moon," "Some Day My Prince Will Come" and "When It's Springtime in the Rockies."

(left) Nothing has changed, it seems, since the days of Queen Victoria (seen in the portrait above the piano). Regatta trophies accumulated over decades suggest athletic prowess. The only things that get thrown out, says the elderly owner, "are things that red squirrels and mice have destroyed."

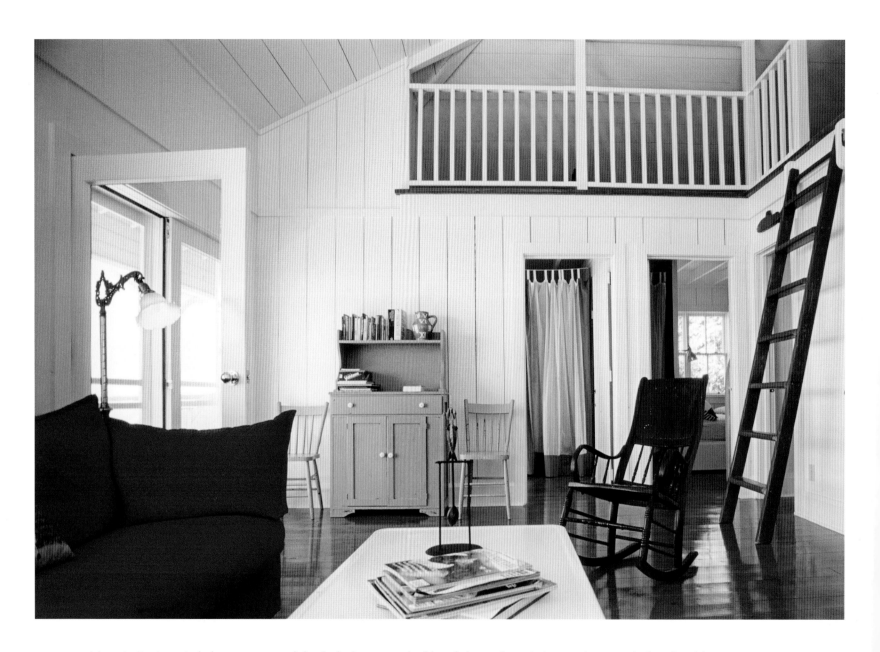

(above) Design-minded owners created the feel of a sea-washed beach house by painting rough-sawn plank walls white to contrast with the cherry floorboards. Two compact bedrooms open off the living area, and a ship's ladder pulls away from the wall to access a loft where there is extra sleeping space.

(opposite) A wood-burning fireplace and an ever-present pile of books bring everyone together on cool summer evenings and dark rainy days.

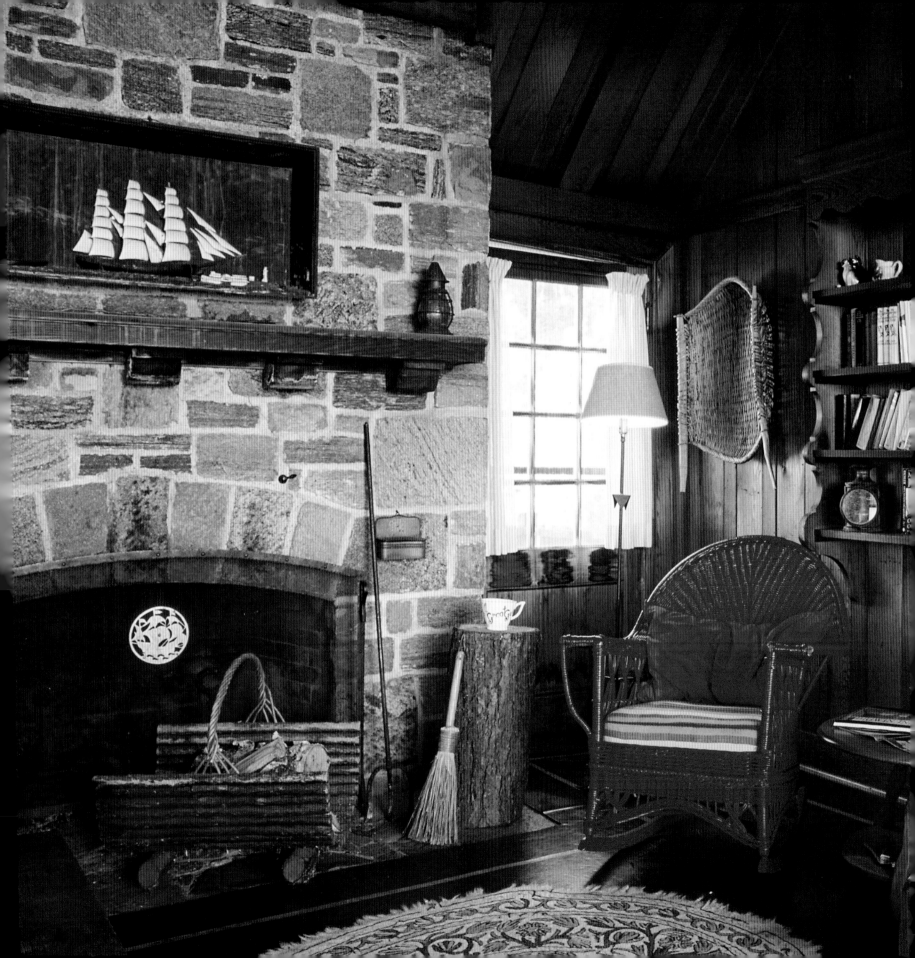

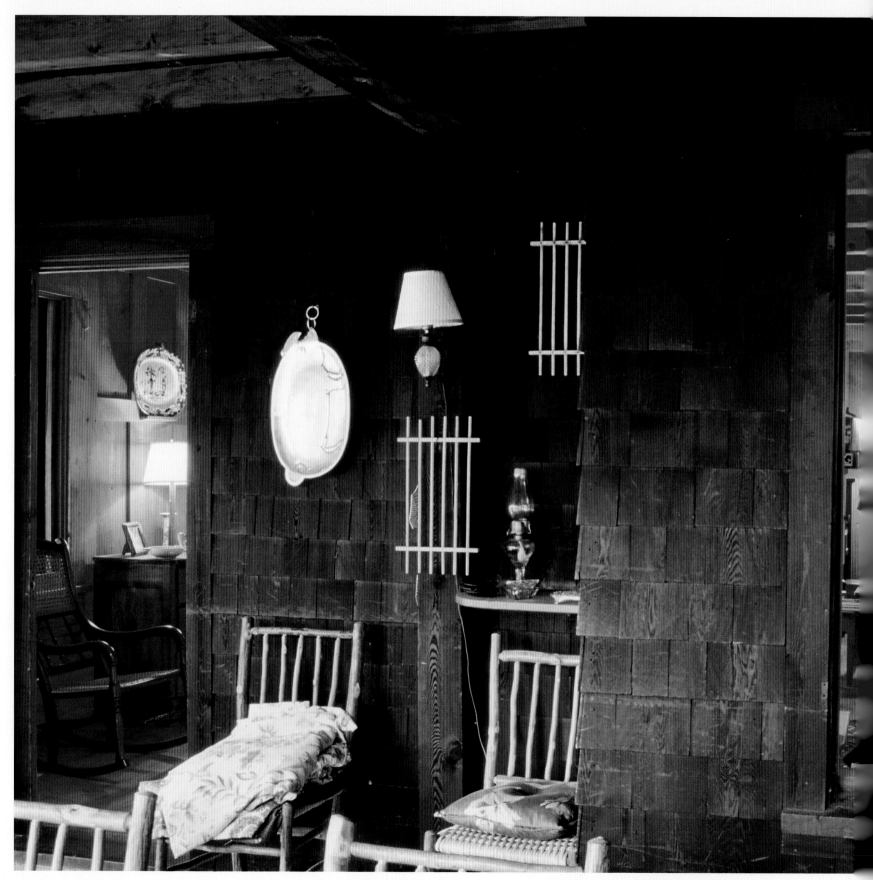

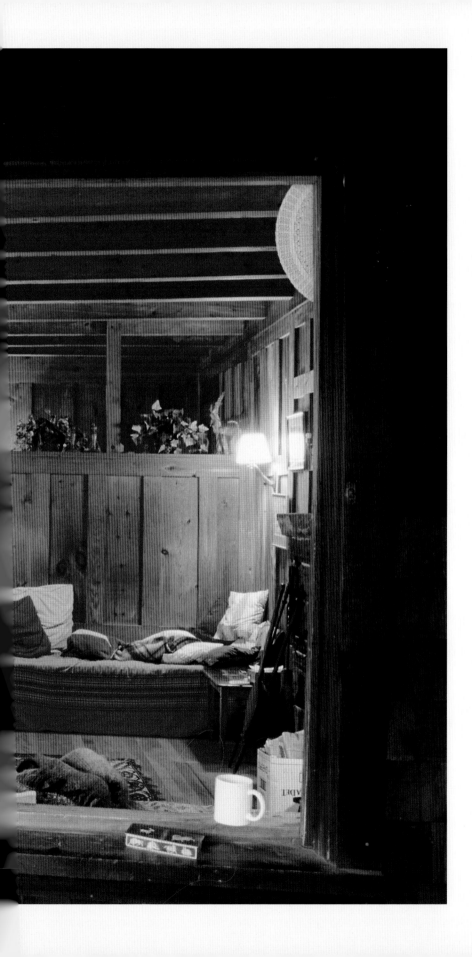

I had rather be shut up

in a very modest cottage,

with my books, my family

and a few old friends ...

than to occupy the

most splendid post ...

THOMAS JEFFERSON

A single sunbeam is enough to drive away many shadows.

ST. FRANCIS OF ASSISI

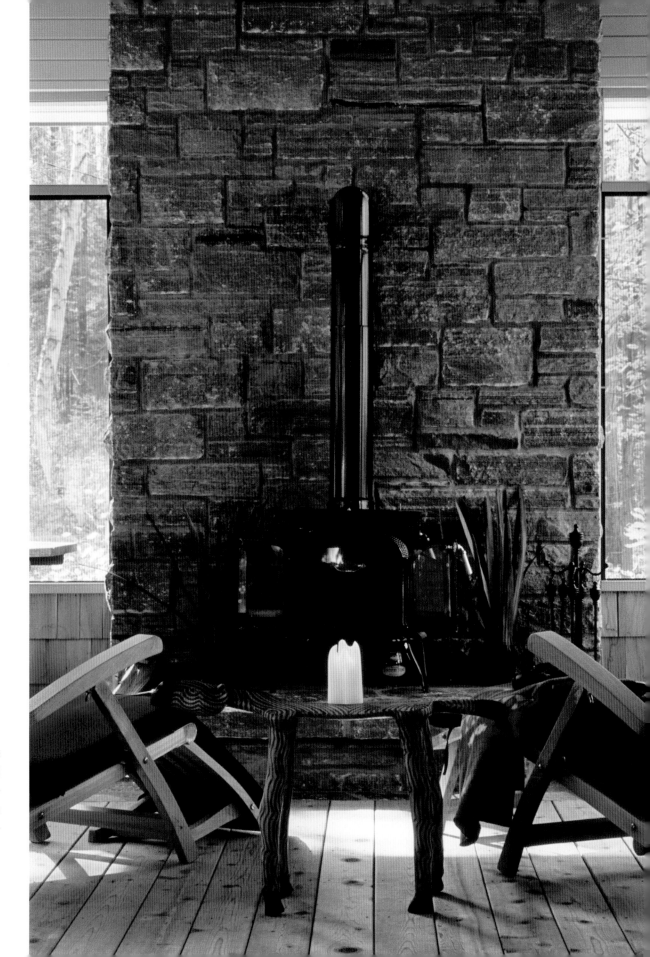

Teak chairs, reminiscent of those on cruise ship decks, are pulled up to the hearth in this contemporary lake house. Tall windows flank the stone of the ceiling-high fireplace.

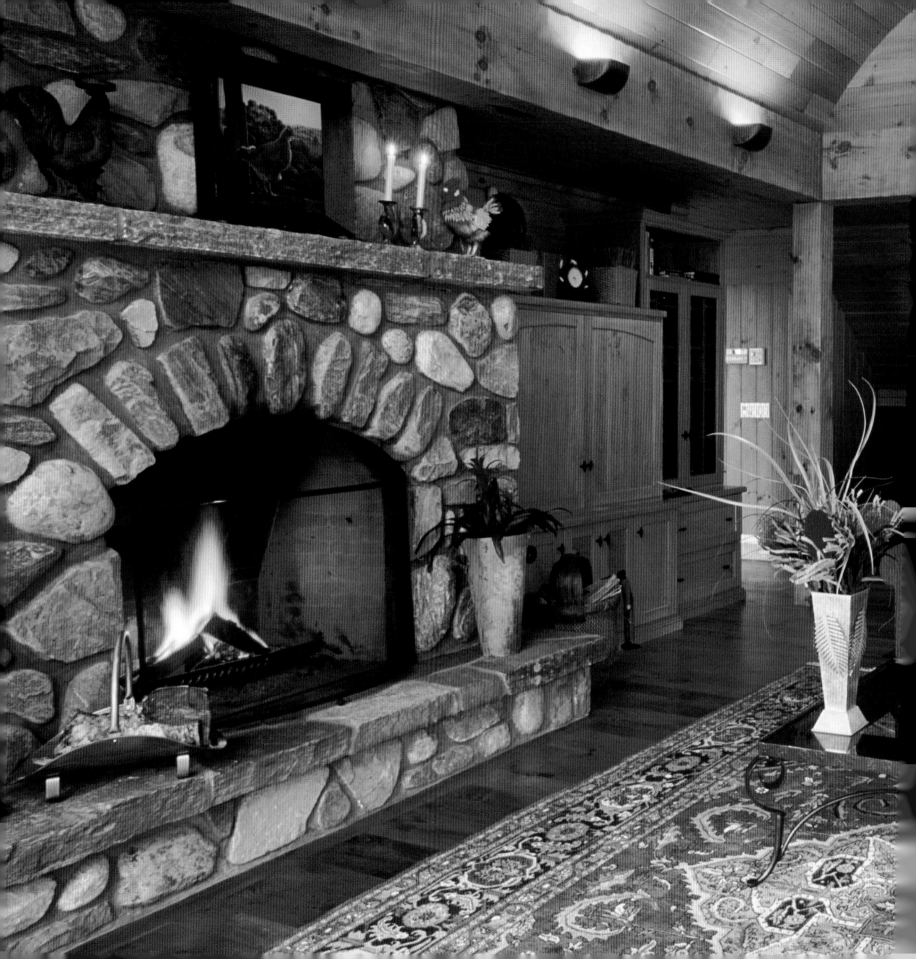

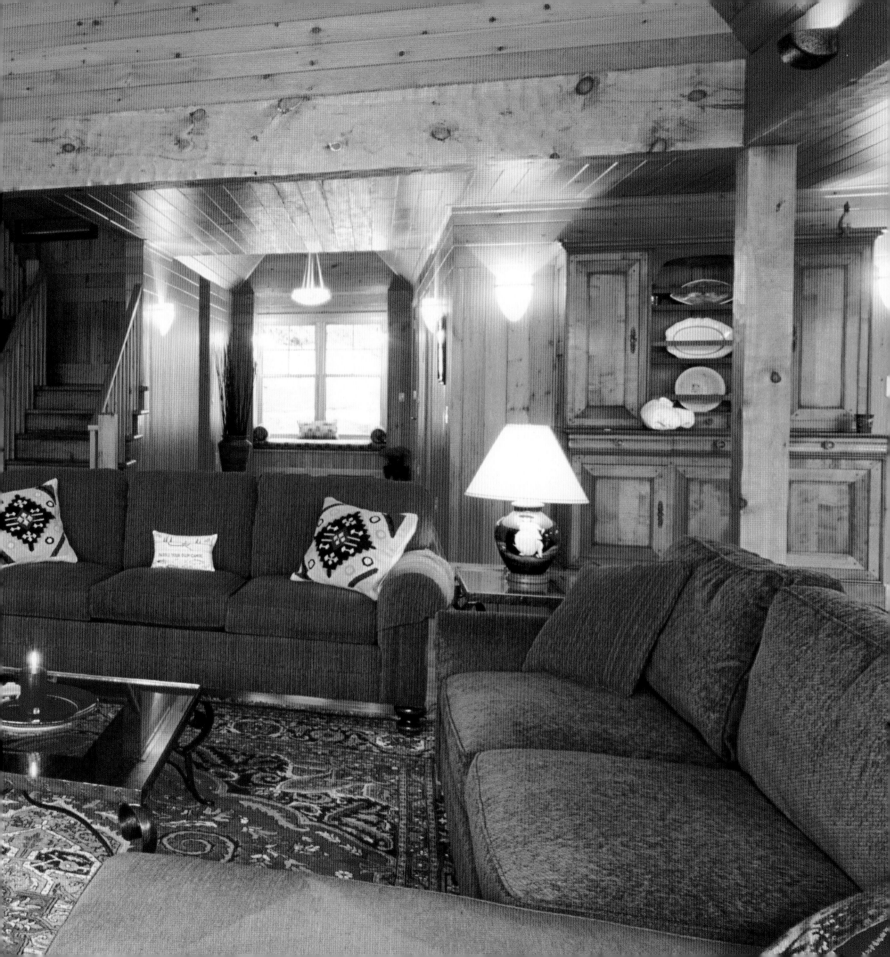

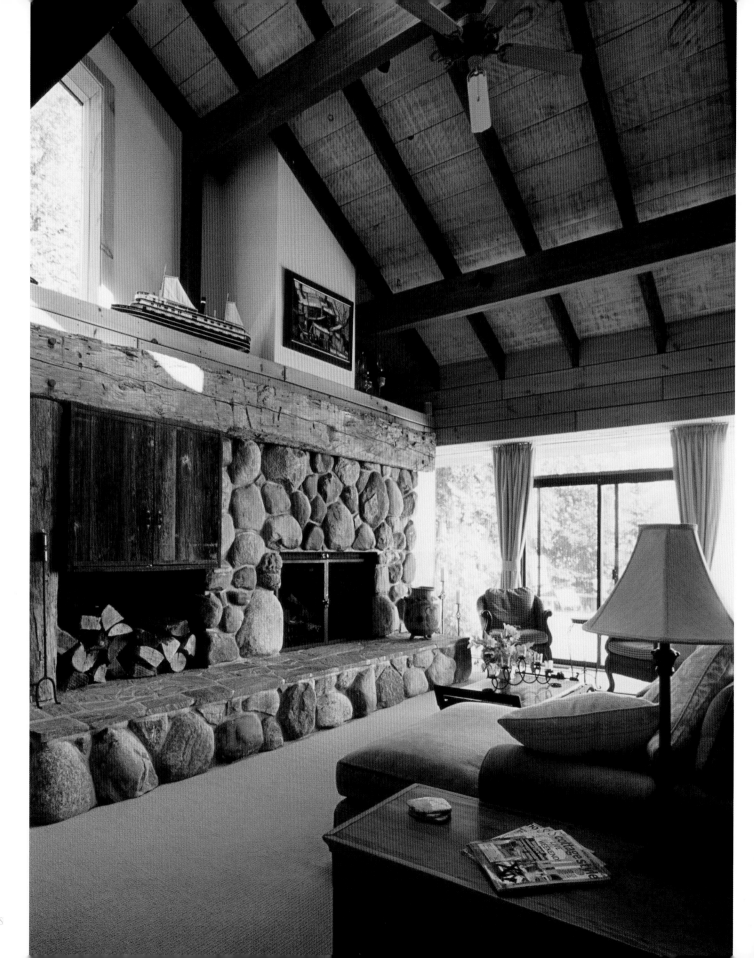

(above) A collection of crocks and baskets add tactile interest to this hearth area during the summer months
when there's no need for a fire.

(opposite) The chunky boulders that face this fireplace are also found scattered outside on the beach,
giving the house an indoor-outdoor ambiance. The mantel, a weathered barn beam, was found in a farm field.

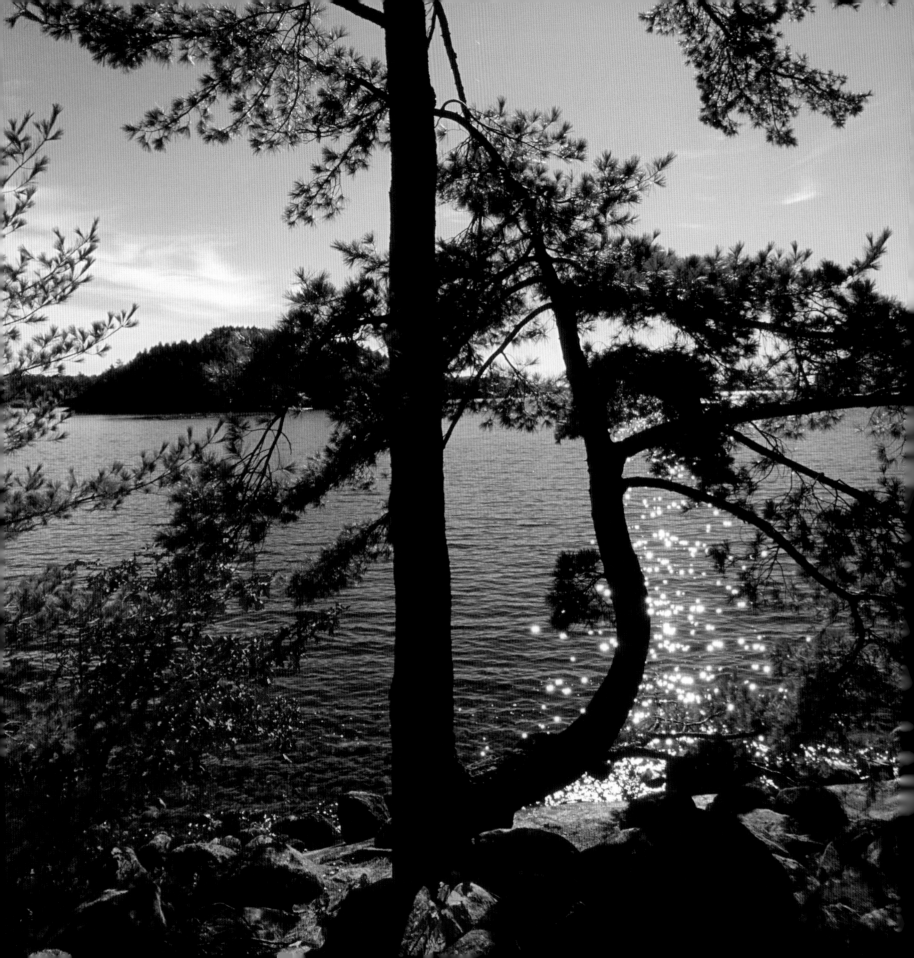

Outdoor Living

In the depths of winter I think back to the cottage and how the green grass feels beneath my bare feet.

A COTTAGER'S MEMORY

For most lake areas in North America, summer is a fleeting season. It seems to be over before it has really begun. But, however brief, it gives us our fondest and most-lasting memories. Long after summer is over, we remember mornings when the sunrise painted the sky crimson, days when the air was heady with the fragrance of pine, and twilight moments when the lake was so still that the only sound was a paddle slapping the water.

Nights are special too. The night sky, so full of stars, is something we never see in cities anymore, and certain nights, when the northern lights shimmer across the horizon, we will remember all winter long.

For lake house dwellers, the outdoor spaces where we spend these star-filled nights and golden summer days could include a wooden dock covered in carved initials, a wraparound deck built above a boathouse or a patch of sandy beach where we can dig our toes into the warm sand. Despite a trend toward landscaping our lake house environs, the most beautiful settings are often the ones left completely untouched.

For summer picnics there's nothing quite as perfect as a smooth glacier-scrubbed slab of granite.

All that's needed is a big blanket, a basket full of goodies and a cushion or two.

Appreciating natural surroundings was always at the heart of the lake experience. In olden days they built gazebos, fanciful structures often sited on quiet points away from the main house. Here, family and guests would sit and meditate and contemplate their blessings.

Wraparound verandas, common at older lake houses, were the setting for outdoor activities a century ago. Women, in particular, rarely ventured from their wicker rockers. Back then, sunshine was something to be avoided. So they gathered on the porch, and from that breezy vantage point, they enjoyed the lake views.

Unlike those shady summer porches, our decks today tend to be large, uncovered and angled to capture every vestige of sunlight. For shade, we allow a leafy tree to grow through the floor or we build a pergola along one side. And most important, our outdoor rooms have private places where we can settle into a comfy lounge chair with a tall drink and a thick book and lose ourselves on a summer afternoon.

(opposite) The timeless allure of rock and water.

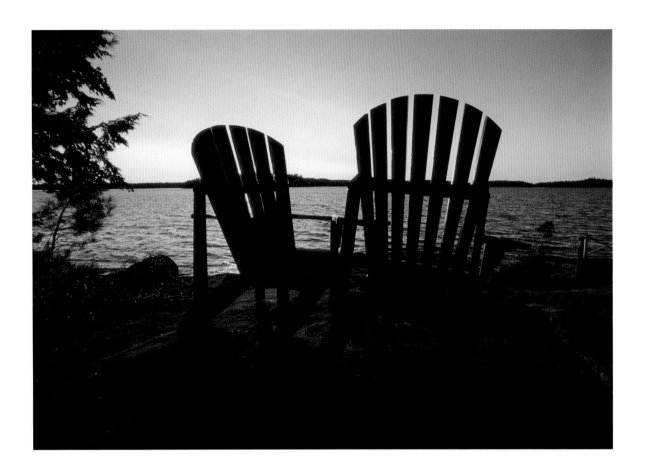

(above) The classic cottage chair — called either Adirondack or Muskoka —
but sheer comfort in either case.

(right) A sunny deck beckons at the water. "We often go down to the boathouse in the
morning and never come back up the hill till the end of the day," says the owner of this
cliffside property where the main house is perched high above the lake.

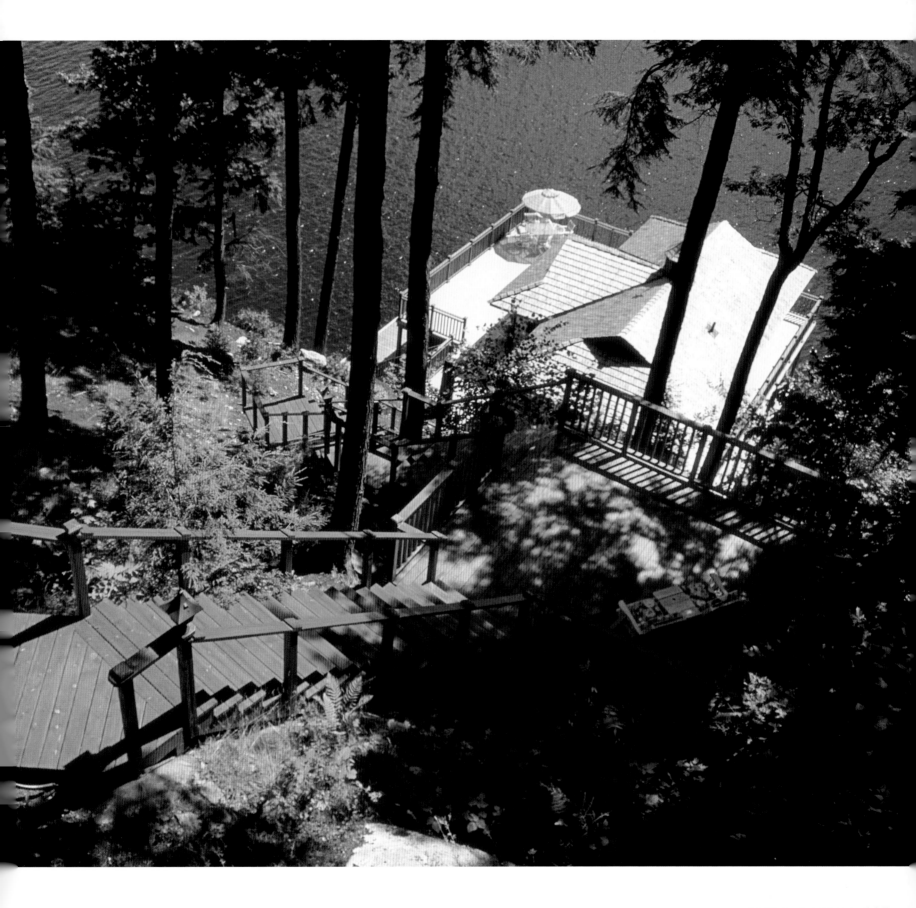

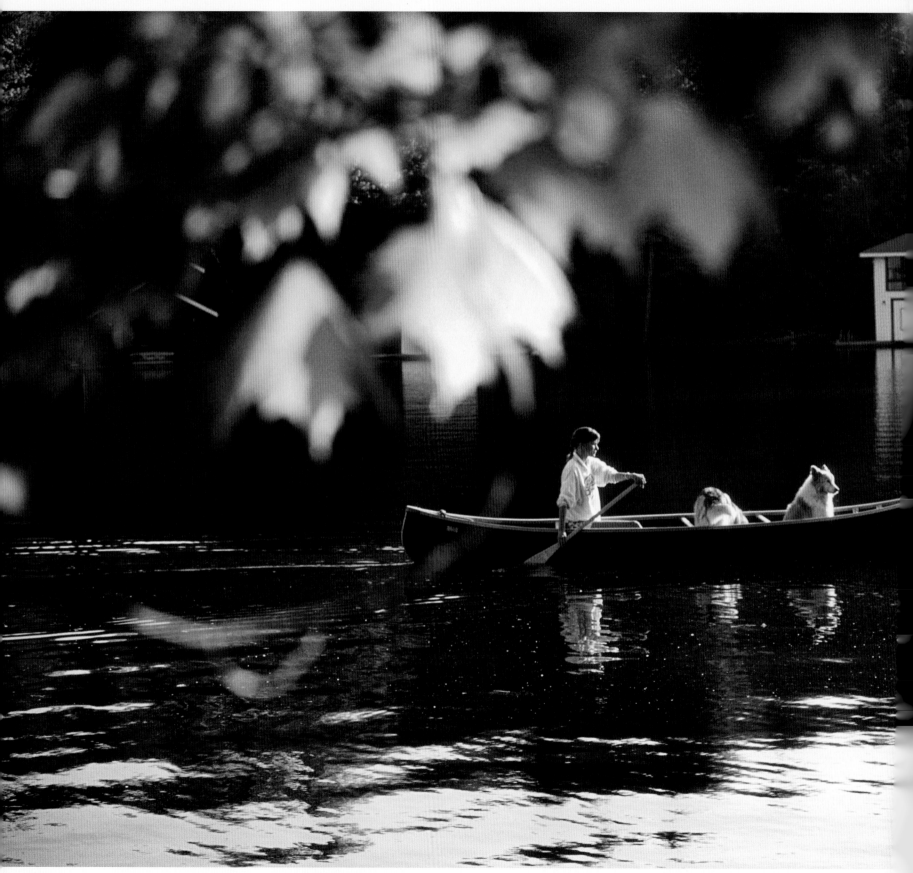

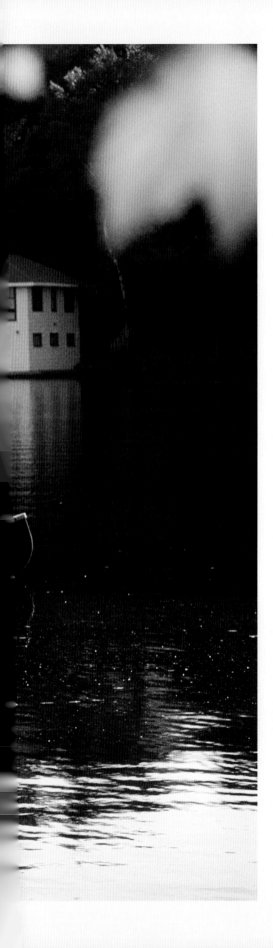

Summer afternoon — summer afternoon;

to me those have always been the two most beautiful

words in the English language.

HENRY JAMES

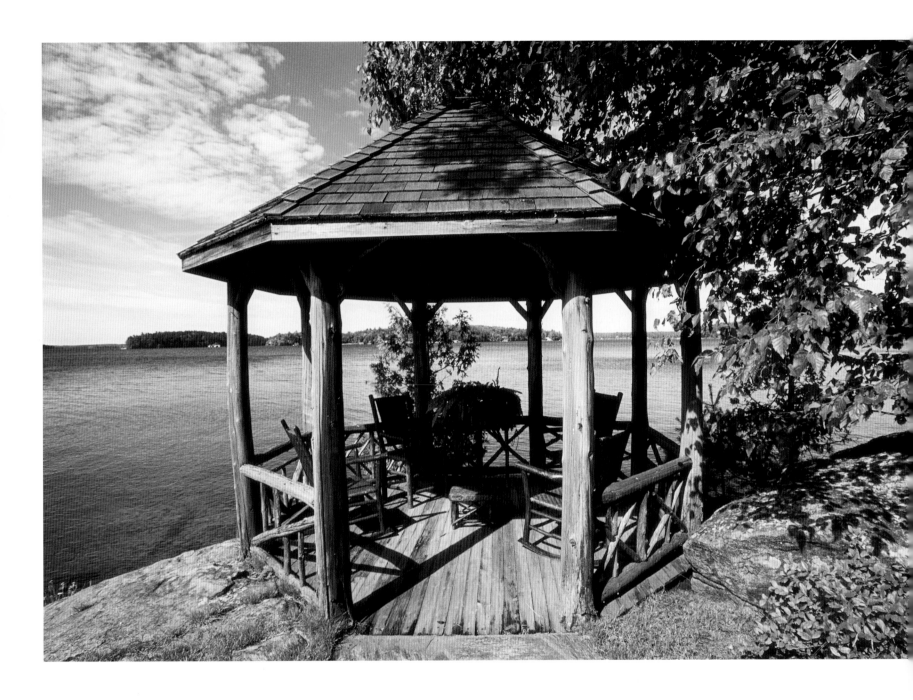

(above) The dictionary definition of a gazebo: "a small building or structure designed to give a wide view."

(following pages) Bent pine trees define the path of the wind in this rugged lake country.
Artists have been capturing these vistas on canvas for generations.

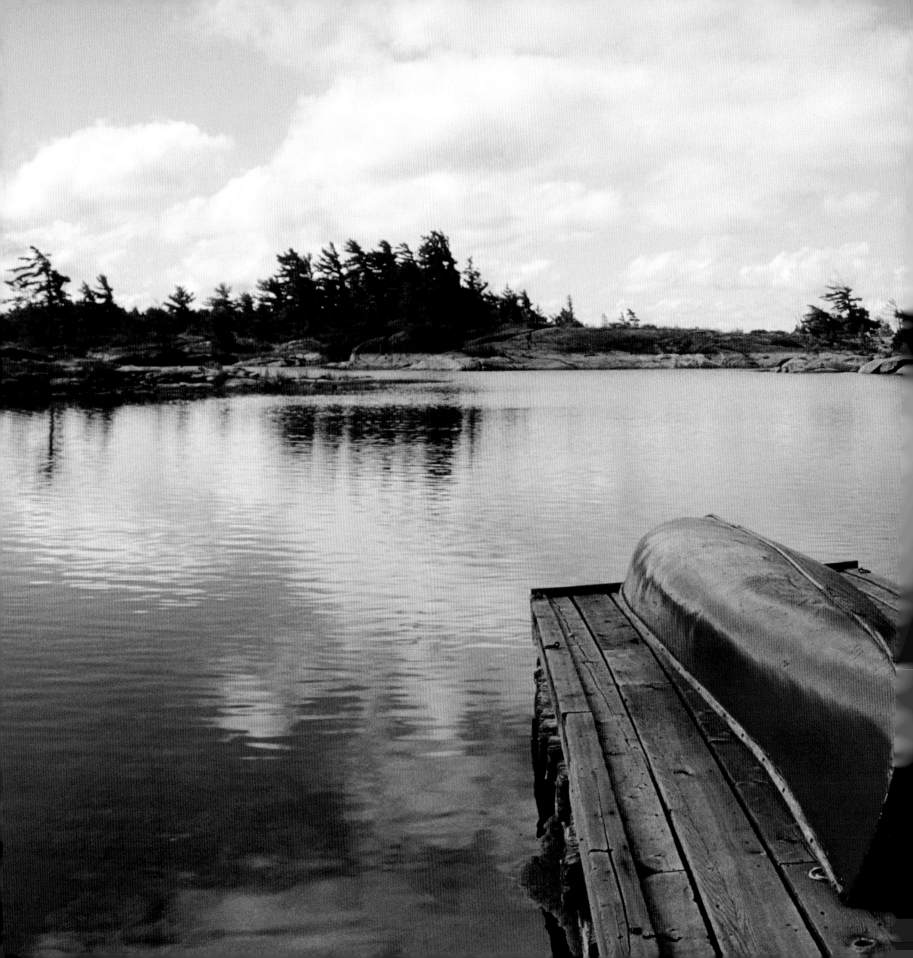

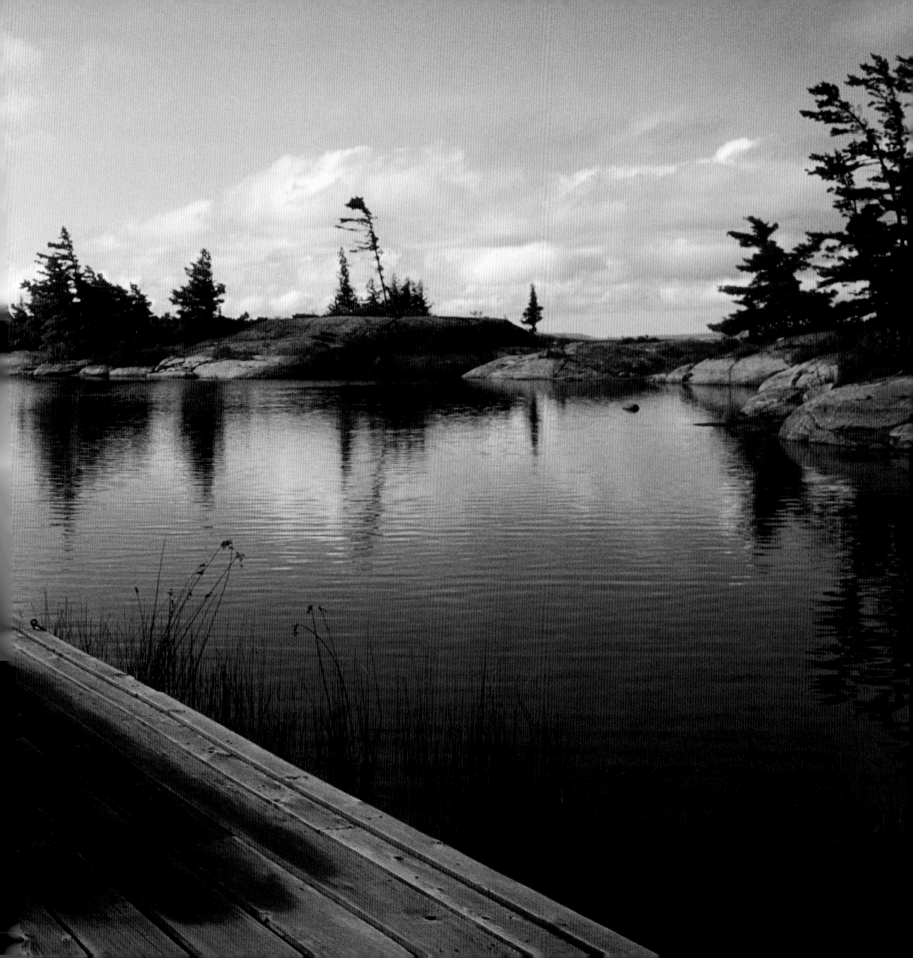

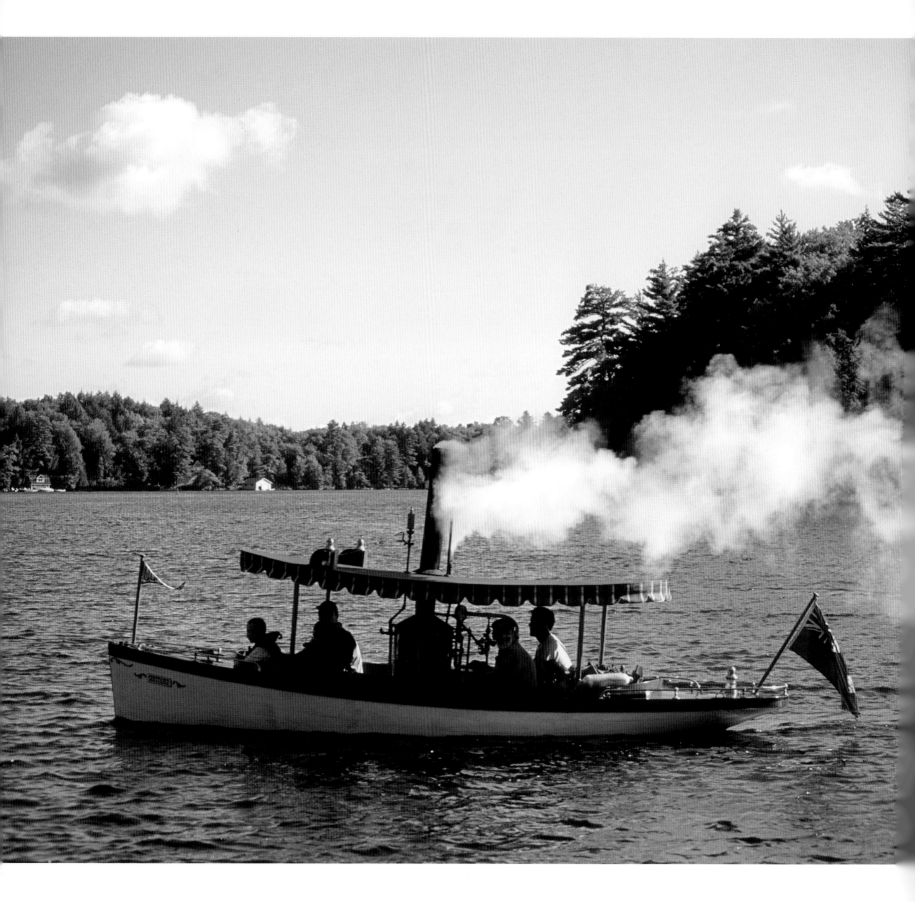

(left) Antique steamboats, fired by wood, still ply the lakes in some parts of cottage country.

(below) Collector's items like steamboats and vintage yachts are lovingly maintained.Every summer they are displayed for all to enjoy at classic boat shows.

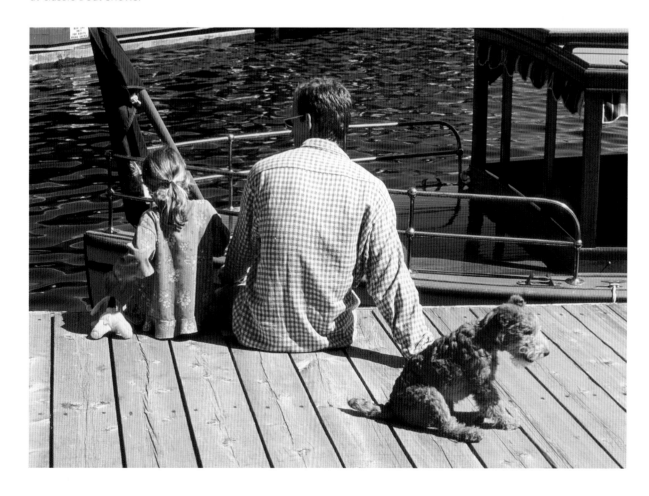

Go to the woods and hills! No tears

Dim the sweet look that Nature wears.

HENRY WADSWORTH LONGFELLOW

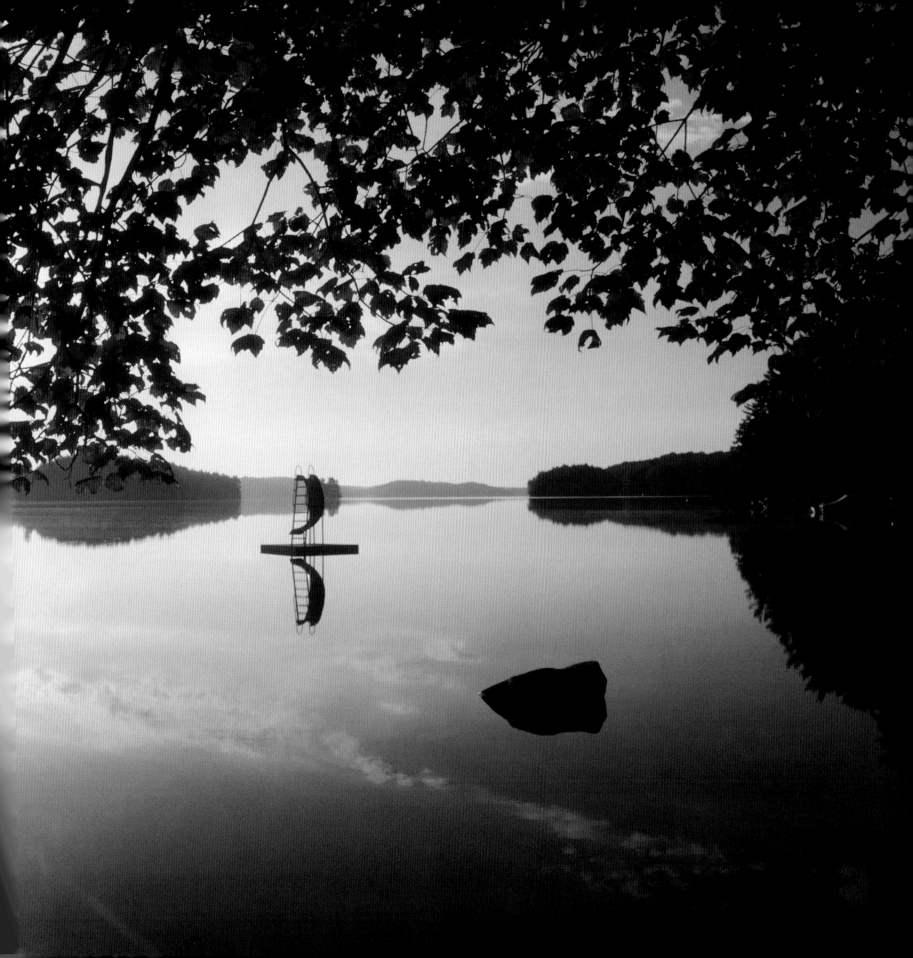

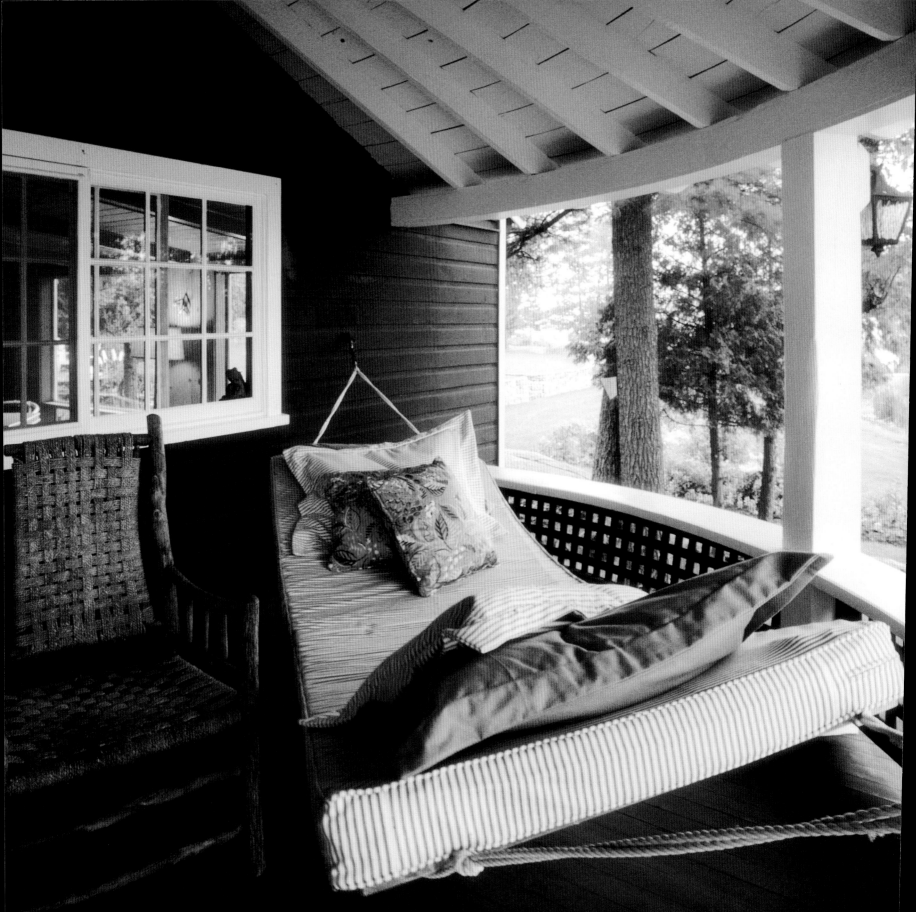

Summer Porches

In long-established summer colonies, homes tend to be tucked at the end of country lanes or shrouded in trees along the shoreline. Situated for privacy, they can barely be seen. Many of the older places were built to keep sunlight out so they stay cool and dark inside. Back then, the heat of the day was believed to give young ladies "the vapors."

It was this thinking that spawned the ubiquitous covered porch. Porches with split cedar railings meandered along the sides of many vintage lake houses. These verandas were much used, especially by the long-skirted women who sat fanning themselves in wicker rocking chairs (called digestive chairs by doctors in those days because it was believed that the rocking motion aided digestion). Sepia-toned photographs show women gathered in circles, sipping tea or doing needlework. The men standing at their sides and viewing the camera impatiently look as if they would prefer to be out fishing.

Porch furniture has come a long way, but the love affair with wicker that began in Victorian times seems undiminished. In its original state or freshly spray-painted, this woven rattan furniture is still in vogue. Today, reproduction wicker made of synthetics and metal looks just like the real thing and can be left outside in all weather. Other porch furniture made of bent willow and hickory and porch swings that hung by chains from the rafters were handcrafted by caretakers during the winter months and can still be found clustered in cozy groupings on shady verandas.

The huge porches found in some areas had medical origins. Lake areas became attractive in the early 1900s because of the presumed health-giving qualities of the fresh air. Back then, both tuberculosis and asthma were common afflictions. Asthma sufferers found relief in the ragweed-free country air, and long rests outdoors were prescribed by doctors for tuberculosis.

In the Adirondacks, for instance, many early lake houses were "cure" retreats with vast covered porches. As well, there were screened rooms built off the bedrooms that enabled patients to get fresh air all night, lying on daybeds and wrapped in wooly blankets.

Although covered porches are no longer required for medical cures, they are still favorite places to gather and escape the heat of a long summer day. And families today are rediscovering the joys of the screened-in sleeping porch and incorporating it into new designs. On warm summer nights when the breezes waft in from the lake, there's no better place to fall into a deep sleep.

(opposite) A thick mattress adds a layer of comfort to the hammock on this covered porch where an afternoon nap is an essential part of the summer day.

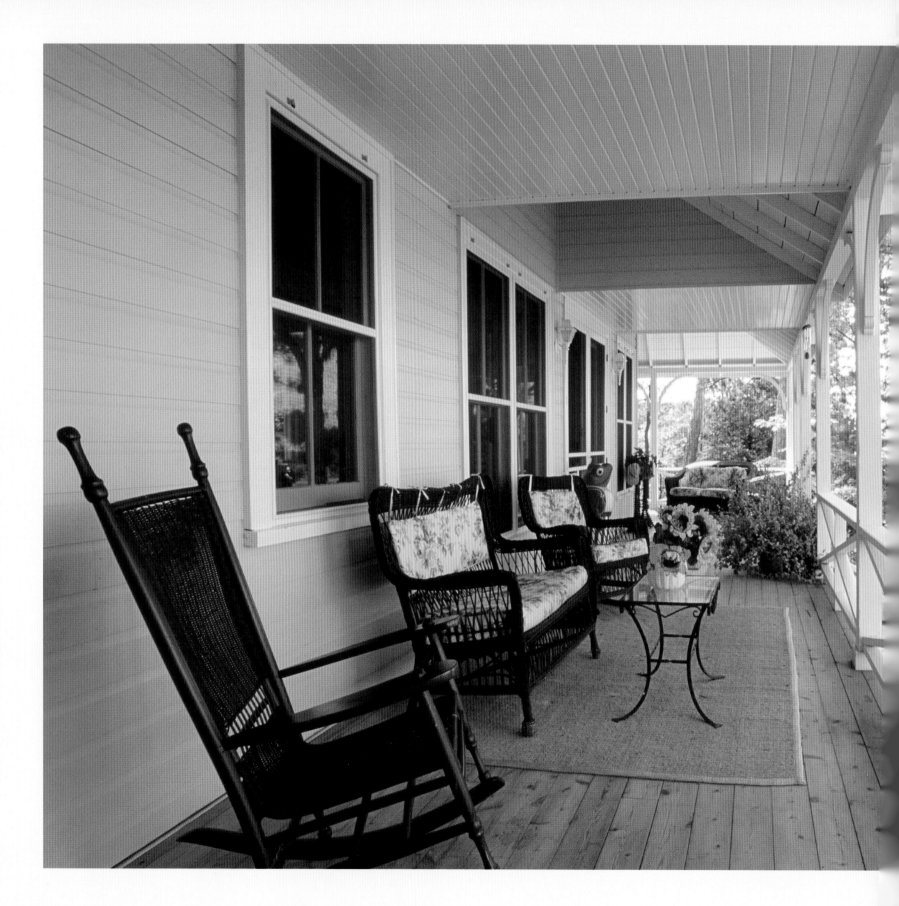

Summer is the time when one sheds

one's tensions with one's clothes,

and the right kind of day is

jeweled balm for the battered spirit.

A few of those days and you

can become drunk with the belief

that all's right with the world.

ADA LOUISE HUXTABLE

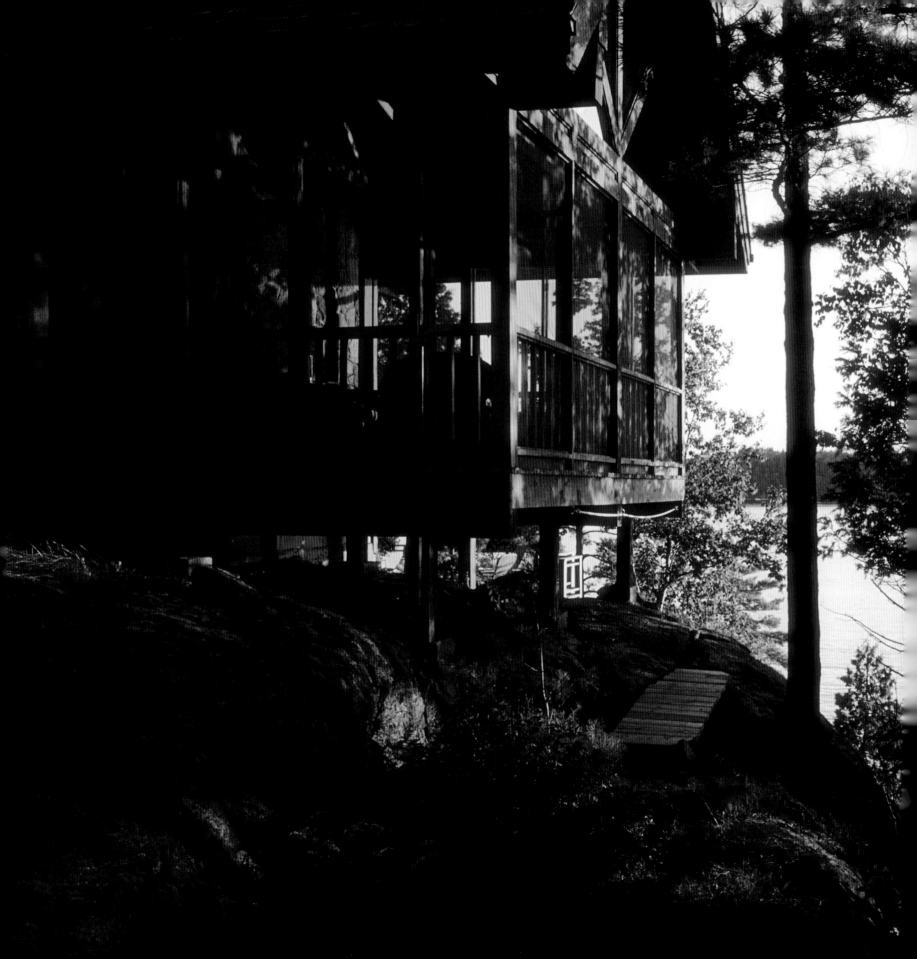

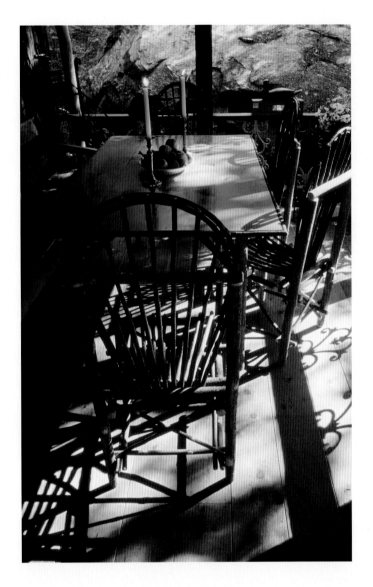

(above) Sun and shadow interplay on the porch of a log cabin. The tabletop was made of pine boards from an old granary.

(left) This screen porch is cantilevered off the side of the house and open to lake breezes on three sides. "A porch like this is essential here," says the owner, "especially at dusk, which is prime bug time."

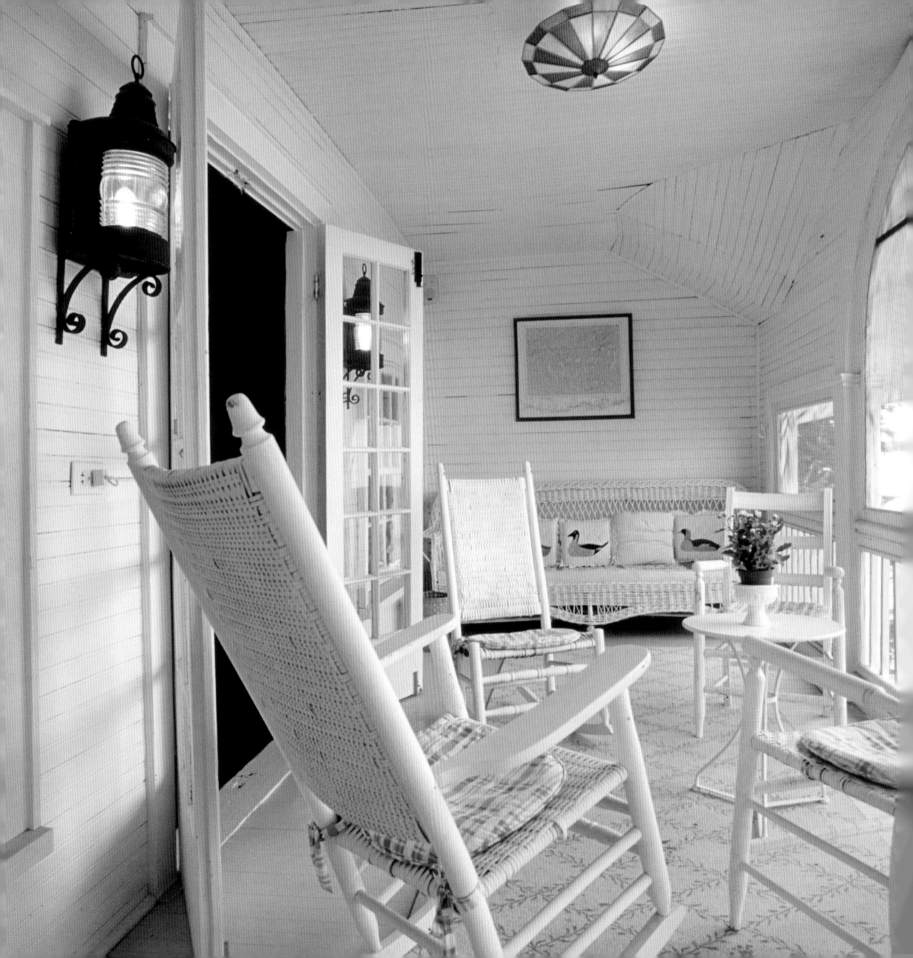

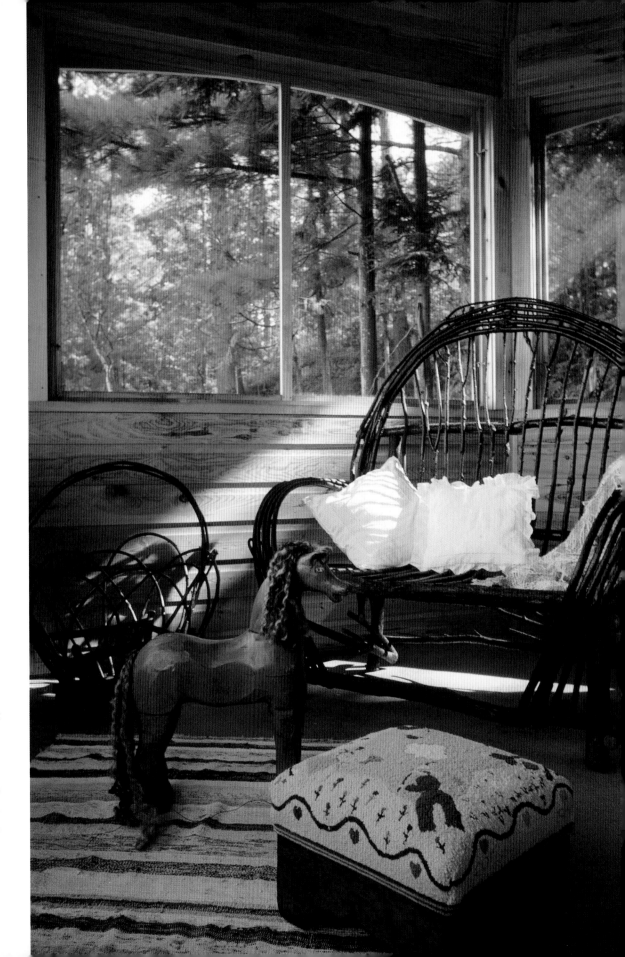

(opposite) This screen porch, which opens off the master bedroom on the second floor, is used as a quiet getaway for morning coffee.

(right) Twig furniture made by the owner and a hooked footstool found at a country auction add rustic appeal to the porch of a canoe house.

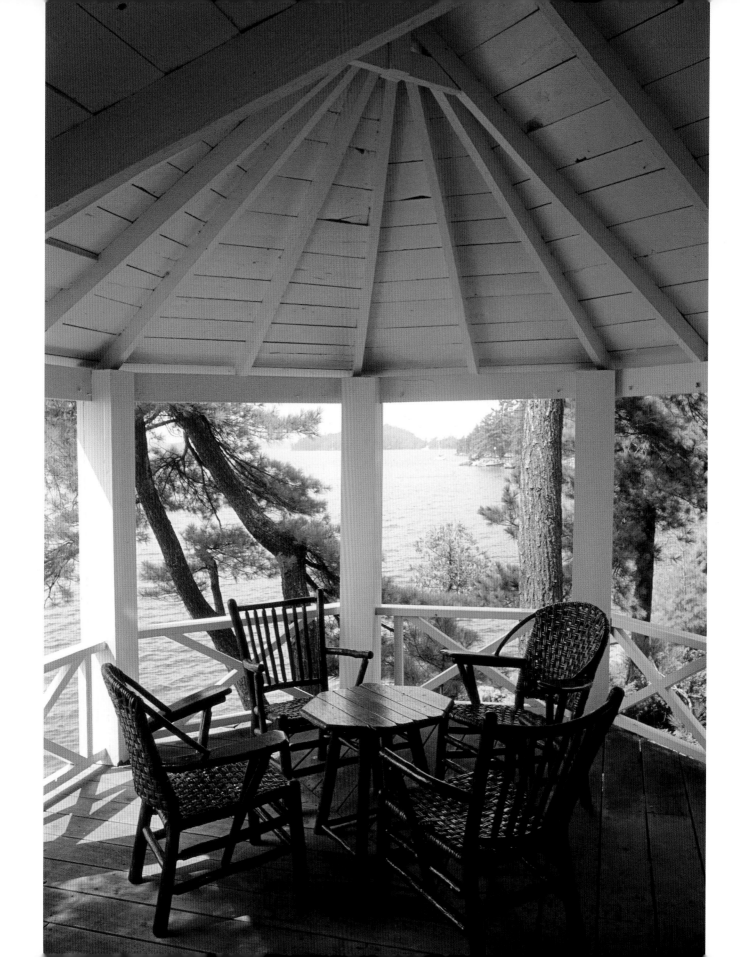

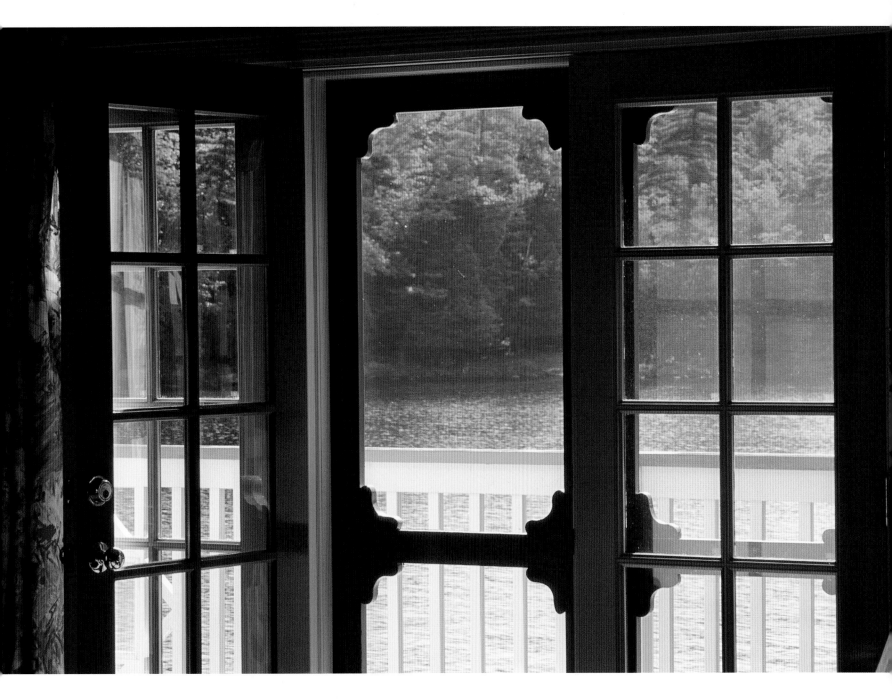

In proportion as he simplifies his life, the laws of the universe will appear less complex,

and solitude will not be solitude, nor poverty poverty, nor weakness weakness.

HENRY DAVID THOREAU

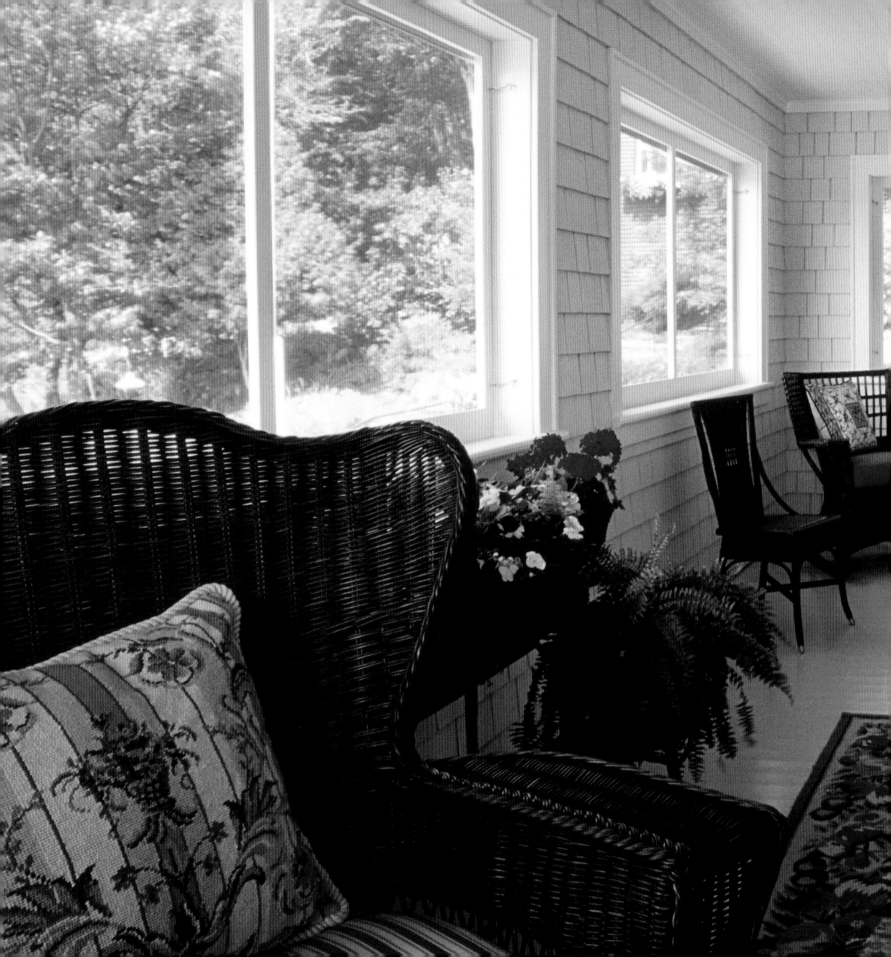

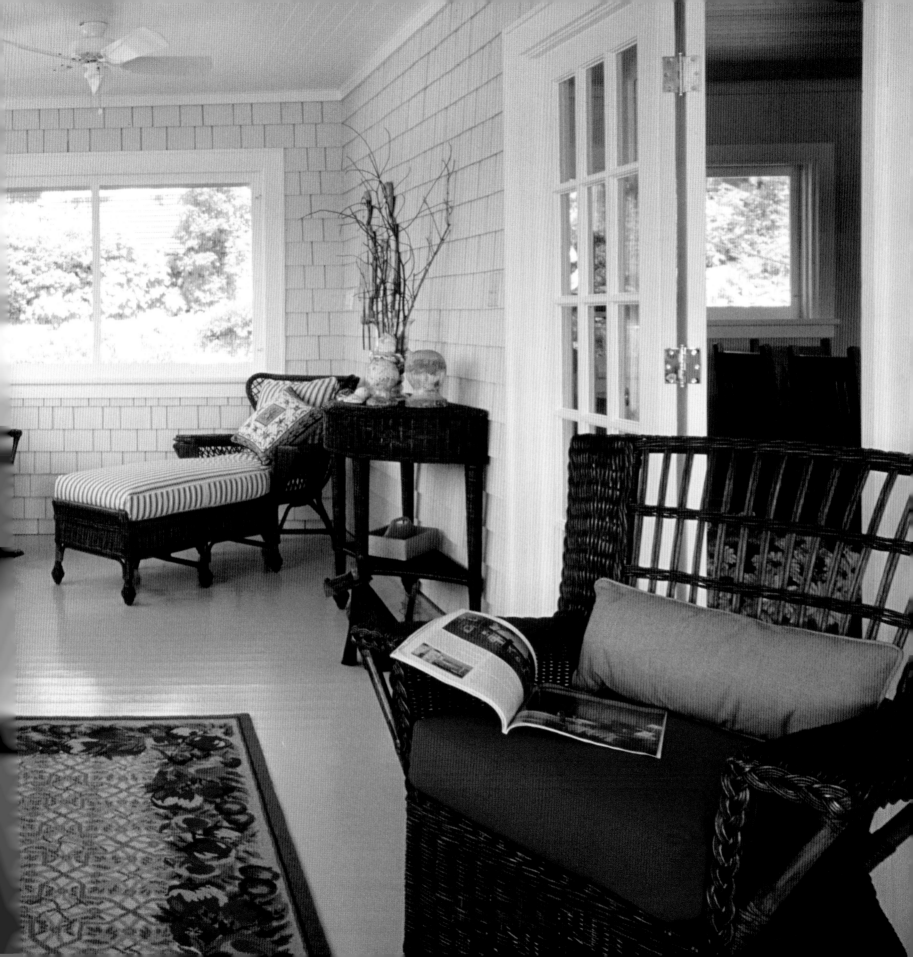

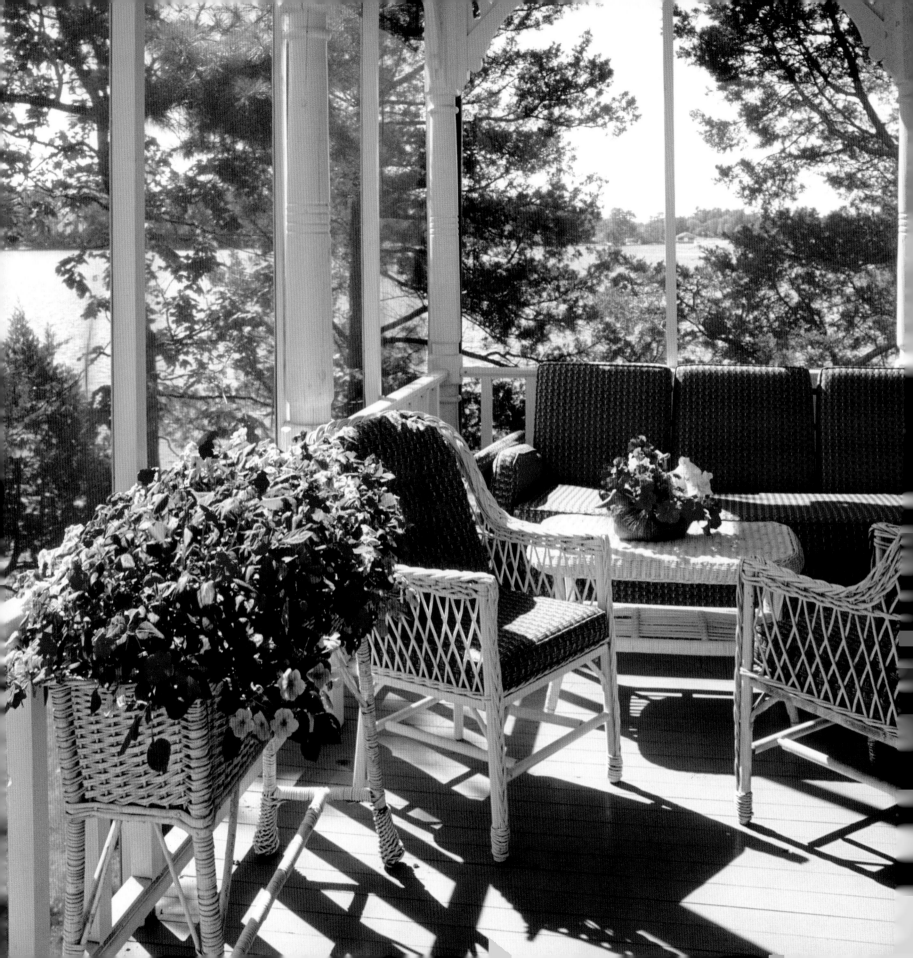

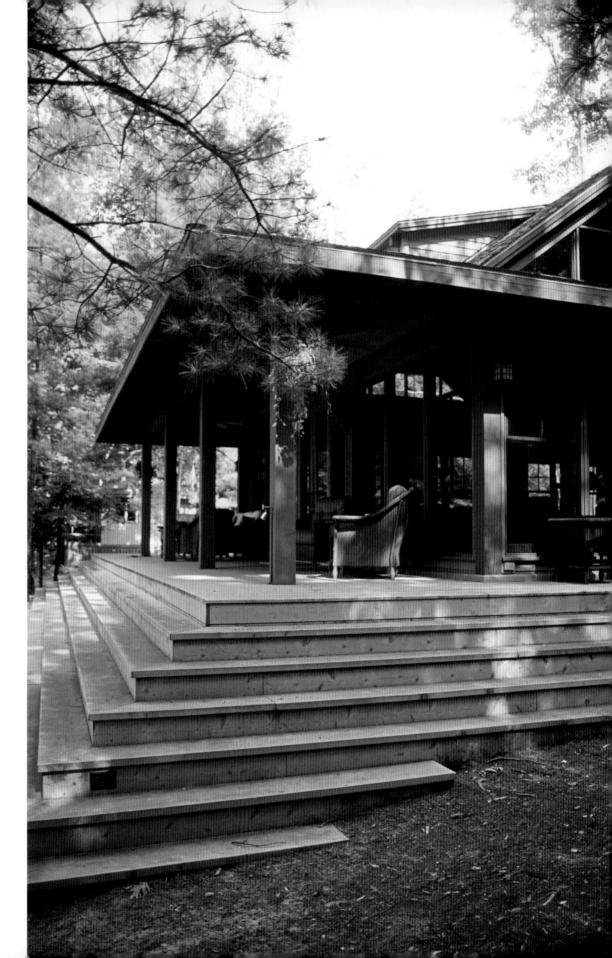

(opposite) Old wicker has a timeless quality and a durability that make it ideal for screen porches where wind and rain can sweep through and create havoc.

(right) This low-slung lake house was designed by an architect known for his environmentally sensitive approach. Few trees were removed and the building seems to hug the land, blending the house into the setting. A large roof overhang provides shady outdoor living and keeps the open interior space cool as well.

(preceding pages) A screen porch, with shingles and floor both painted sunny yellow. It was designed with waterproof fabrics to withstand all forms of weather. Swimmers can come in after a dip in the lake and settle into a comfy chair.

Deep summer is

when laziness

finds respectability.

SAM KEEN

(right) The covered porch of this boathouse, built in
1927, faces west toward neighboring islands. Off the
porch is a spacious bedroom, and down below, a 34-foot
slip that houses the family's mahogany cabin cruiser.

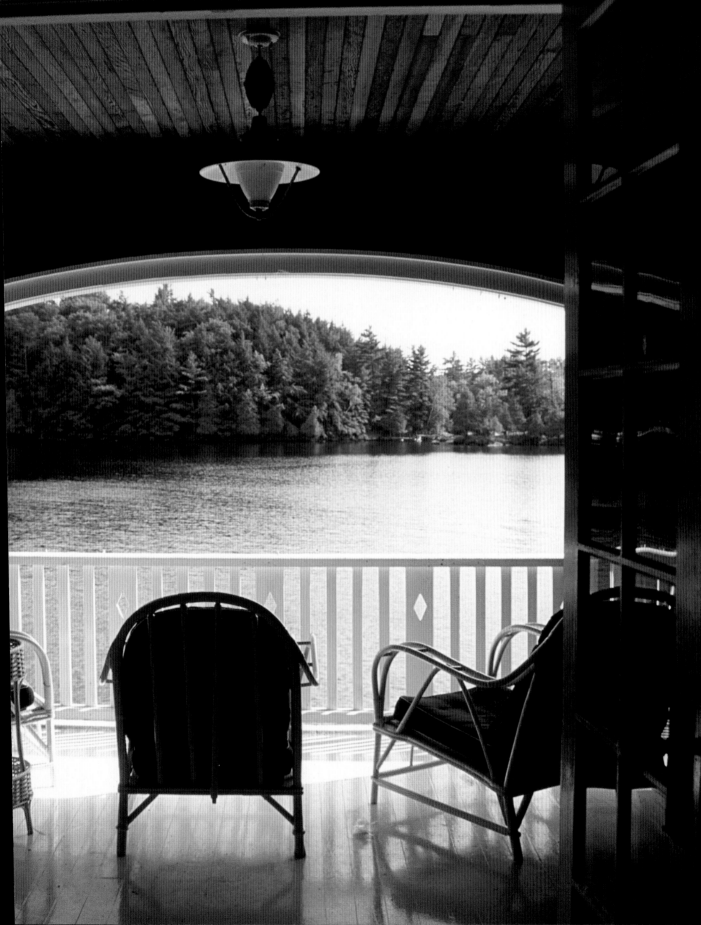

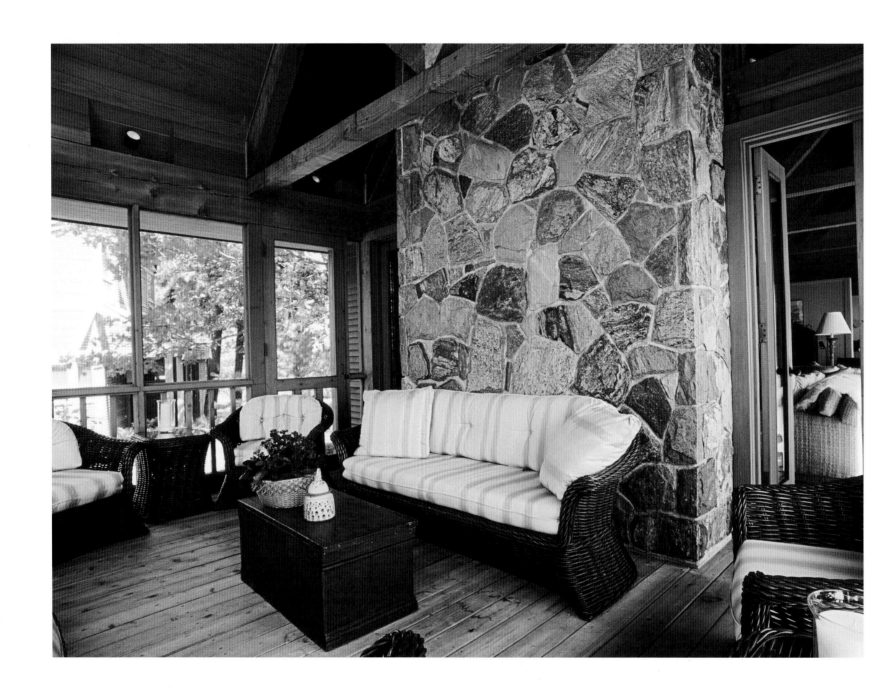

The back wall of the living room's stone fireplace adds a layer of texture to this screen porch.
Dark wicker chairs with soft cushions can be arranged for sociable gatherings on warm summer evenings.

The late afternoon sun casts long shadows at this timeworn summer place where the lake beckons in the distance.

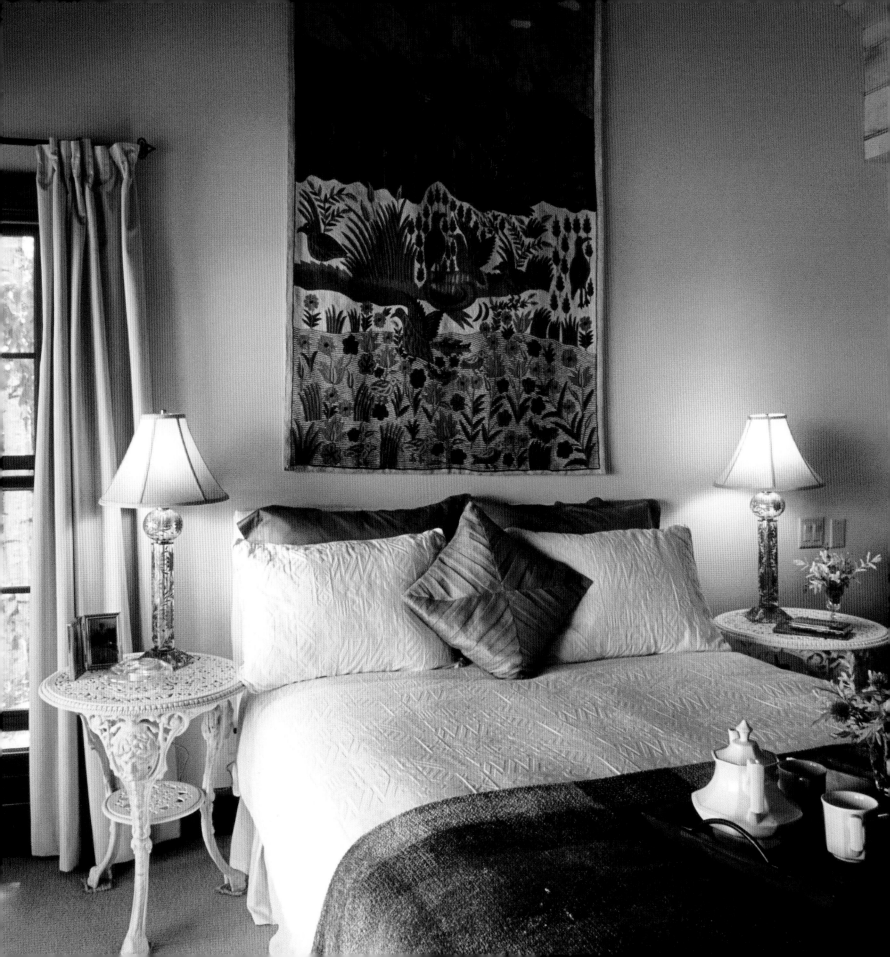

Bedding Down

Few things are more memorable than the woodsy scent of an old lake house bedroom, the kind with creaky wooden floors, old iron beds (that also creaked), an enamel washbasin in the corner and windows framed by thin curtains moving in the breeze. Here, in these mellow, musty rooms where as children we read with flashlights under the covers and fell asleep to the sound of waves, our fondest lake house memories were born. In many old places, little has changed in these Spartan camp-like bedrooms — except, perhaps, the mattresses.

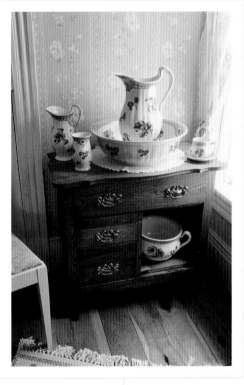

Back in the days before plumbing and electricity, the well-appointed bedroom had a complete china set for washing (including a chamber pot and a slop bucket), a dresser with built-in candle stands, coal-oil lamps for reading and a screened sleeping porch to retire to on steamy summer nights. Even now, in vintage lake houses, carefully preserved porches are favorite places to sleep. "Our sleeping porch is often the only place to hide when all the kids are here," laughs the mother of a lively clan. Their master bedroom opens onto a screened porch spanning the front of the house and overlooking the lake.

When generations expand and new grandchildren arrive, bunk beds are the ultimate solution for cramming extra family and guests into small spaces. Lined up in rows and hung with curtains (like berths on a train), they become favorite hideaways for children on rainy days.

And bunk beds aren't just for kids. Now they are going upscale, with sophisticated versions for grown-ups. At one lake house, double bunk beds were built into the wall, each bed with its own casement window, reading light and plenty of headroom. "We found that our guests enjoy these beds," says the owner, "because it brings back childhood memories."

At contemporary lake houses, the master bedroom gets the best view. By keeping the decor simple and serene, the lake view takes center stage. Easy lake house style includes uncovered windows, bare wood floors and plenty of soft white bed linens. Early risers are treated to the sight of mist rising above the smooth silver sheen of the lake. And later in the day, when things get hectic on busy summer weekends, the room becomes a quiet refuge.

(opposite) Windows open to a cluster of birch trees and a cooling wind off the bay in this lake house guest room.

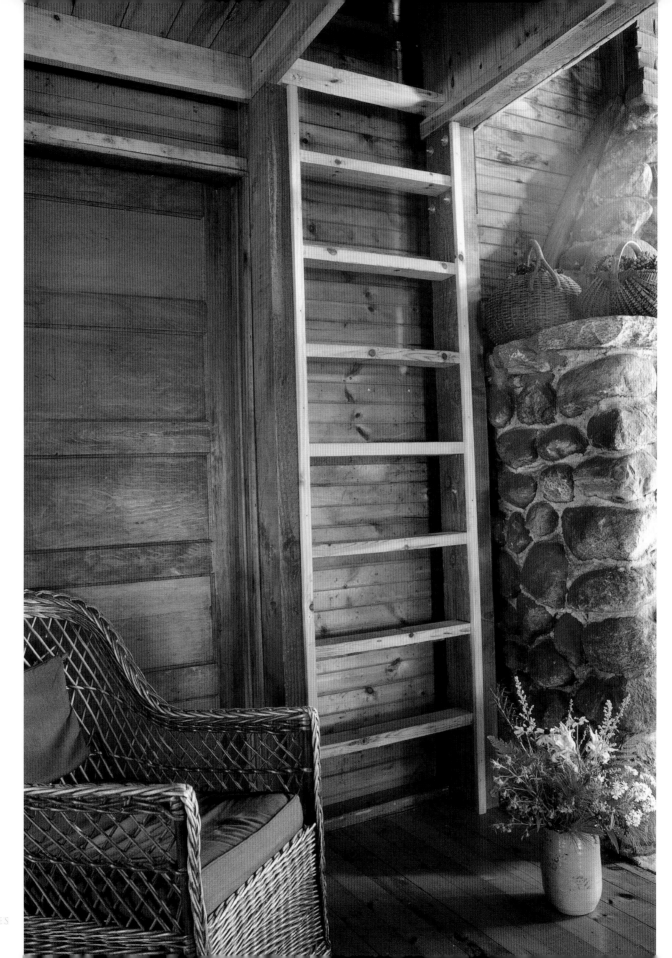

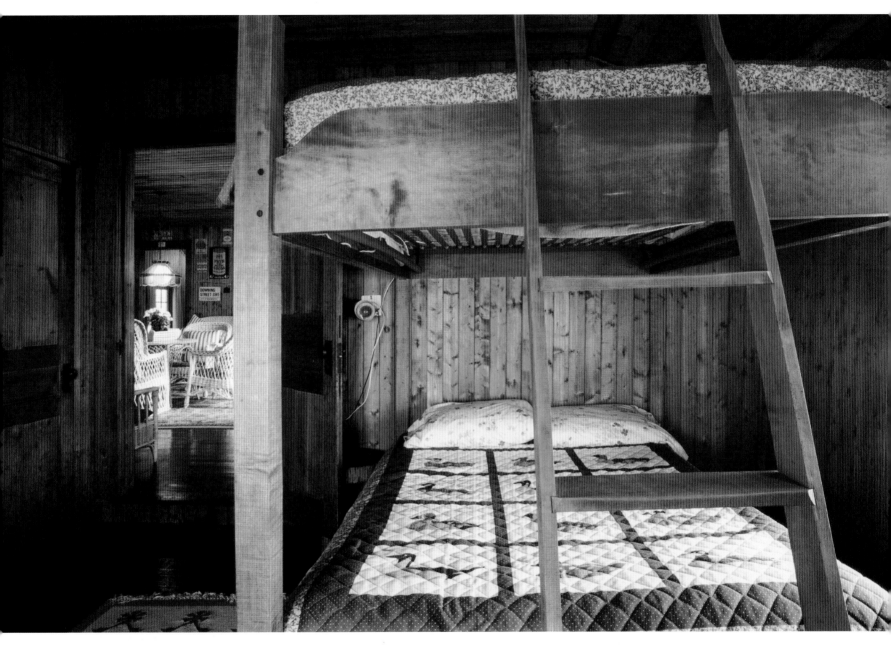

(above) Double bunk beds make the best use of space in this small wood-lined bedroom.

(opposite) A ladder tucked beside the fireplace in an old-fashioned living room leads to the sleeping loft.

(following pages) At this island there are side-by-side vintage boathouses — one with sleeping quarters for boys and the other for girls. Nothing has changed here over many generations — including the old metal hospital beds in the boys' room.

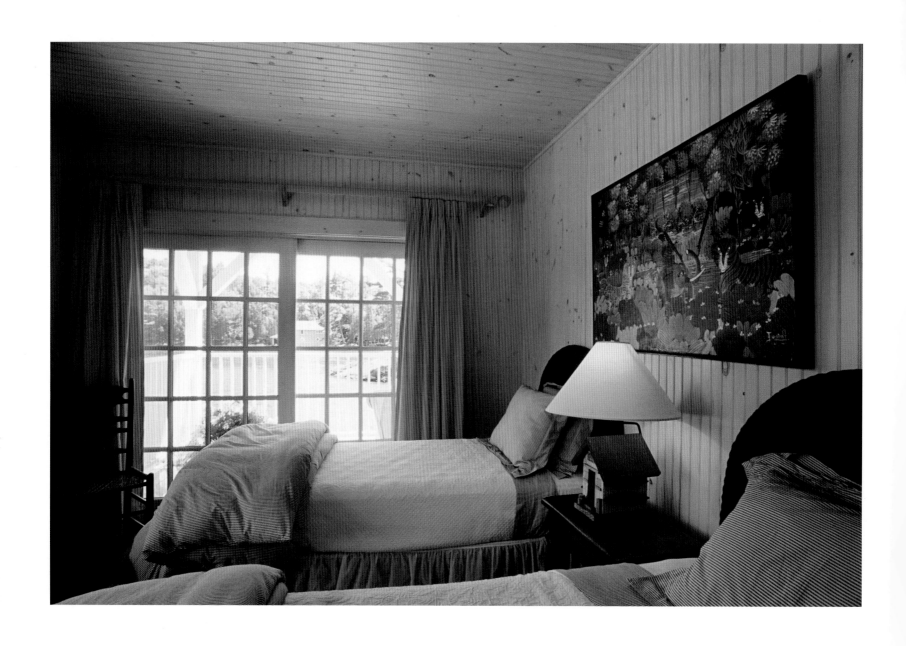

(above) A guest bedroom in summery blues and yellows has its own private balcony with a lovely lake view.

(opposite) The walls have exposed studs in this rustic cabin used only in summer months.
The owner made the birch headboard from felled trees on the property.

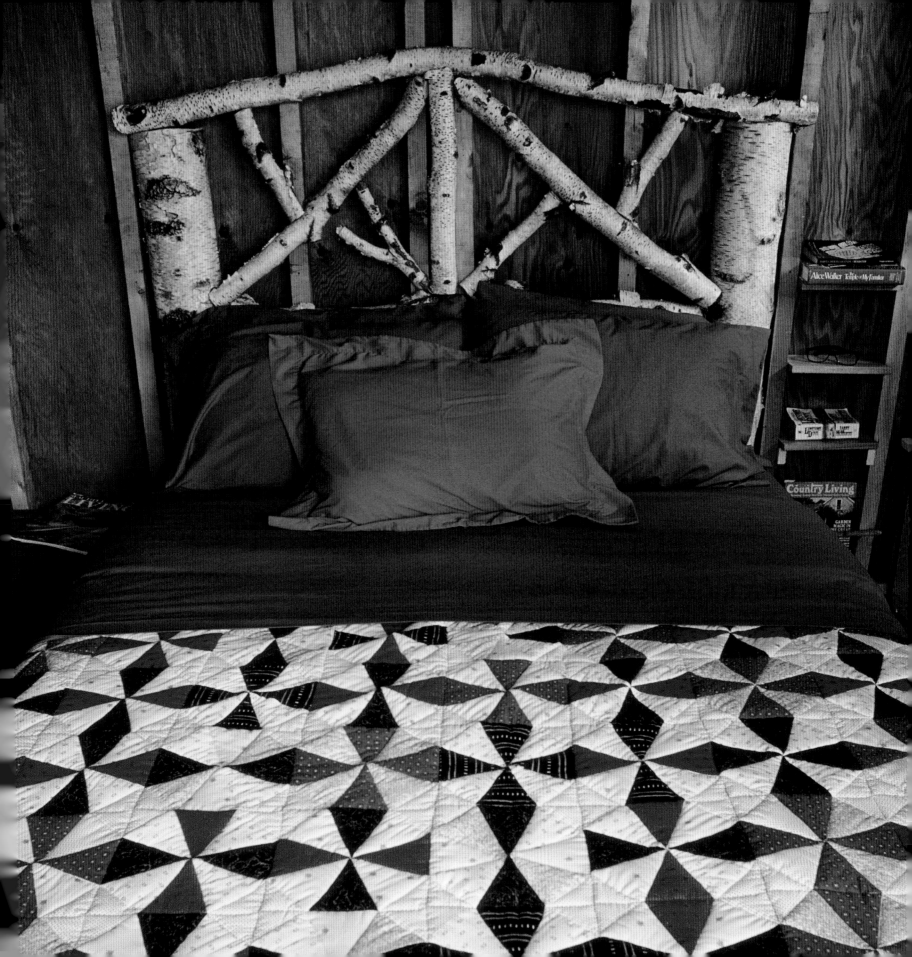

Sleep comes easily in bedrooms on the lake —
especially in ones with a screen porch that allows
breezes to waft through the open doors at night.

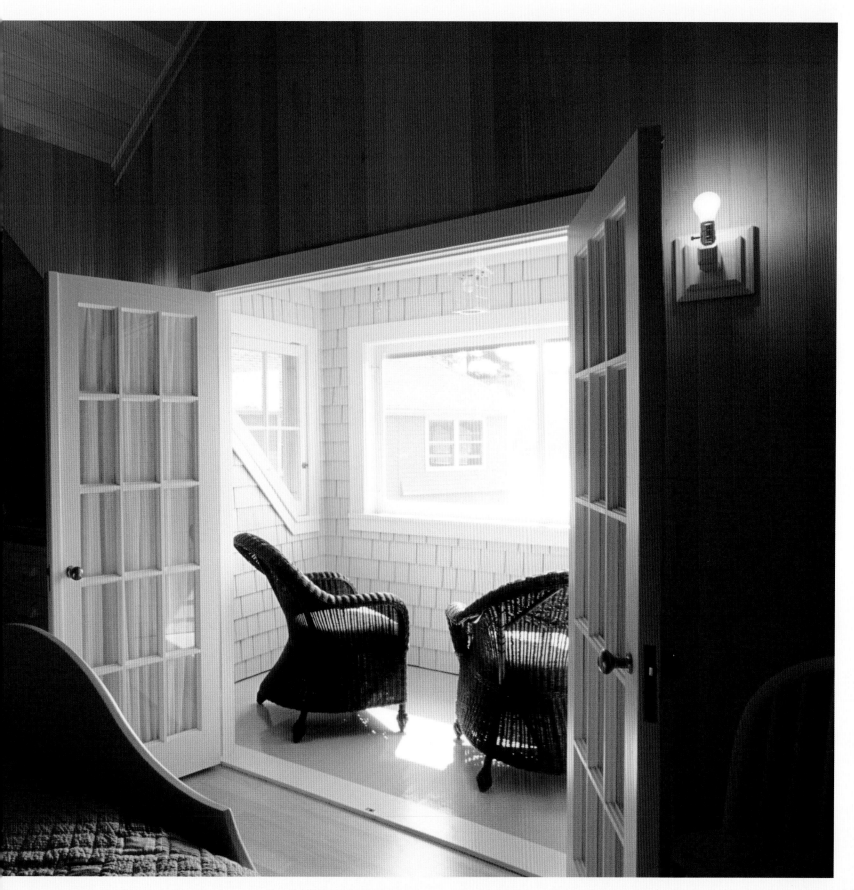

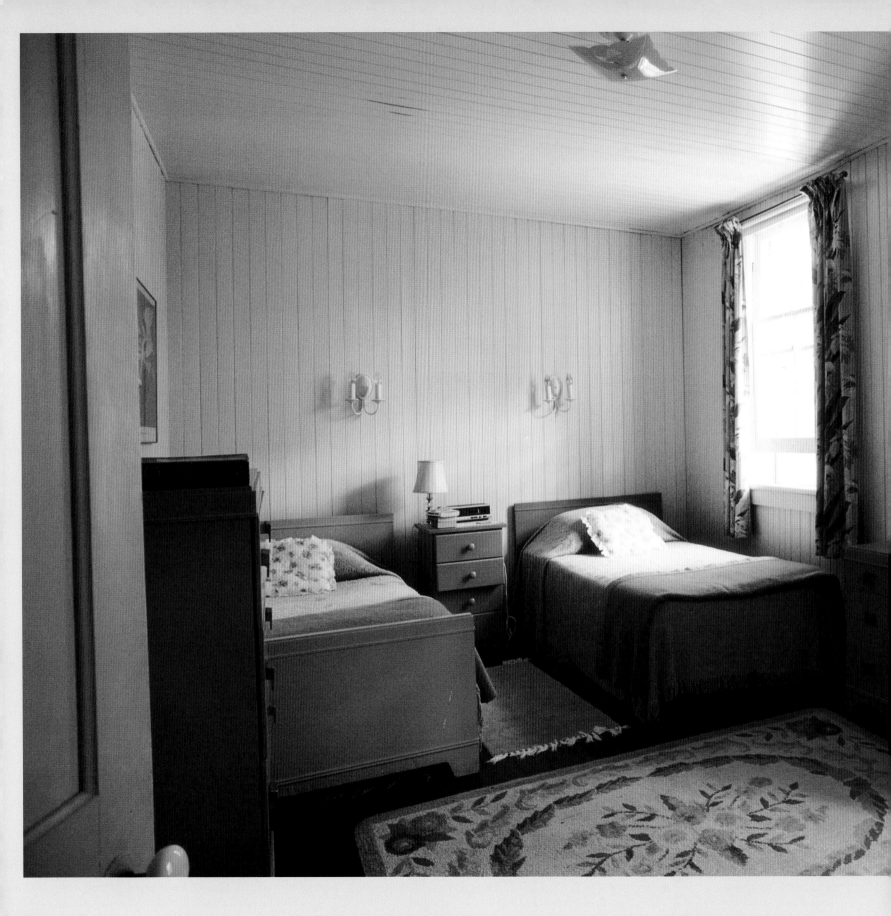

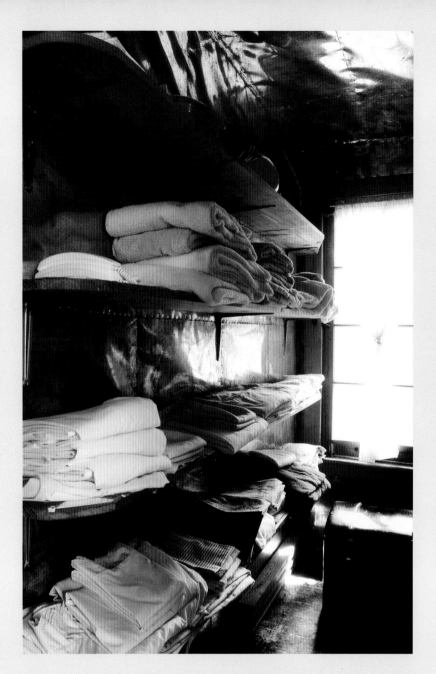

(above) A tin-lined closet was once a necessary feature for storing towels and bedding during the winter months when the house was shuttered and closed up. It acted like a large cookie tin protecting the linens from mouse and squirrel damage. "It's still a great idea," says the owner of this vintage place. "I store pillows and duvets here in winter."

(left) In century-old lake houses, the furniture rarely changes — it just gets painted. Here, the cedar tongue-and-groove walls and ceiling have also been rejuvenated with coats of pastel paint.

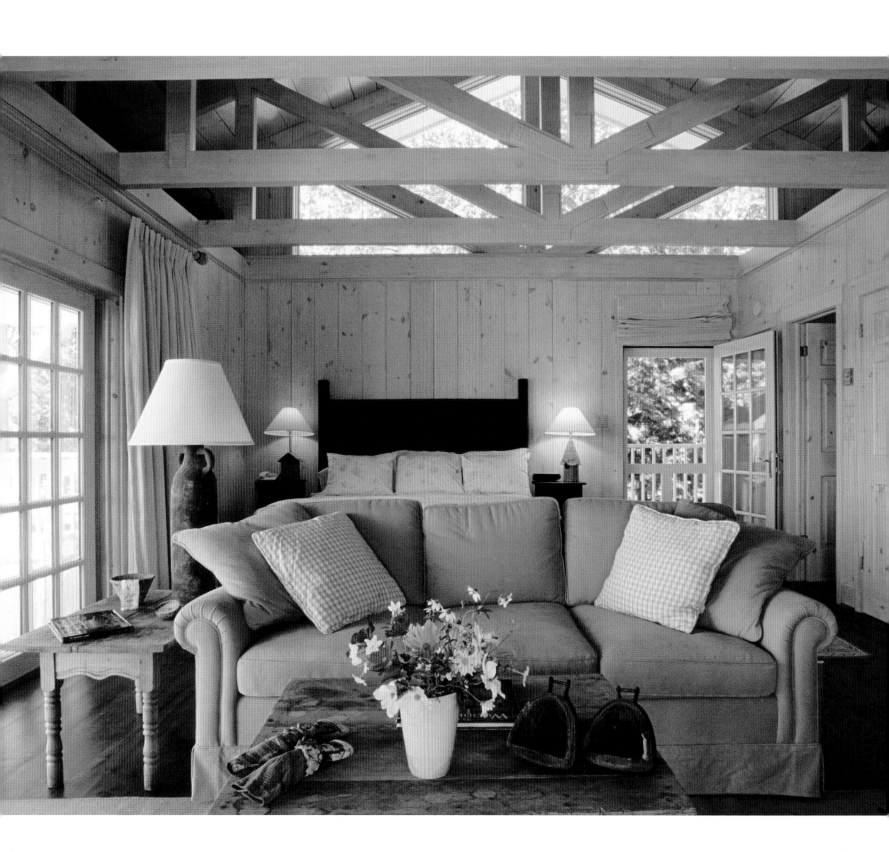

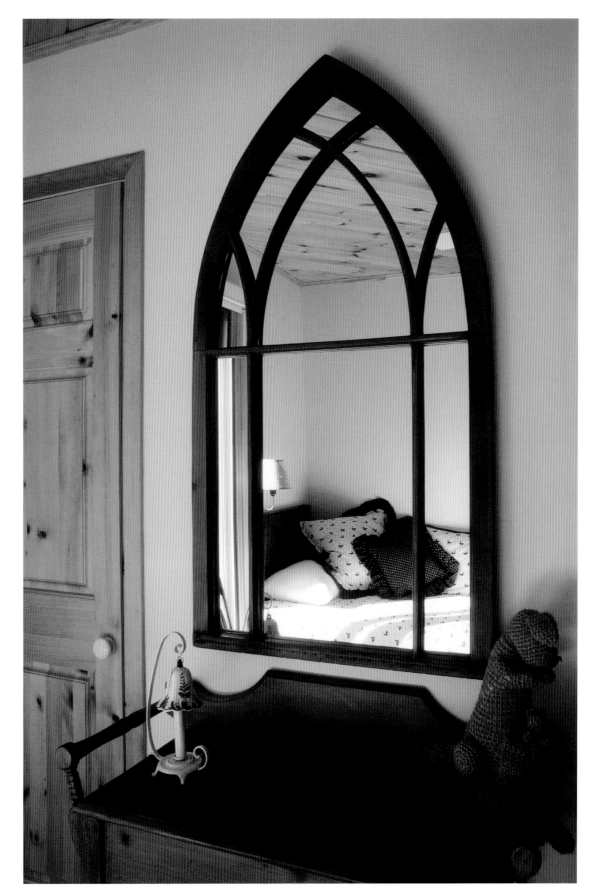

(opposite) Exposed trusses and glass panels in the gables keep this bedroom/sitting room airy and filled with light. Oversized glass doors open to a veranda on three sides. A thin wash of white paint covers the pine walls to keep the wood from yellowing.

(right) The simplicity of an old-fashioned bedroom is reflected in the dressing-table mirror.

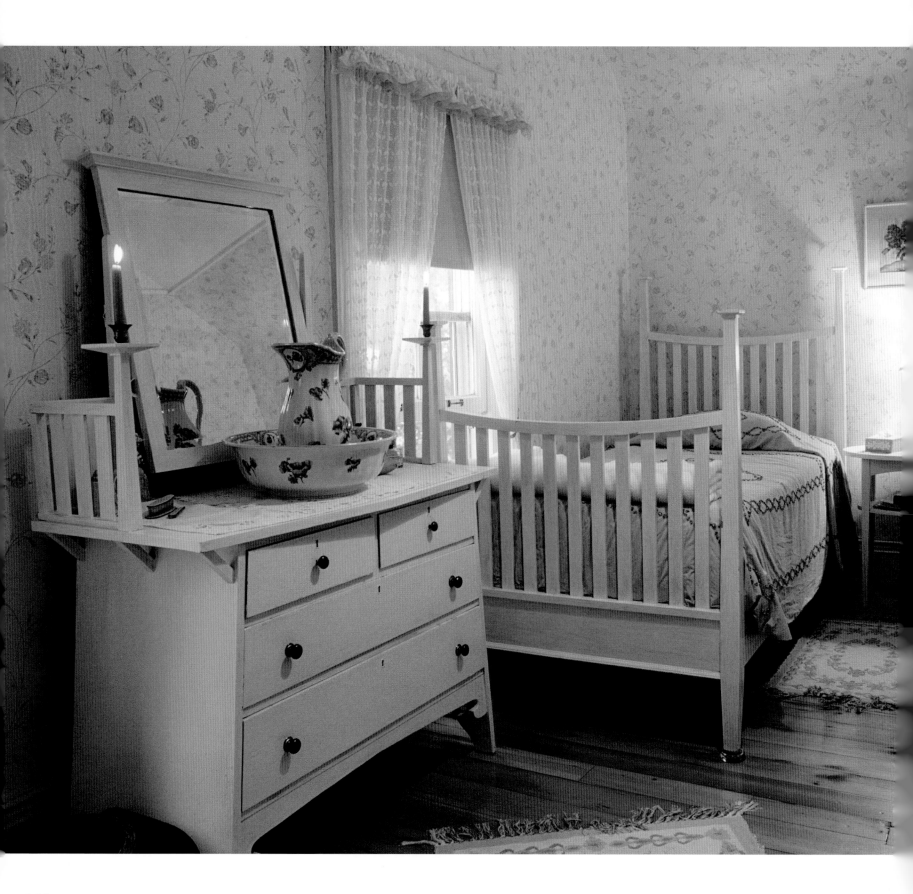

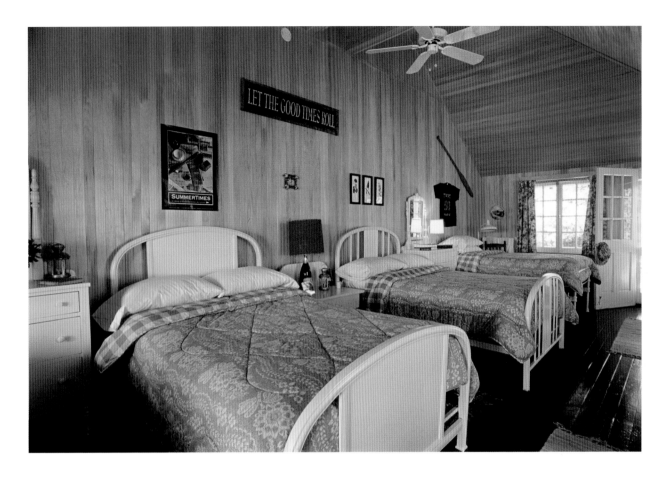

(above) Dormitory-style sleeping quarters for the children (boys in one, girls in the other) were once common. Here, new bed linens and a fresh coat of paint on the furniture bring the girls' room up to date.

(left) In olden days, candleholders were built into the bedroom dressers to offer light, and a basin and jug were provided for washing up. Water in those days was either brought from the lake in pails or drawn from a hand pump at the kitchen sink.

Anything may be called perfect

which perfectly answers the purpose

for which it was designed.

SHAKER SAYING

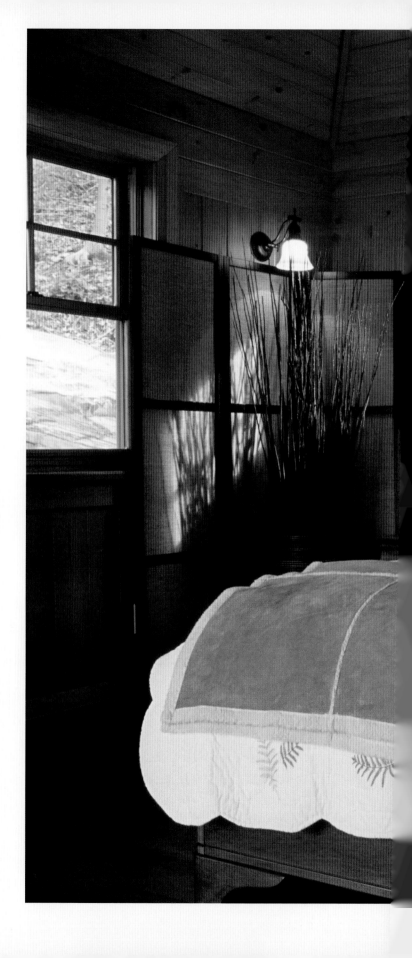

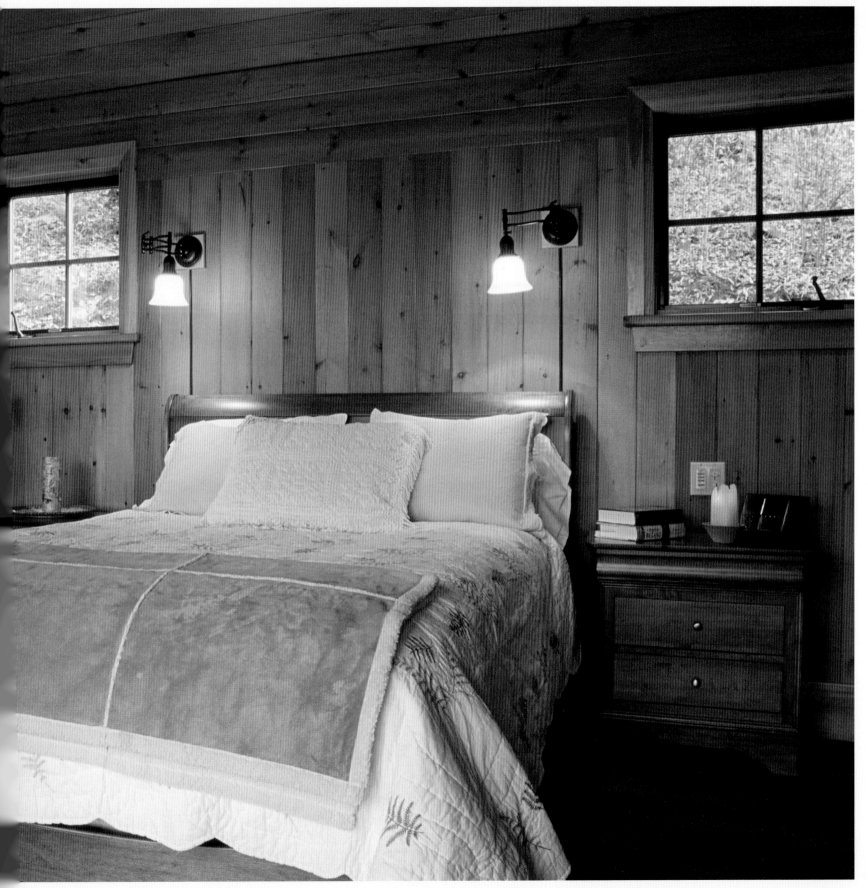

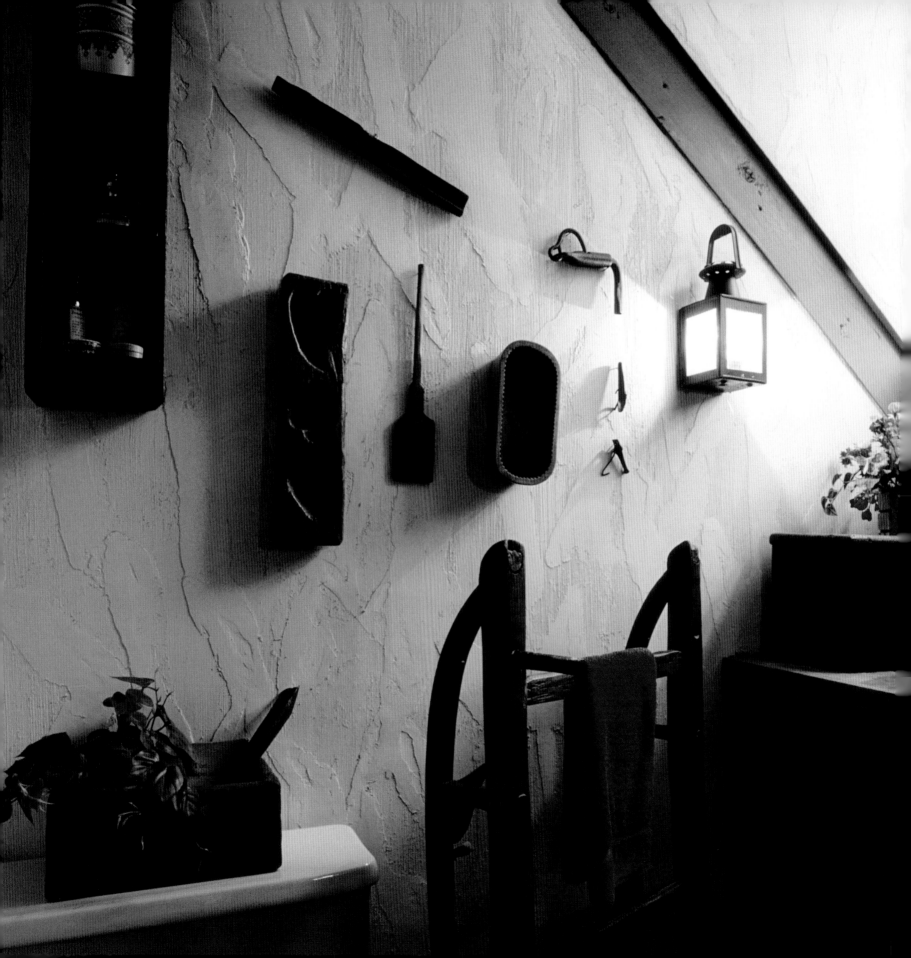

Prize Privies

No room in summer lake houses has been through more changes than the washroom. As plumbing improved we moved from the old wooden outhouse tucked discreetly in the woods to the indoor bathroom with a hand pump providing water at a wall-mounted sink. Then came claw-foot tubs and real running water drawn from the lake by motorized pumps.

"Something is missing since plumbing moved indoors," laments one old-fashioned cottager with fond memories of outdoor bathing houses and rustic privies.

Indeed, at many old places, much of the cottage lore has to do with outhouse adventures in the good old days, hilarious tales of nighttime encounters with wildlife, and spooky experiences with spiders emerging from the depths.

At one island lake house, summer home to a large extended family with numerous children, the solution is provided by two separate bathing pavilions — one for girls and one for boys. Inside the quaint buildings, which look more like playhouses than bathrooms, are showers, a claw-foot tub (for girls only), wall-mounted sinks and separate WCs. Tiny windows mounted near the roofline let in fresh air

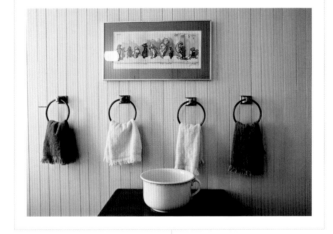

and also maintain privacy. "But of course," says the mother of the clan, "there are frequent attempts at peeking."

Lake house bathrooms have come a long way from the primitive outhouse. Now they're outfitted with marble vanities and glass showers, bidets and huge Jacuzzi tubs, a style that reflects improvement of septic systems. In these modern bathrooms, there's no need for the quaint reminders of the septic system's fragility that we used to post on the bathroom wall.

The favored decor in newly created bathrooms still evokes country style, with beadboard walls, vintage reproduction vanity sinks and tubs, bare wooden floors and seaside colors to add a spa-like atmosphere. For utter relaxation, soaker tubs are positioned with a view of woods or water.

One ironic twist is that indoor plumbing has finally been perfected, but owners are moving their tubs and showers outside. Hot tubs down at the dock or on the boathouse deck are favorite places to wind down on summer evenings. And the outdoor shower, put up with cedar walls and a large rainhead in a private wooded setting, is the ultimate treat — just like showering under a pine tree in a rainstorm.

(opposite) An antique ice sleigh is recycled as a towel holder. The wall collections include items found on the property.

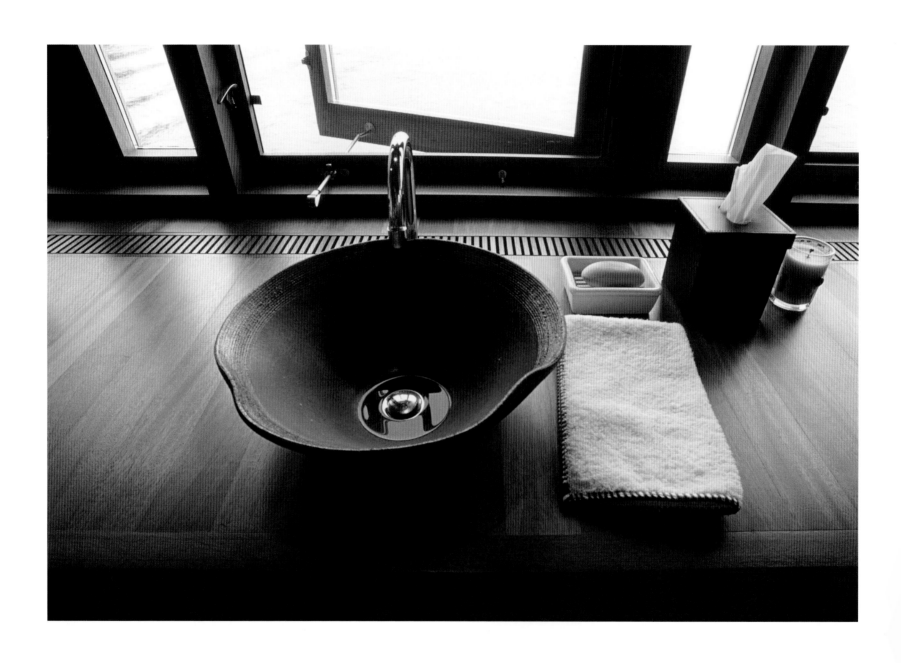

(above and opposite) Japanese influence is evident in this bath and dressing area. The architect-designed space features ceramic vessel sinks and teak countertops. Custom mahogany-framed windows offer private views of both woods and water.

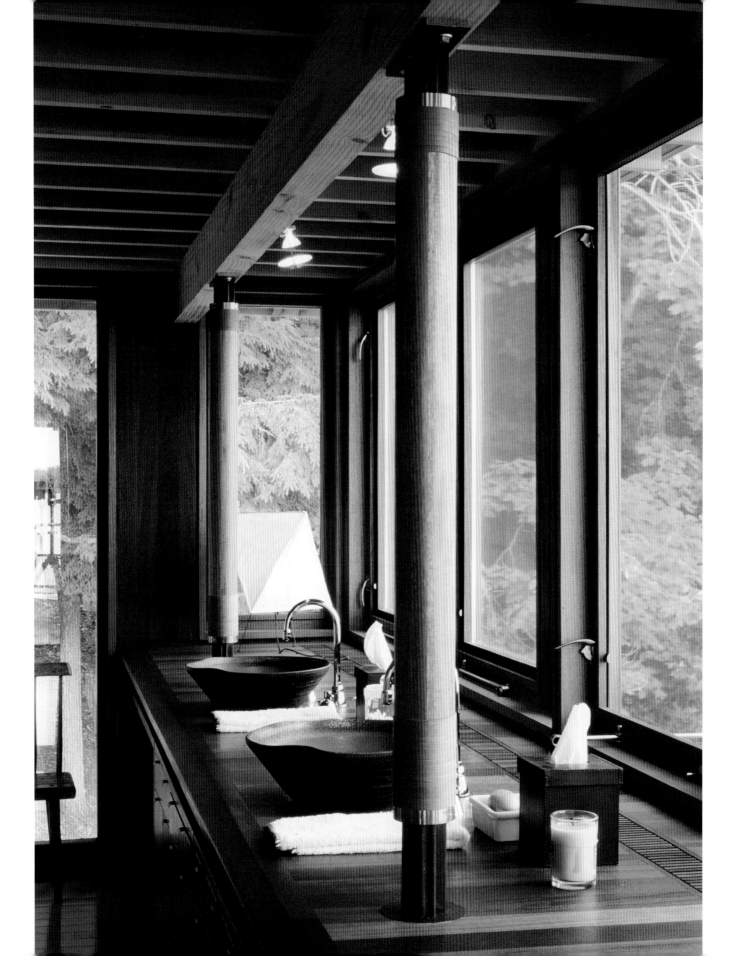

THE NATIONAL FLAGS OF THE WORLD · LES DRAPEAUX NATIONAUX DU MONDE
DIE NATIONALFLAGGEN DER WELT · LAS BANDERAS NACIONALES DEL MUNDO

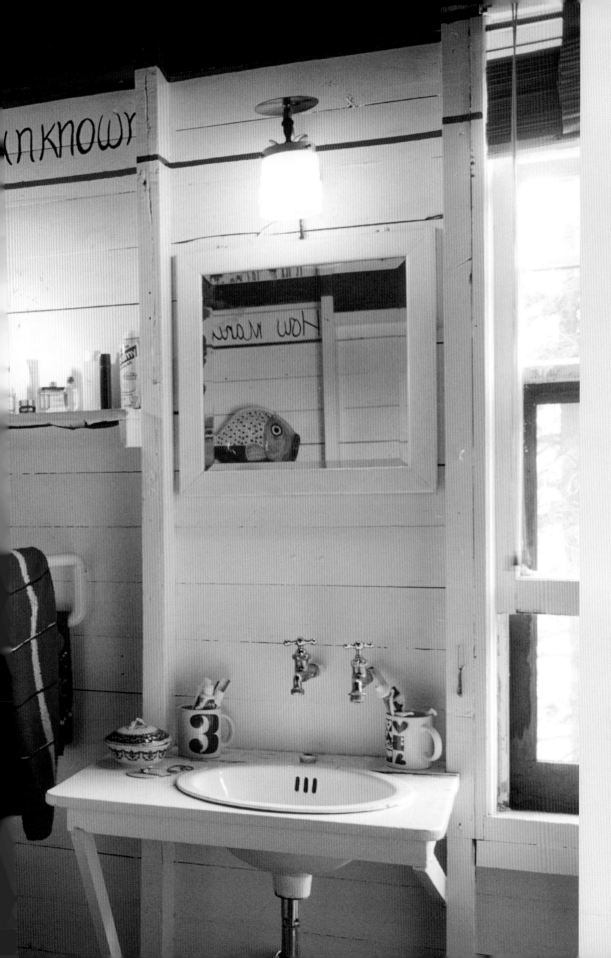

The owner of this quirky old bath-room painted the dark walls white and scripted a quote from William Shakespeare's *Julius Caesar* as a border. It reads, "How many ages hence shall this our lofty scene be acted over in states unborn and accents yet unknown!"

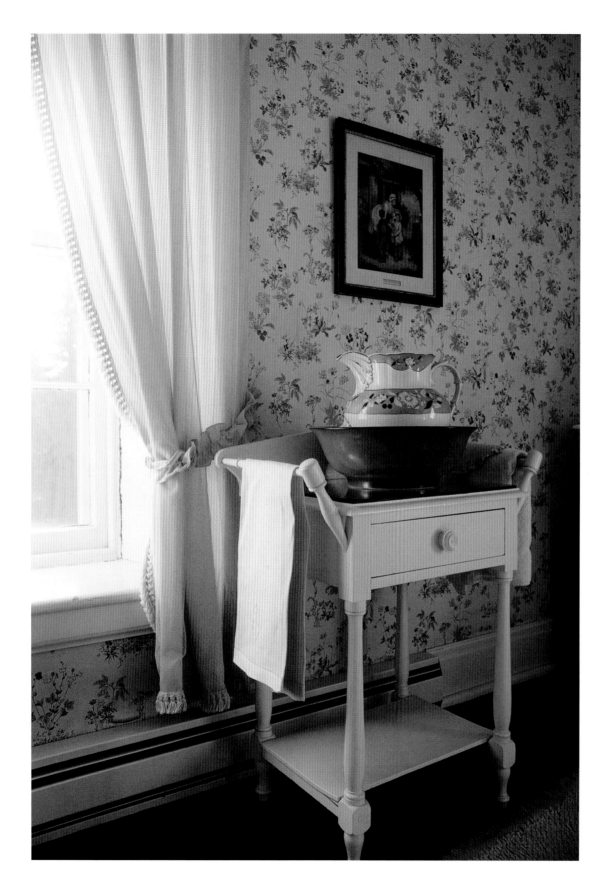

A dry sink, porcelain wash set, linen hand towel and floral wallpaper — all the accoutrements of a vintage bedroom.

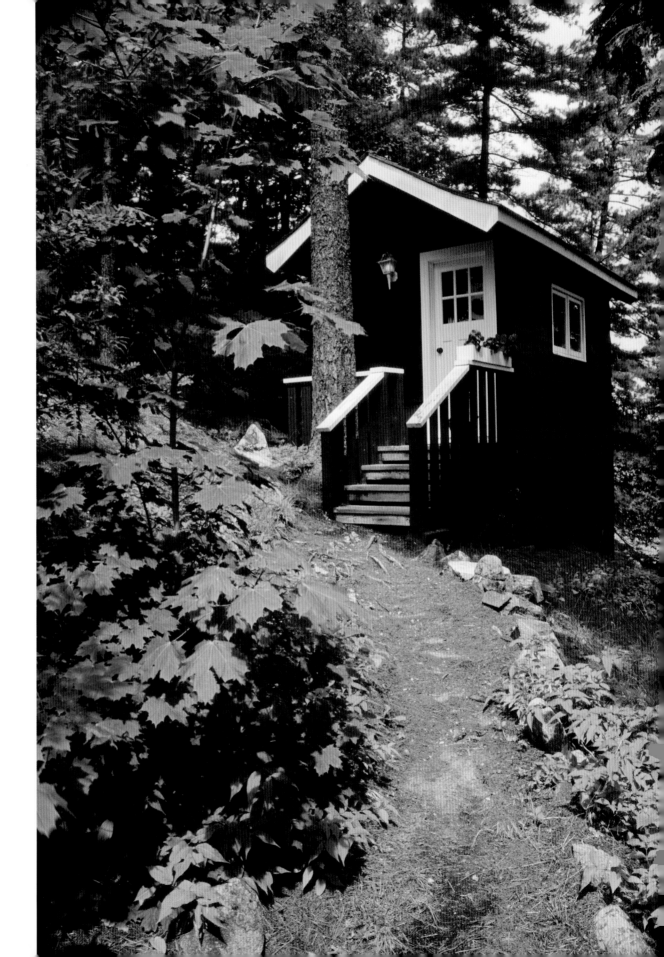

The bathhouse on this island is just a few steps from the back door of the main house. Inside, there's a shower, sink and toilet — as well as a claw-foot tub with a dreamy view of the lake.

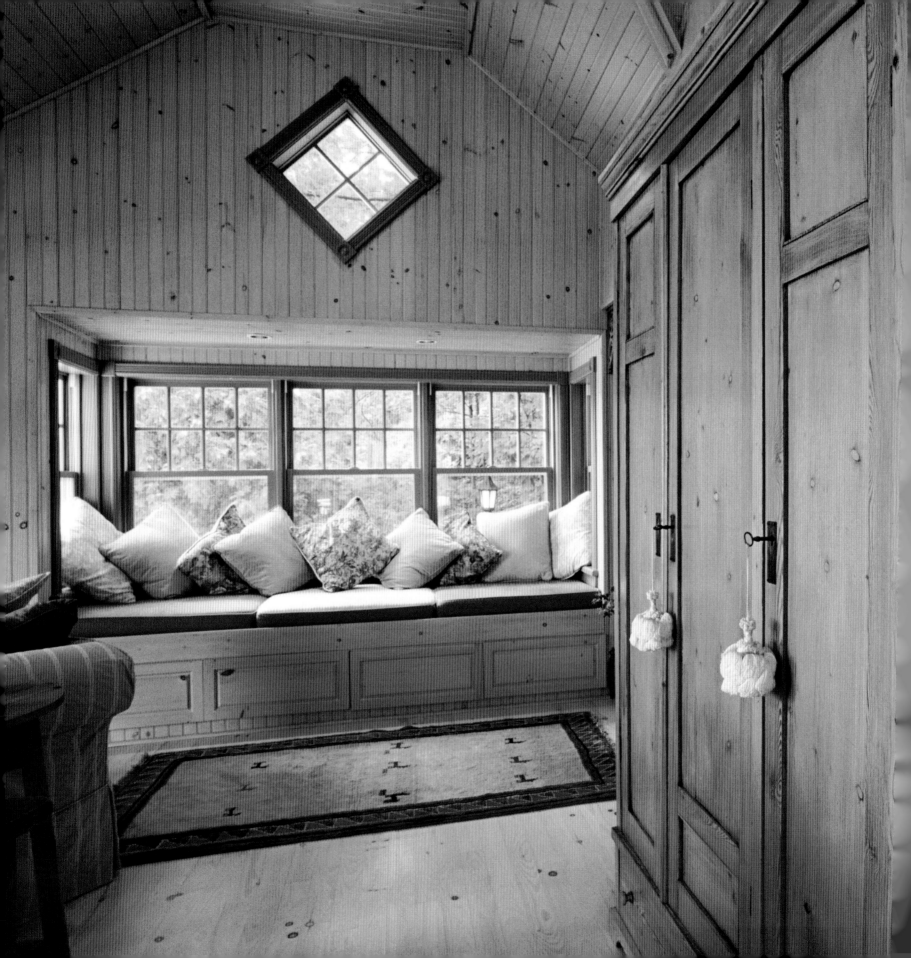

Grand Hallways

Whenever I think of rainy days at the lake house," recalls one old-timer who grew up in a lakeside summer mansion, "I remember the upstairs back hallway. I think we called it the servants' hallway, but we children turned it into a raceway on rainy days. We had more fun racing along the hardwood floors up and down the back staircase. I think my feet still have slivers from those days."

Back in the days when lake houses were built on a grand scale and the stairs leading to the second floor were as wide as a king-size mattress, there was often a morning room off the upstairs hall where tea was served to the early risers. And usually, tucked at the end of a corridor near the back staircase, there was a walk-in closet lined with tin. It was here, at the end of summer, that all the freshly laundered bedding would be stacked in neat piles, safe from the mice and squirrels and protected from the winter dampness.

Today, there's little need for tin closets. Lake

houses are usually fully winterized, so bedding does not get put away after the summer. And space planning is unlikely to include a vast second floor hallway unless the lake house design is a replica of a grand summer estate.

Now we have mudrooms instead of grand hallways and lake houses that are generally built on one level. Hallways are often long passages that separate living areas from bedrooms. It's these walls that become like galleries telling the story of a rich family life. Collected memorabilia fill the space — family photos, regatta ribbons, boat show posters, maps, children's artwork, and paintings of the lake house done by houseguests who might return.

In one contemporary lake house, the bright red hallway walls are lined with photographs of the house taken in all seasons and from every possible vantage point. "It's a tribute wall, I guess," notes the owner who also took the photographs. "A salute to our favorite place in the world."

(opposite) Designed for the owner's three teenaged daughters,
this cozy space has a built-in window seat for "hanging out" on rainy days.

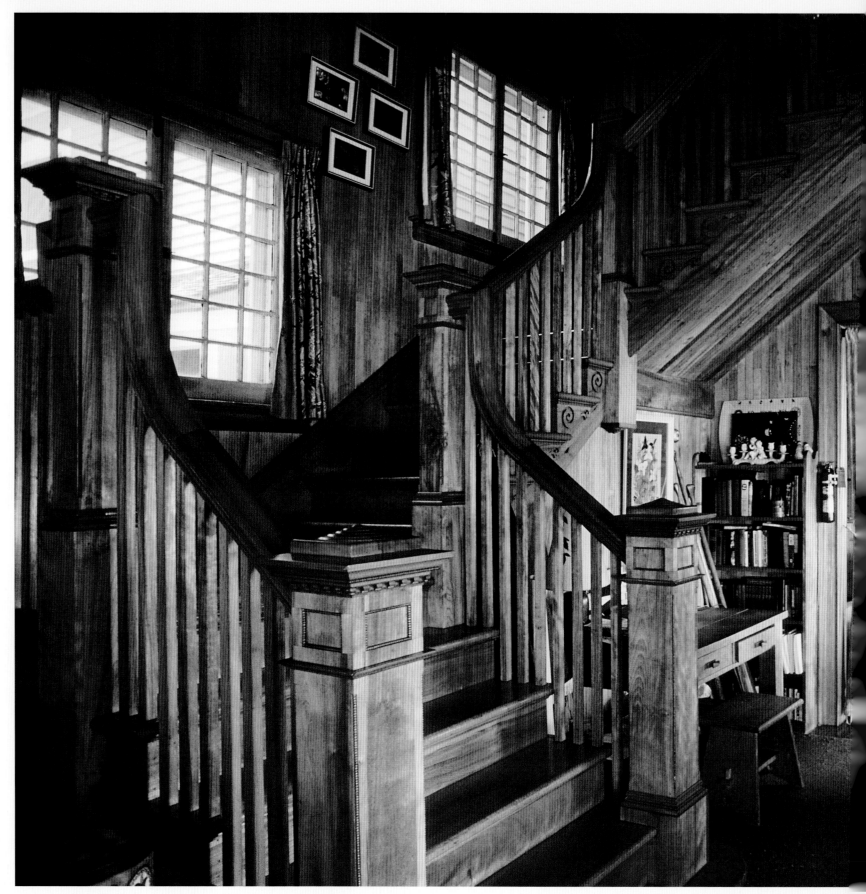

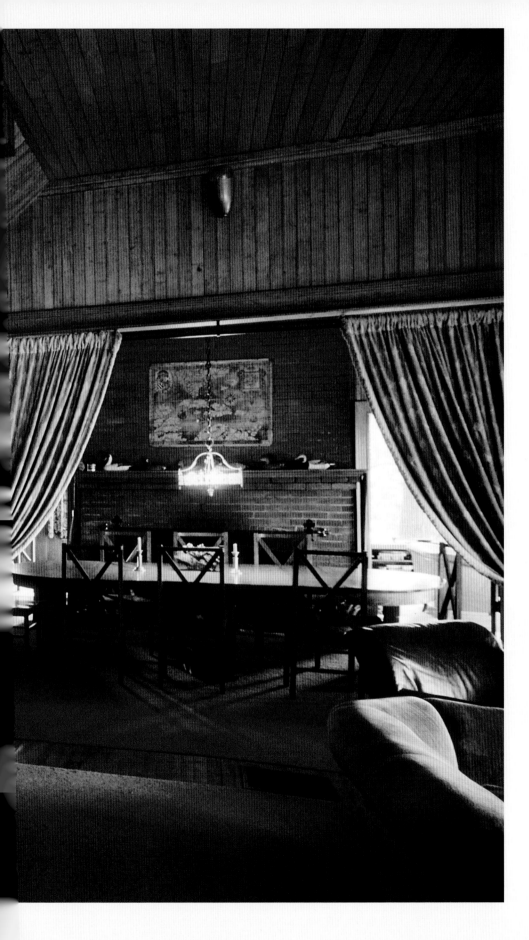

The grandeur of classic lakefront estates showed little concern for economy of space. Wide staircases led to massive second-story hallways, and vast dining rooms had wood-burning fireplaces. The doorway drapes were used to contain the heat in one room.

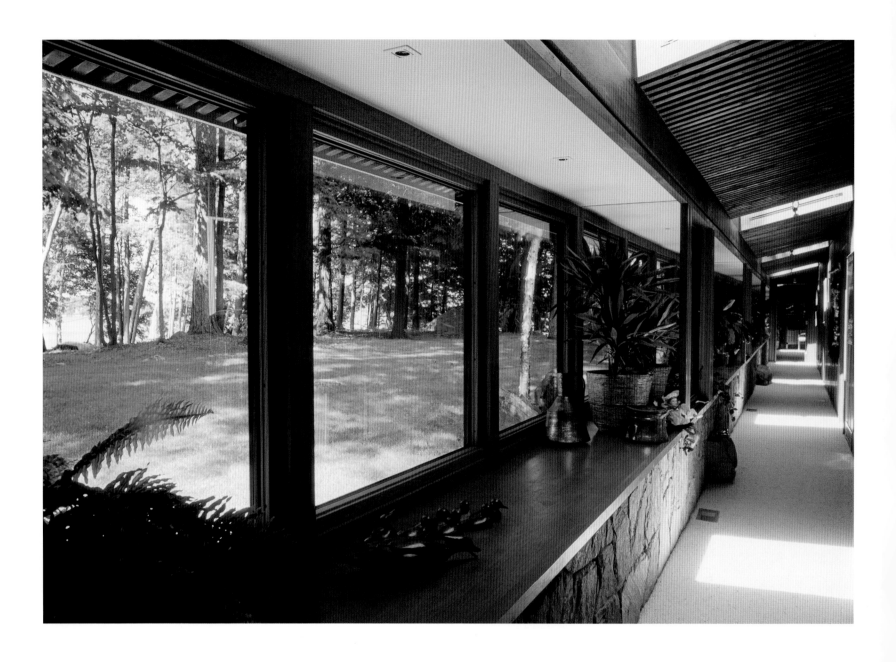

(above) A long, formerly gloomy corridor was brightened by adding a wall of windows and skylights in the roof.
The owner, a passionate gardener, uses the space for nurturing her indoor plants.

(opposite) Inside this Tudor-styled lake house, the rooms smell of musty cedar and woodsmoke. The paneled hallway is reminiscent
of an English manor house. At the end of the hallway is a dining room where guests gather at the large oak table before a roaring fire.

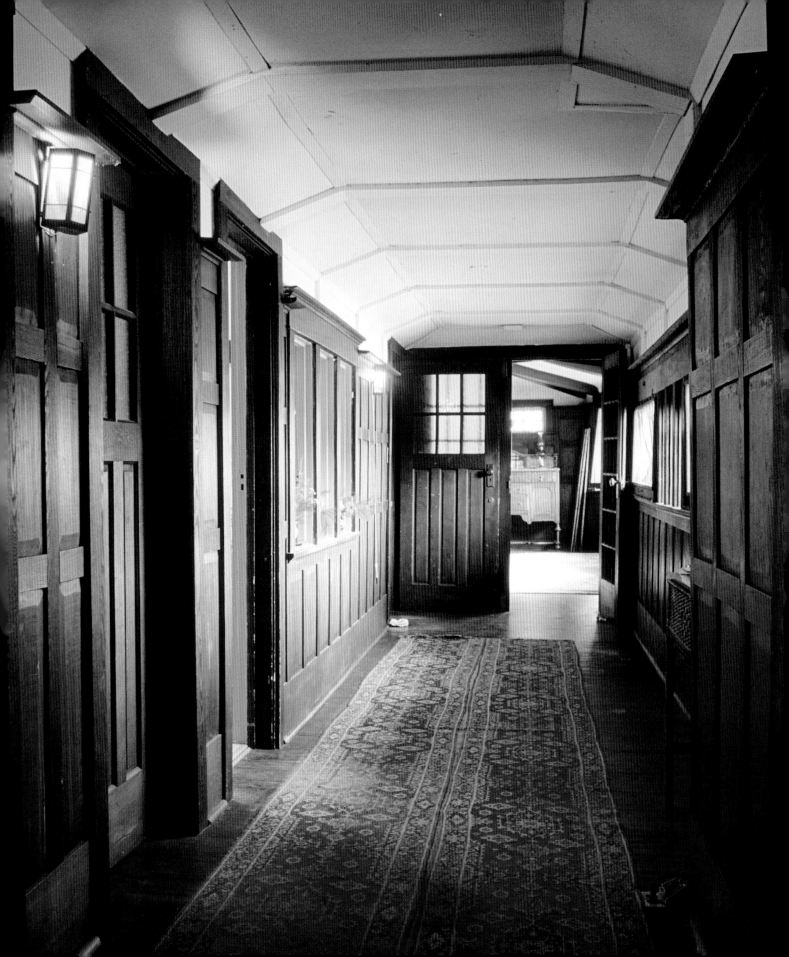

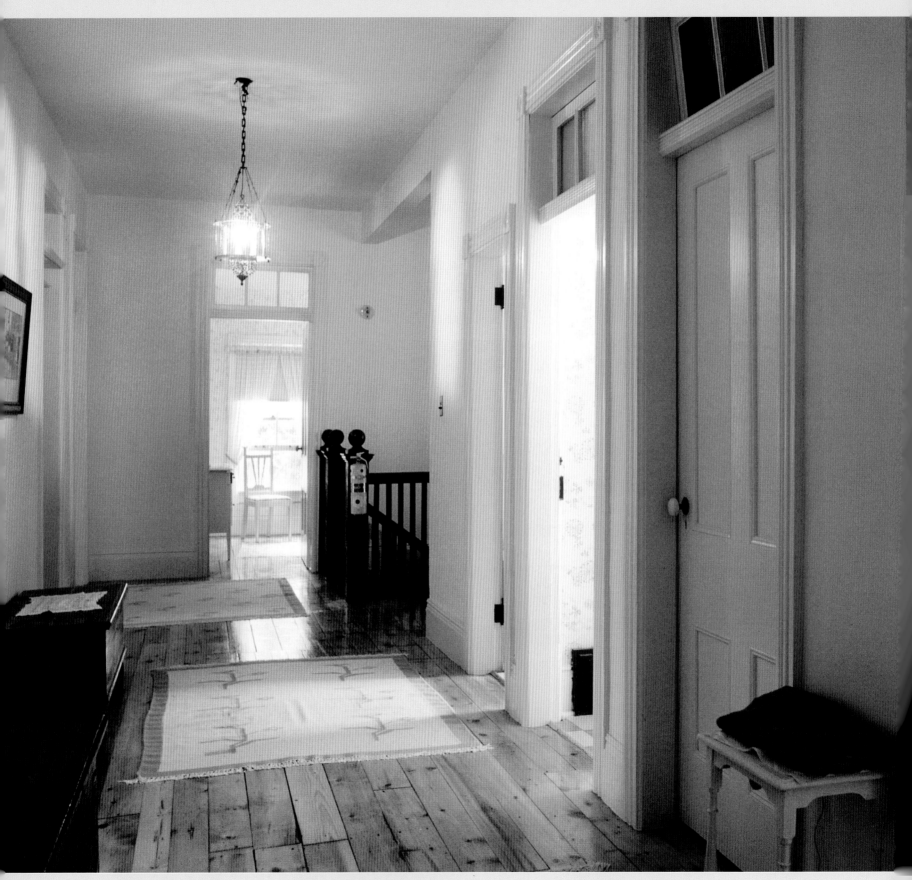

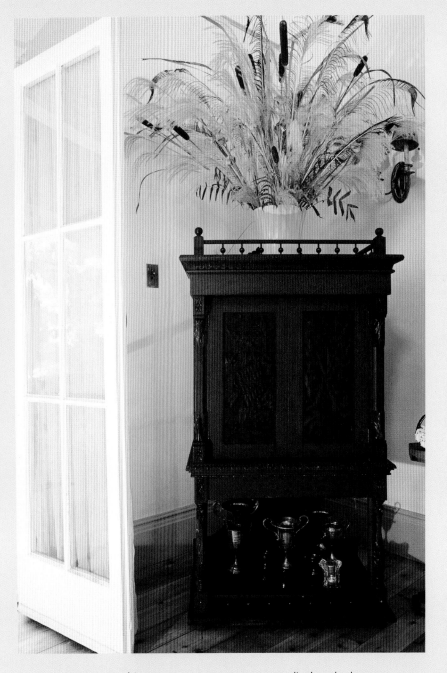

(above) Regatta trophies won over many years are displayed wherever space is available.

(left) Porcelain doorknobs indicate the age of this house, as do the transoms over the bedroom doors that allow air to flow in from the second-floor hallway. These hallways were often used as children's playrooms. The owners continue to maintain the integrity of the house — "preserving a bit of history," they say.

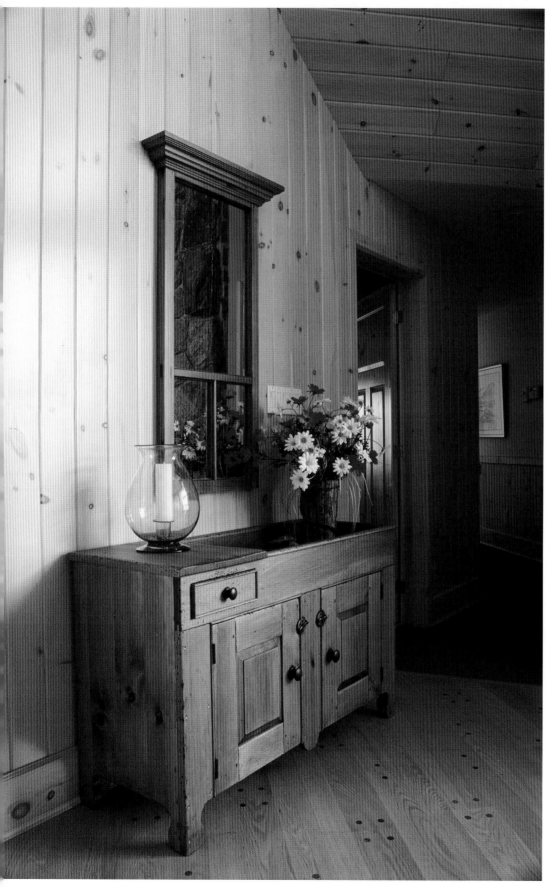

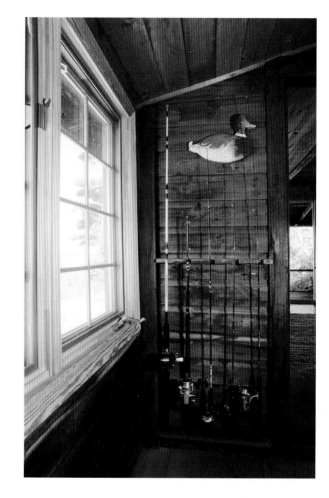

(above) Fishing is a favorite activity at this cottage where every member of the family keeps a rod handy in the hallway.

(left) A pine dry sink with an arrangement of daisies from the garden greets visitors to this lake house.

(opposite) An ornate etched and leaded glass window adds dramatic light to the stairway landing in this grand old lake house. Green lawns beyond suggest the formality of the gardens.

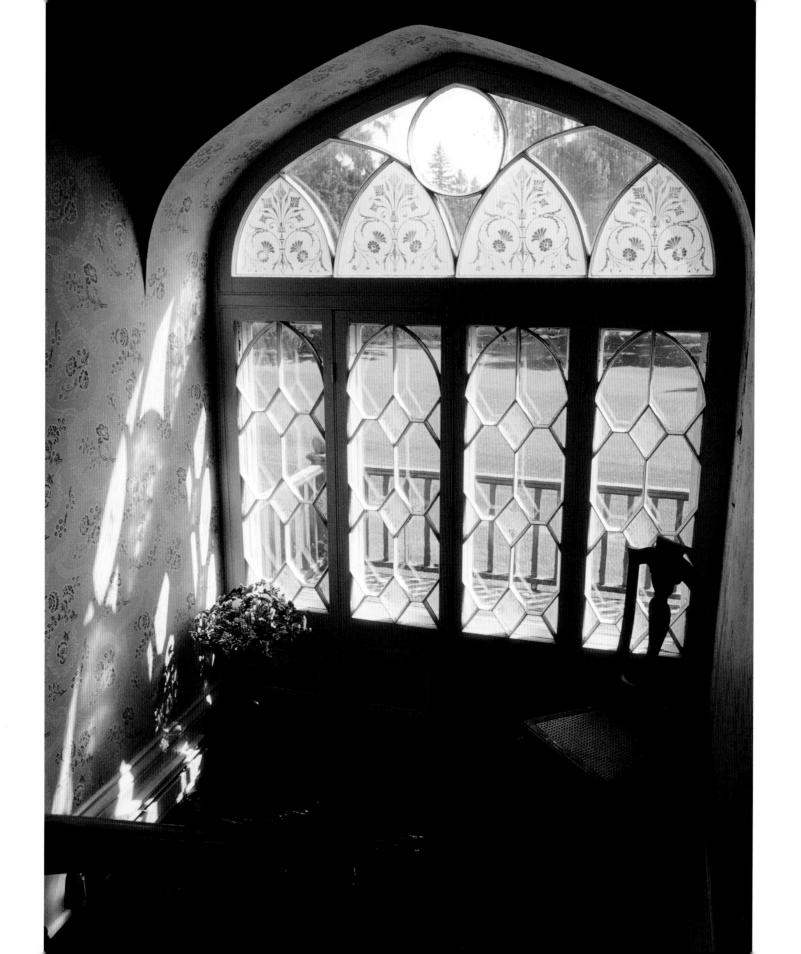

(left, above and below) Cottage collections run the gamut from framed family photos, to carved folk-art birds collected in the Caribbean, to handmade toy sailboats. The sailboats shown here are raced every summer in an annual 10-inch sailboat regatta. "Everyone gets in the water with their boats," says the family patriarch, "and there's always a lot of cheating."

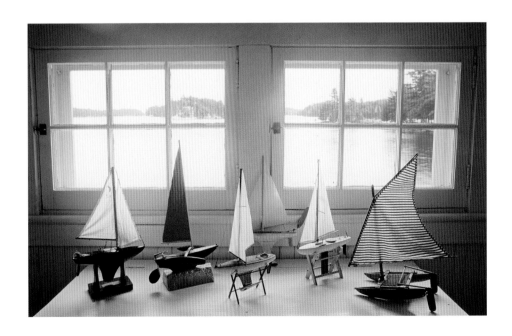

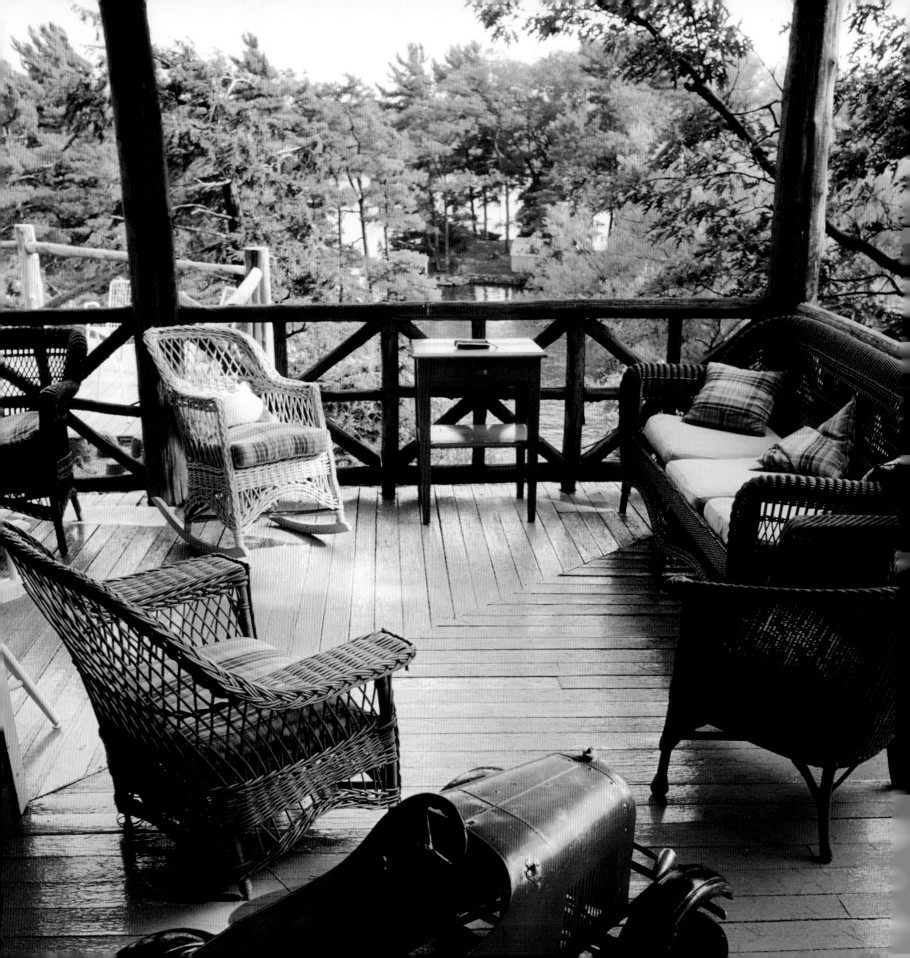

A Room with a View

Where"er you walk, cool gales shall fan the glade, Trees, where you sit, shall crowd into a shade;
Where"er you tread the blushing flow'ers shall rise, And all things flourish where you turn your eyes.

ALEXANDER POPE

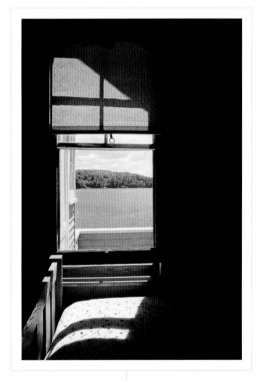

About the most valued of all lake house assets is a heart-stopping view. Settled in our quiet getaways, we treasure the wraparound vistas of rock, water and woods, finding solace in the fact that nothing has changed since our last visit. The two words most mentioned when owners talk about their views are *private* and *unchanging*.

Architects, when siting a building on a lake property, spend time walking the land to observe the path of the sun and feel the prevailing winds. They plan for unspoiled views and, when possible, angle the house just so, for privacy. "Privacy is the new luxury," comments one architect known for his environmentally sensitive designs.

Lake houses built over a hundred years ago will almost certainly have small windows with no view. In those days you went outside to observe nature. Owners of these old places look for creative ways to increase the natural light and open up the views. At one island house with a big covered veranda, they added a bank of new windows above the existing vintage ones — the indoor light was instantly improved.

Contemporary buildings, designed to meld into the landscape, use glass walls in place of wood to provide a seamless indoor-outdoor space. And wherever water exists, the orientation is toward the sea, bay or lake. Water and its many moods becomes the main attraction.

We position telescopes at lookout points and scan the horizon for birdlife, cloud formations and passing boats. One owner whose place is surrounded by shallow weedy water claims she bought it for the private view of great blue herons feeding on the shore. And up at a remote lake in northern Ontario, a boathouse tucked in a lonely cove is so private that there's nothing but untouched shoreline as far as the eye can see.

The more things change, the more we treasure the things that remain the same.

(opposite) Old family furniture with mismatched fabrics adds cottagey appeal to this open porch.

185

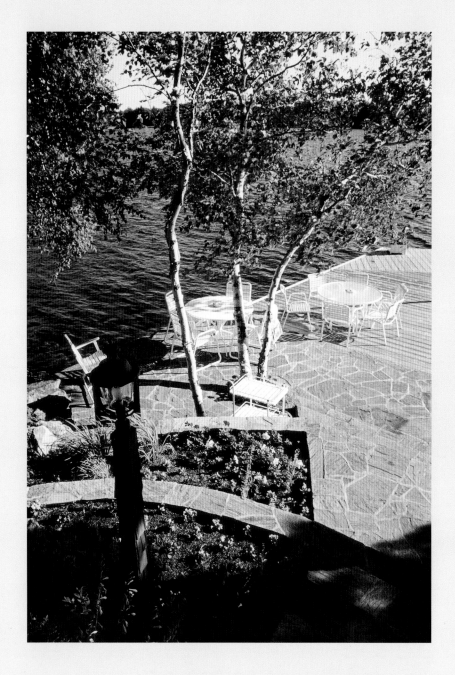

(above) Flagstone planters are stepped down the hillside and filled every summer with bright pink annuals. Seating areas next to the water are favorite places to gather for cocktails as the sun goes down.

(right) Dogs on patrol keep a close watch for passing boats.

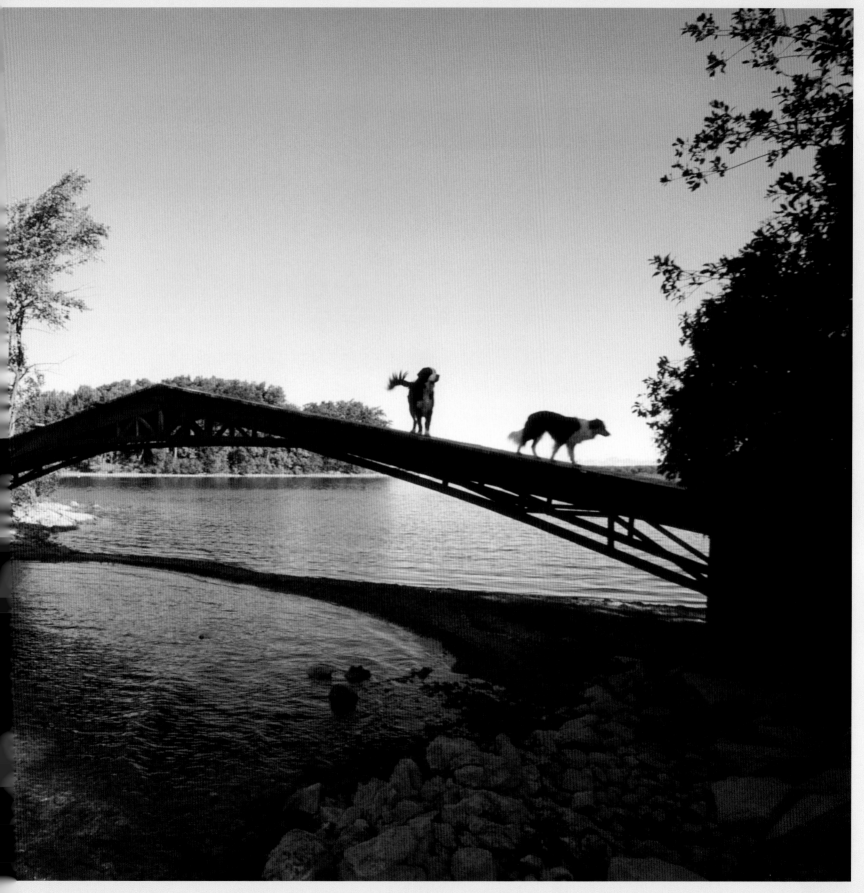

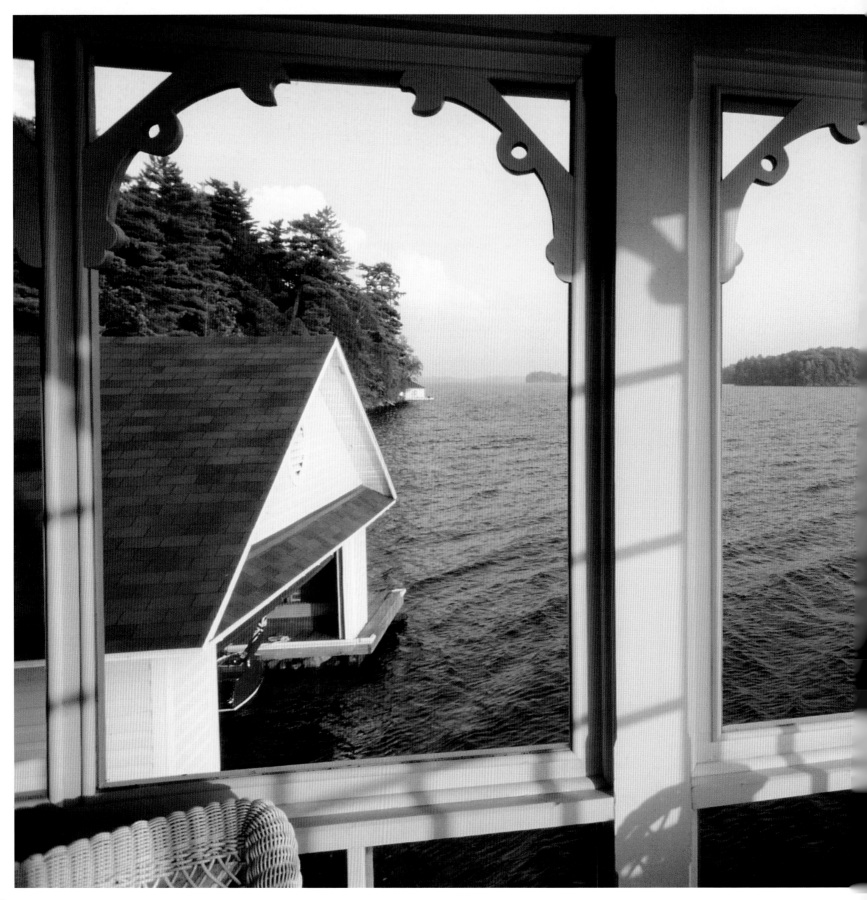

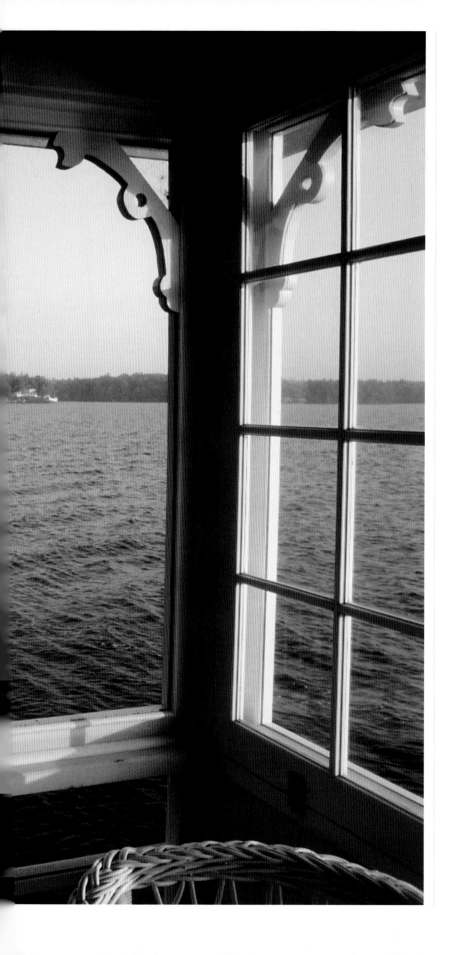

Shall I compare thee
to a summer's day?

WILLIAM SHAKESPEARE

(left) A long lake view from the screen porch —
as close as you can get to the water without being on a boat.

(following pages) A classic view of rock, pine and water
from an island lake house.

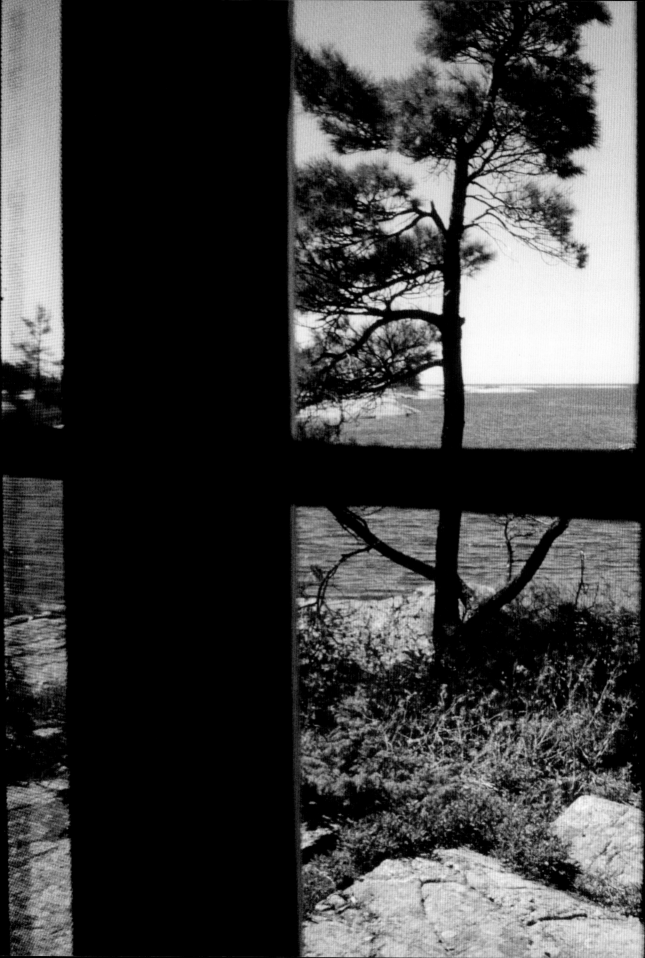

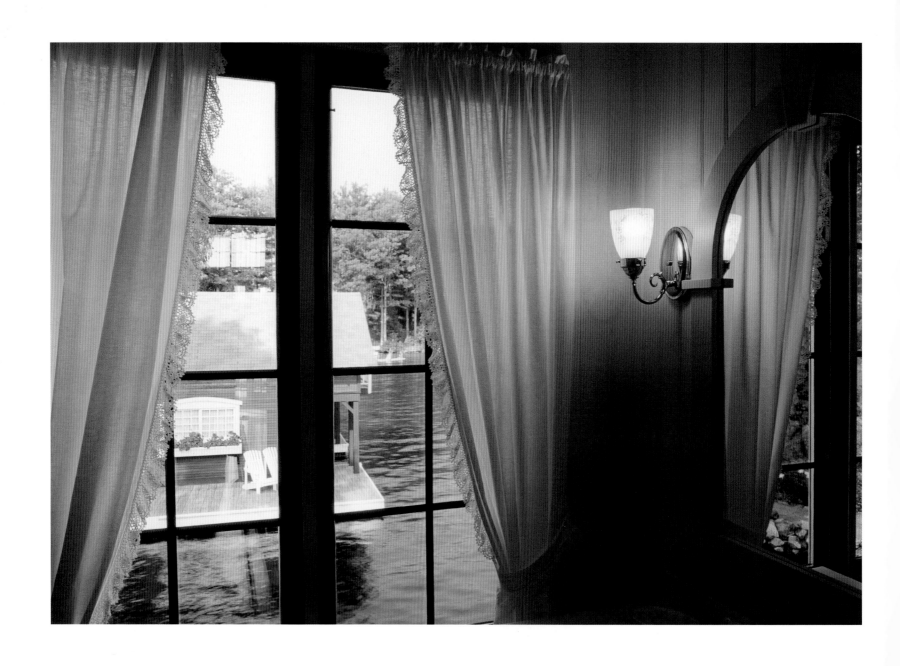

(above) The boathouse viewed from a bedroom window.

(opposite) A table for two — just right for watching the sunset.

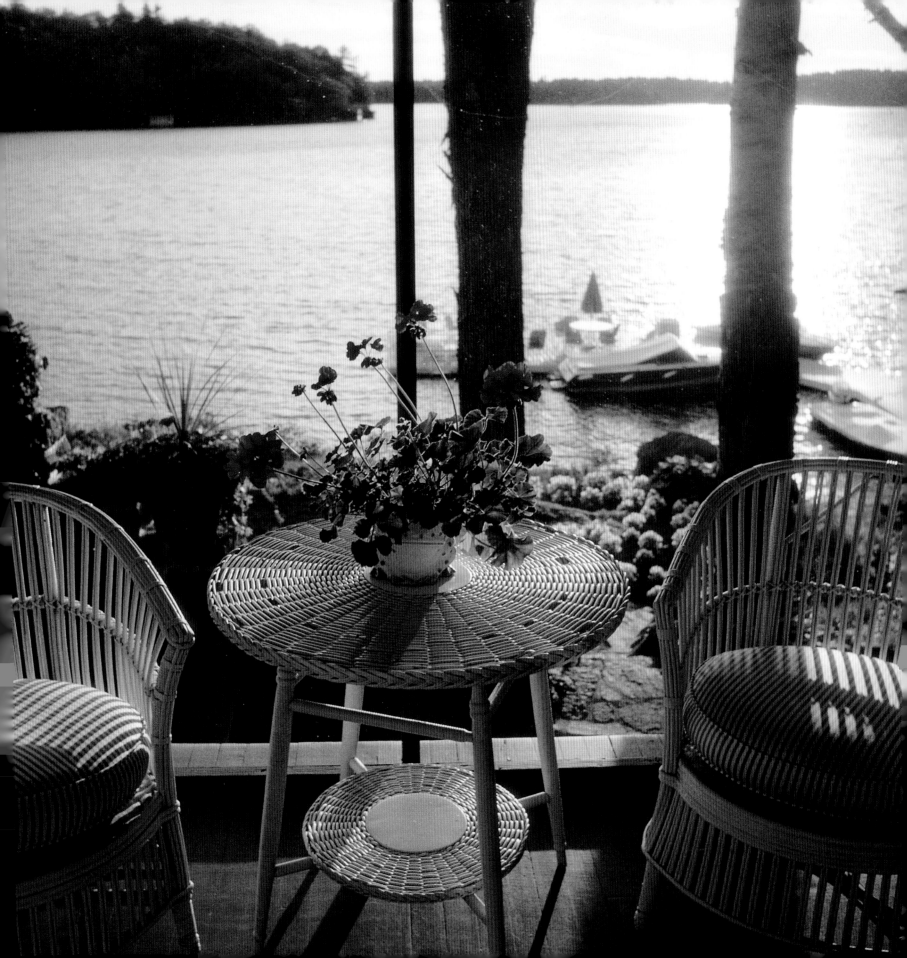

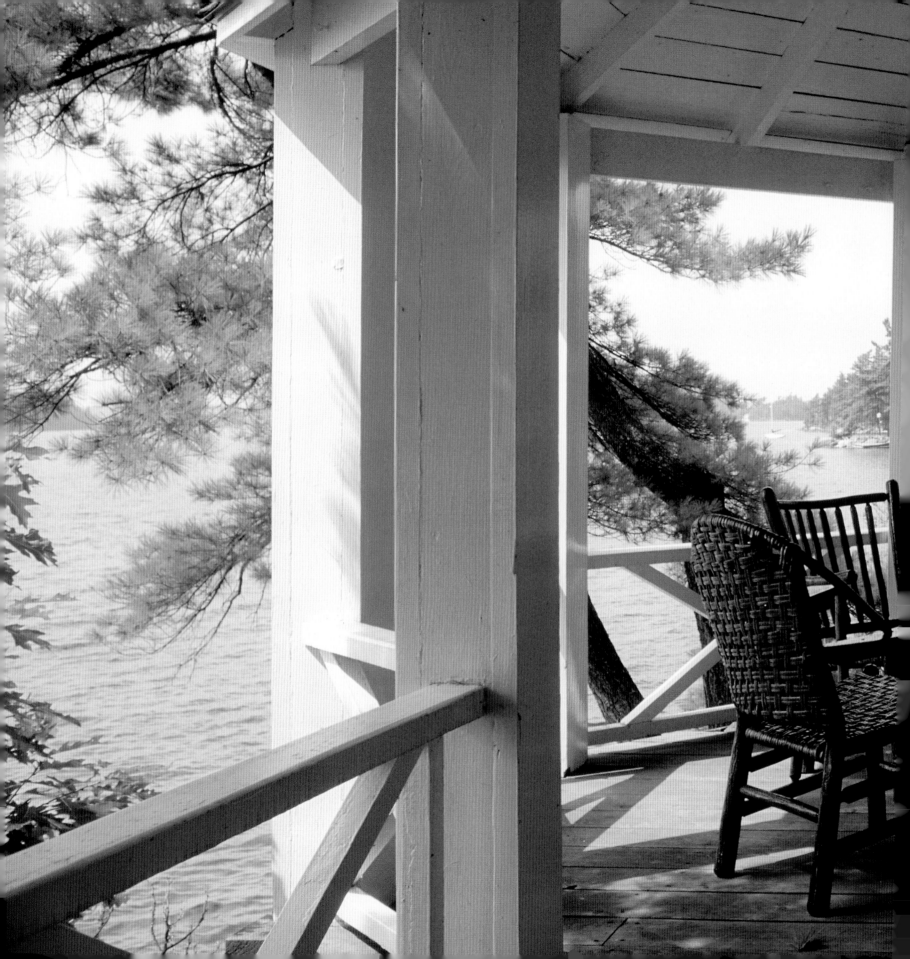

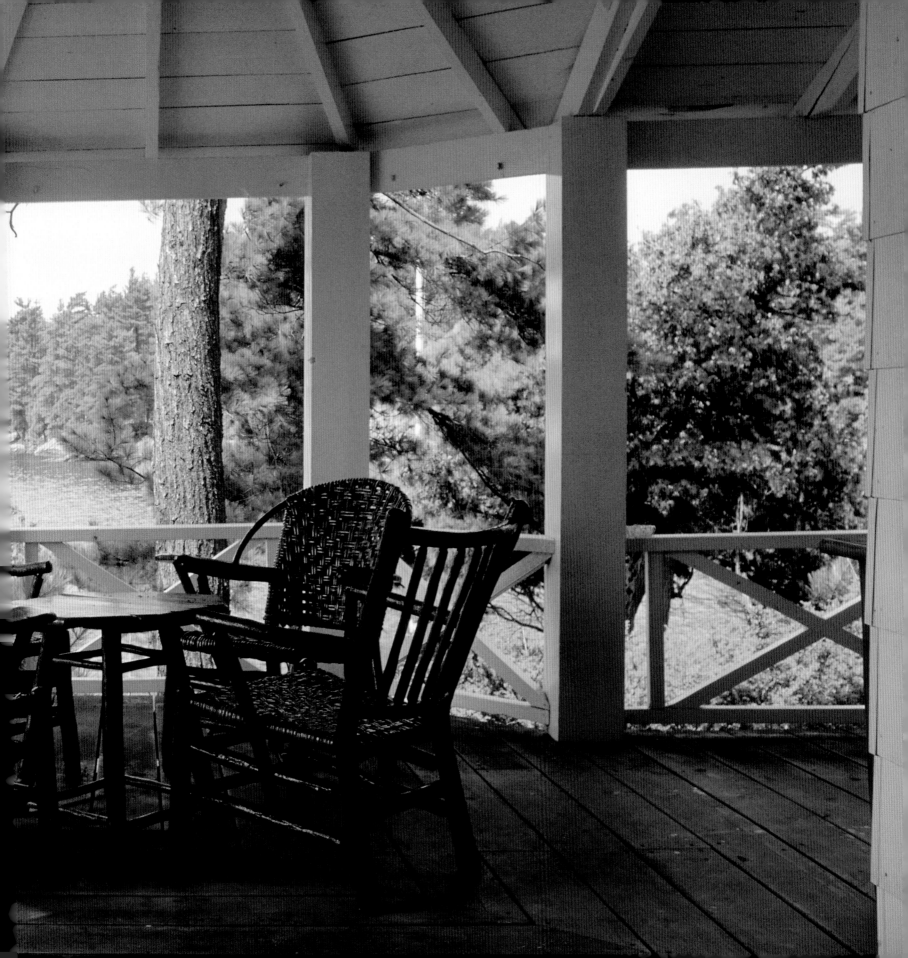

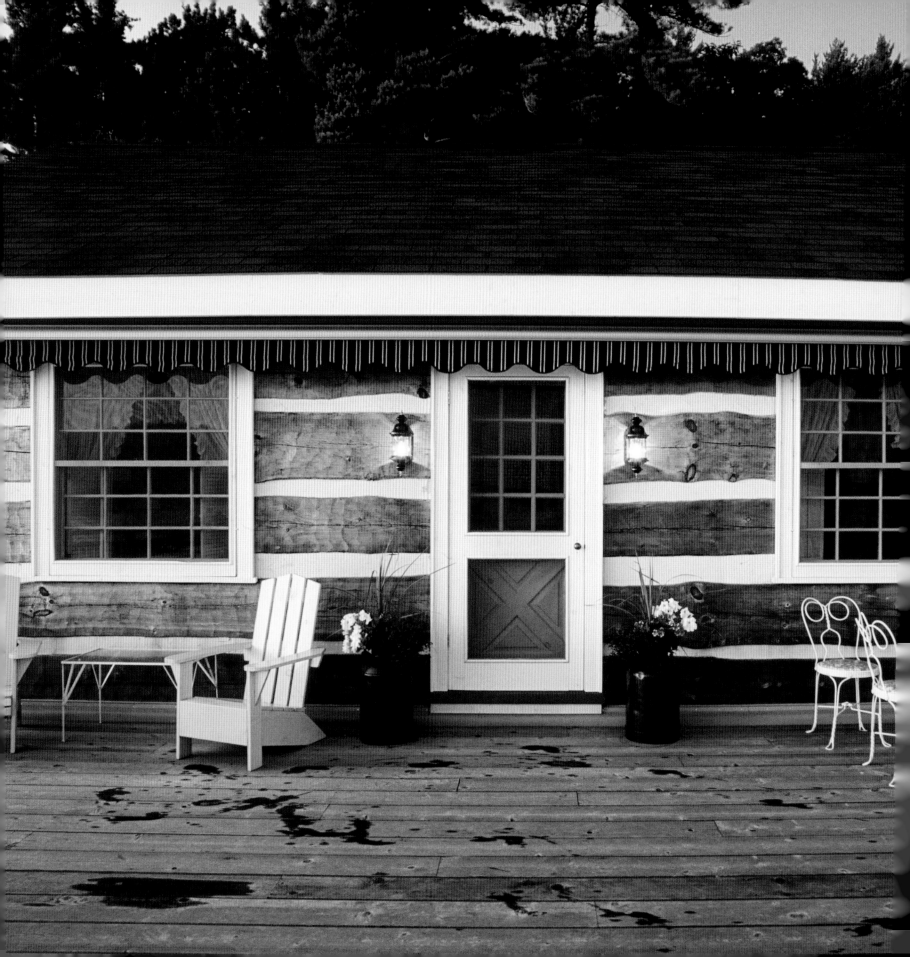

Guest Cabins & Bunkies

In the early years, getting to the lake house, located where there was no road access, was a bittersweet experience. It commonly involved lengthy treks on trains and steamships, and tedious layovers on railway sidings. Cottage journals from those days are rife with laments about the unreliable steamboat companies. Consequently, once they reached the house, families (accompanied by innumerable steamer trunks) usually settled for the entire summer. Mom and the children, along with aunts, grandmothers, nieces and nephews, enjoyed long summer holidays while the men stayed home in the city to work.

Later, with the advent of the automobile, highways and back roads were carved into the lake districts, and cottagers began arriving by car. Even though the trip was still long and arduous, it could be done on a weekend. Men were able to join their families for a few days, and a new category of cottager was born — the weekend guest.

At many lake houses, the cabin that was offered to these weekend guests had humble origins. It had been the icehouse, laundry room or, in some grand estates, the workroom for the boat chauffeur. Outbuildings like these were common at lake compounds in days before building restrictions were

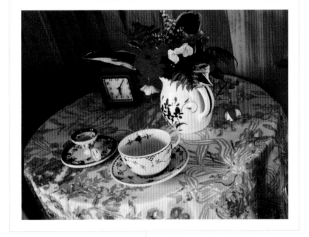

imposed. Whenever a need arose, a new structure was added. They built outhouses, workrooms, toolsheds, pump houses, doghouses, gazebos — and small chapels where Sunday services were held.

When extra bed space was required, the easiest solution was to convert an outbuilding or put up something new — basically four walls, a window and just enough room for a couple of beds. These little buildings were often called bunkies. The term, an abbreviation of bunkhouse, originally meant a workman's house, but in lake house vernacular, it's often the sleeping cabin.

When bunkies go upscale, as they often do today, they become comfortable guest cottages, complete with a bathroom and a kitchenette with coffee-making facilities for early risers. For weekend guests the offer of private quarters is the ultimate luxury.

But many old-time cottagers remember bunkies as hangouts for the children. "One of my fondest childhood memories was moving into the bunkie with my brother for the summer," recalls an elderly cottager. "I can remember the feeling of freedom, of having our very own four walls, far removed — at least 30 feet! — from the eyes and ears of our parents."

(opposite) Guests at this summerhouse stay in the log cabin at the lake. Antique carriage lights and painted milk cans full of geraniums greet them. On sunny days an awning can be extended to create shade on the open deck.

And all the loveliest things there be,

Come simply, so, it seems to me.

EDNA ST. VINCENT MILLAY

The tiny guest bedroom and canoe house are combined at the water's edge. A door in the bedroom wall opens so that canoes and rowboats can be pulled inside for winter storage. "In small places it's important to have rooms that are multifunctional," explains the owner of this quaint property.

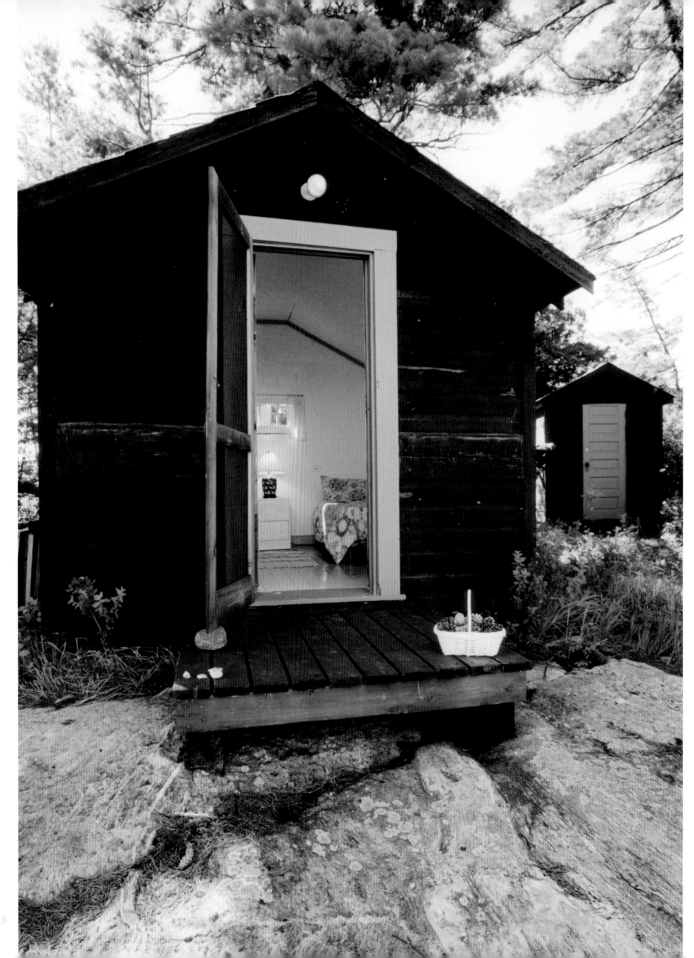

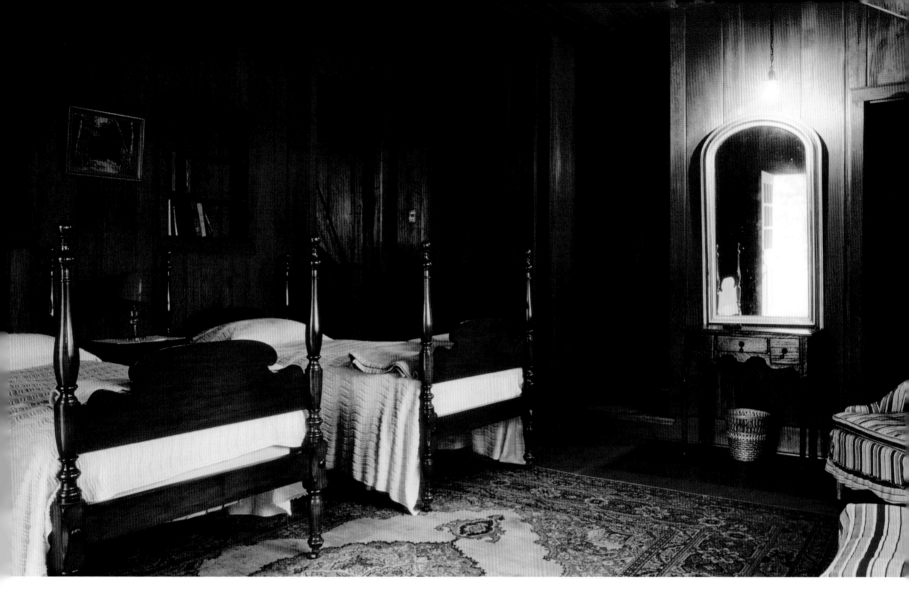

(above) A guest cabin with mahogany four-poster beds and an antique carpet suggests a more formal summer lifestyle.

(opposite) This was originally the island's icehouse, where blocks of sawdust-coated ice kept food cool in the days before electricity and refrigeration. Today, it has been converted to a basic but comfortable guest cabin.

(right) The simple yet welcoming interior of the former icehouse seen opposite.

(following pages) Guests at this island cabin enjoy privacy and an uninterrupted view of rock and water.

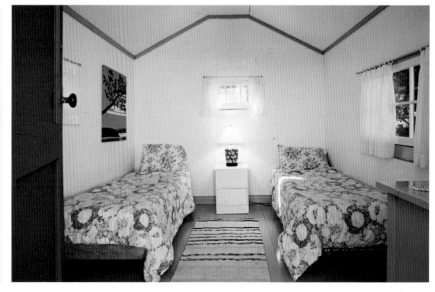

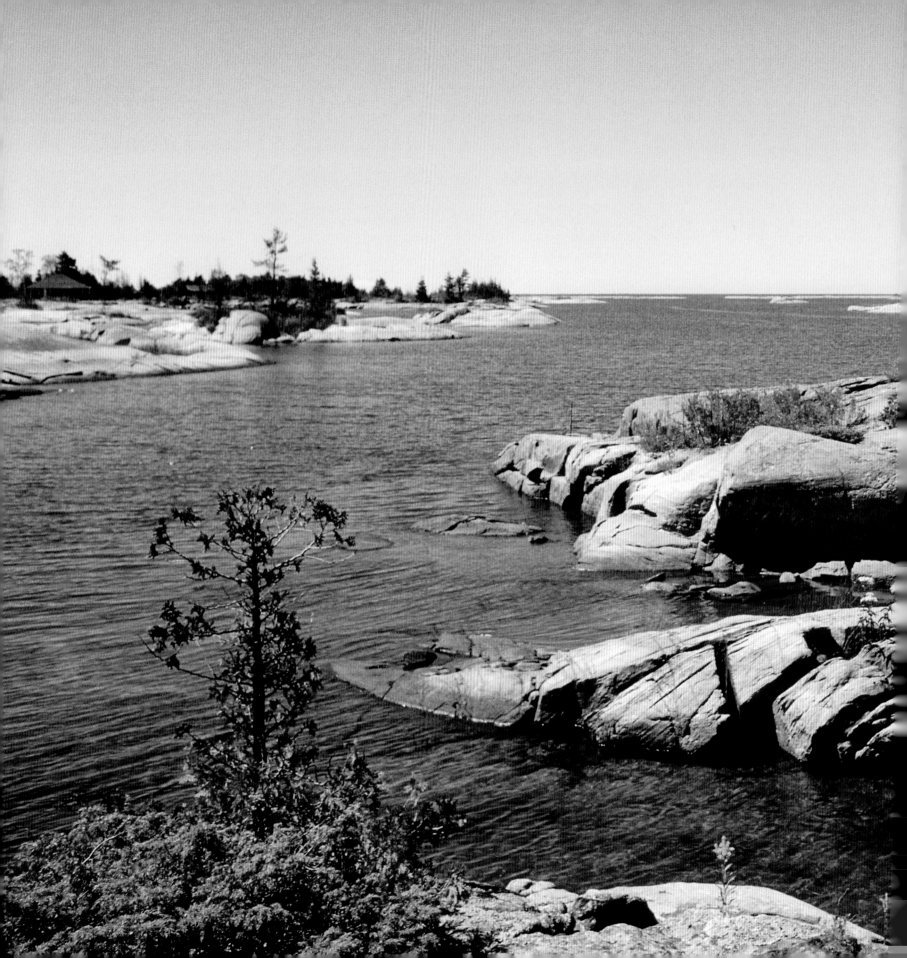

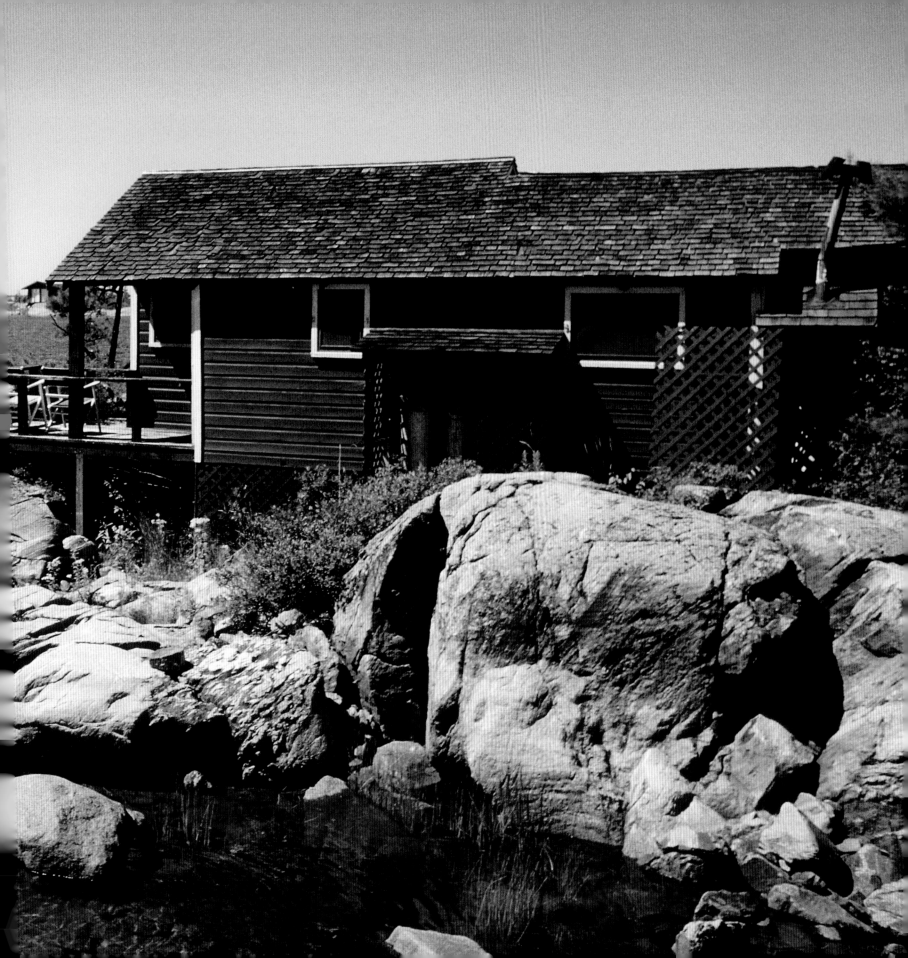

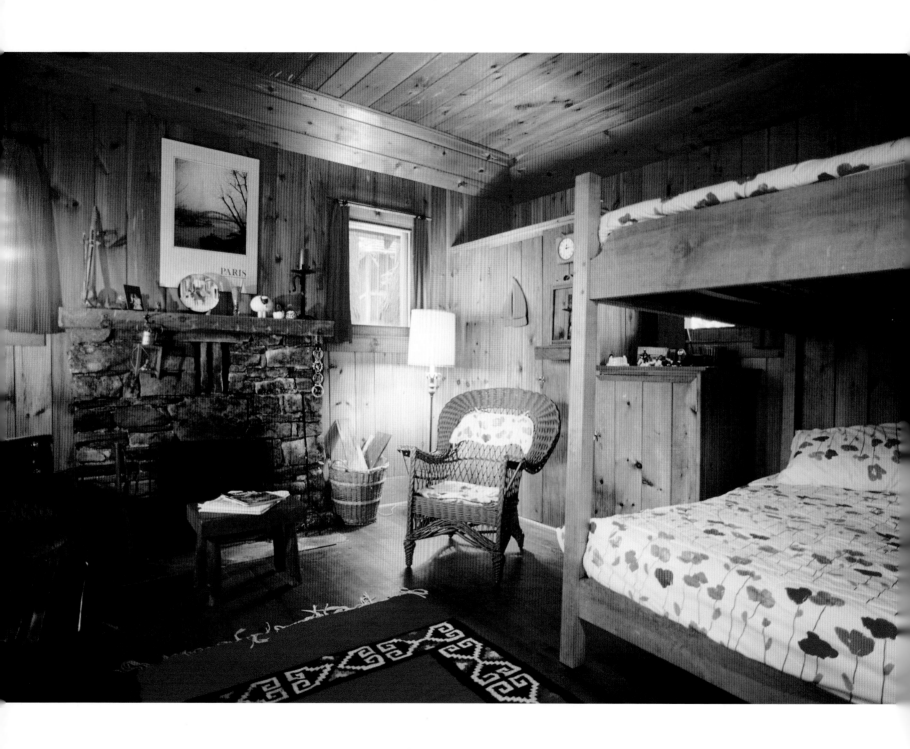

The guest sleeping cabin is literally "a cabin in the woods" at this summer estate.
It has a wood-burning fireplace for warmth when the nights turn cool.

It may be tiny, but there's room inside for a queen-size bed and three-piece bathroom. The view from the wooden porch takes in an expanse of lawn, sometimes used as a croquet pitch.

The Lake House Garden

To own a bit of ground, to scratch it with a hoe, to plant seeds and watch the renewal of life —
this is the uncommonest delight of the race, the most satisfactory thing a man can do.

CHARLES DUDLEY WARNER, FROM *My Summer in a Garden* (1870)

Lake house gardening can be a challenge for many reasons. At lakes that have been carved out of granite, the soil is typically thin and rarely conducive to healthy growth. The season is short everywhere. And then there are winds that gust off the lake and sea — summer gales that batter our fragile plants and dry them out faster than does the full sun.

But gardeners persist. In early spring we cart in trunkloads of annuals to brighten planters positioned on sunny decks and docks. We foolishly increase the perennial borders to include some irresistible new varieties. And we haul in colorful hanging baskets because they're just so beautiful.

For island dwellers this annual flurry of planting means lugging bags of soil and peat moss, flats of flowers and clay containers from car to boat to dock to garden. And for weekend cottagers, the first task on a Friday night is to rush into the garden, check for weeds and hope that the animals haven't invaded the vegetables.

At lake houses where the garden is a focus of activity from spring until fall, there is always something to do. Herbs are cultivated and picked fresh for summer meals. Cutting gardens are kept weed free to provide generous bouquets throughout the season. And if wildlife doesn't get there first, there will be fresh vegetables to enjoy by midsummer.

Automatic sprinkler systems have helped to eliminate the dread of arriving at the lake house to find everything dried out, especially at places with vast manicured lawns. But still, there are late frosts that nip growth in the bud and windstorms that flatten the delphiniums.

It's not at all easy having a successful lake house garden. But we persevere because on a soft July night, when the border plants blaze beneath the lamplight and the sweet perfume of white nicotiana fills the air, it all seems worthwhile.

(opposite) A mass of colorful tuberous begonias. These are just a few of the ten thousand annuals
planted every spring at this 7-acre island. Cedar-post lamps illuminate the pathways at night.

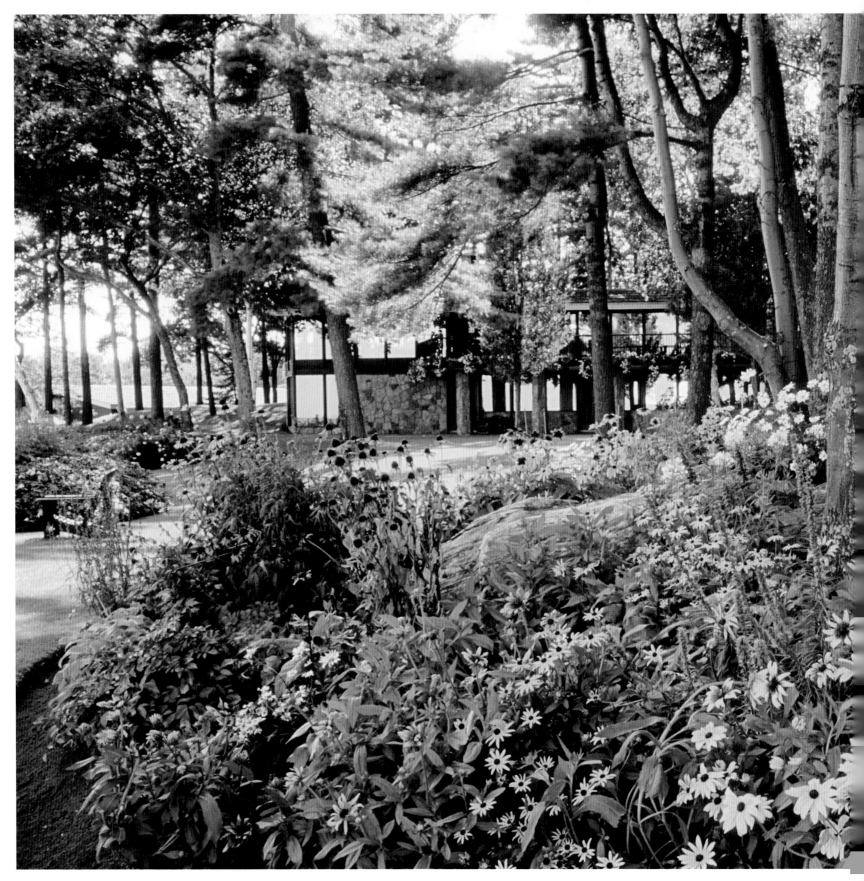

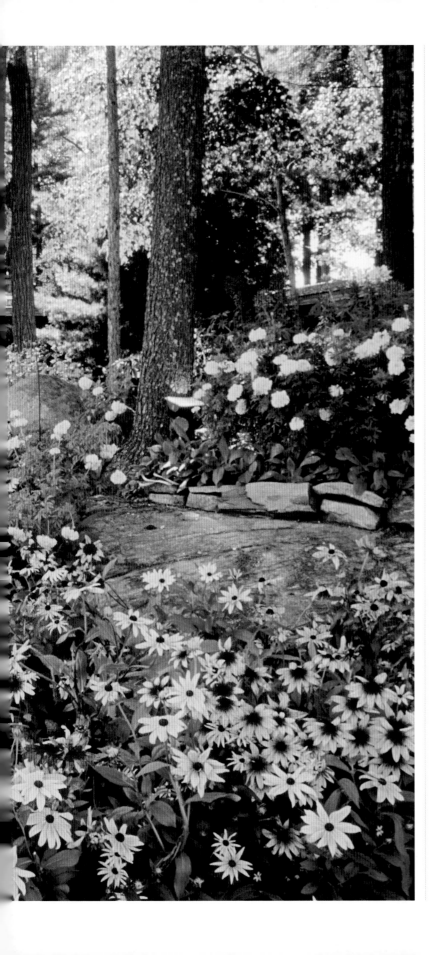

Be like the flower,

turn your faces to the sun.

Kahlil Gibran

The gardens at this lake house are so spectacular that boaters make special trips down the lake and then circle the shoreline for a close-up view of the colorful blooms.

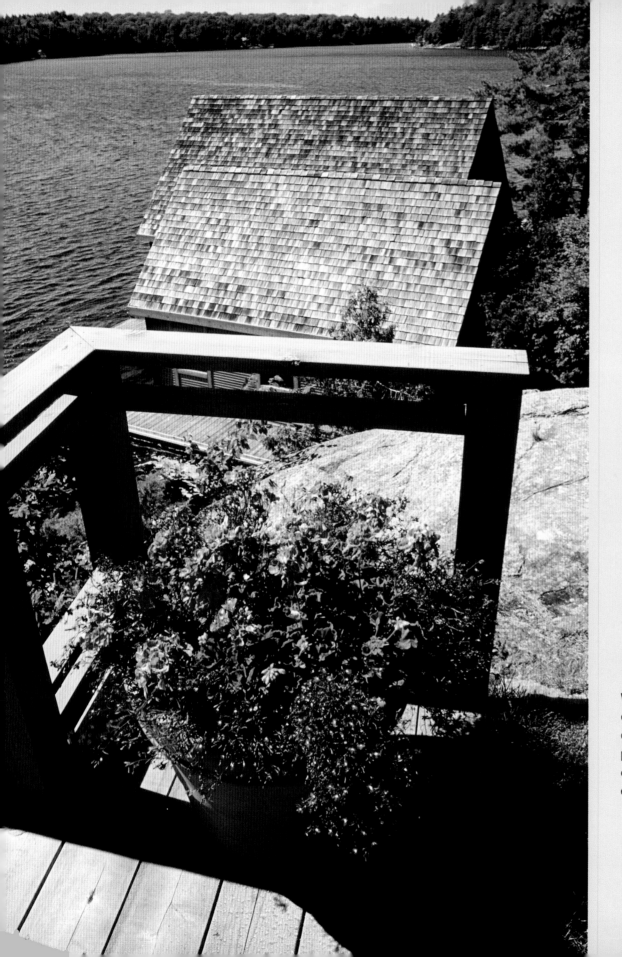

When granite is the dominant feature of the landscape, gardeners face a challenge. Some resort to planting pots full of annuals on decks and docks instead of struggling with perennial gardens.

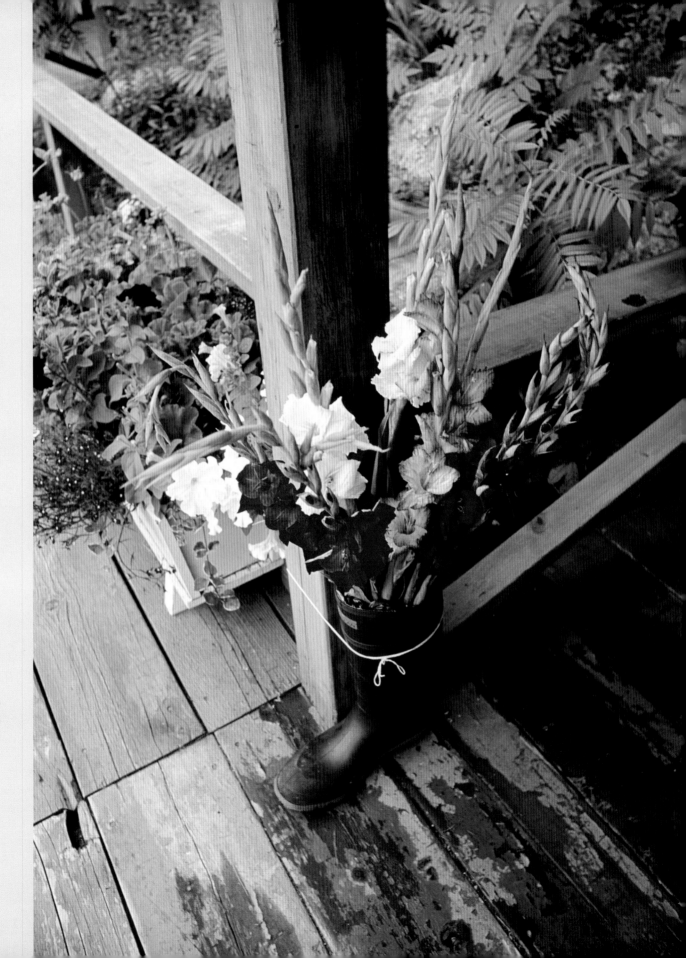

Almost anything that is waterproof can serve as a vase for fresh flowers.

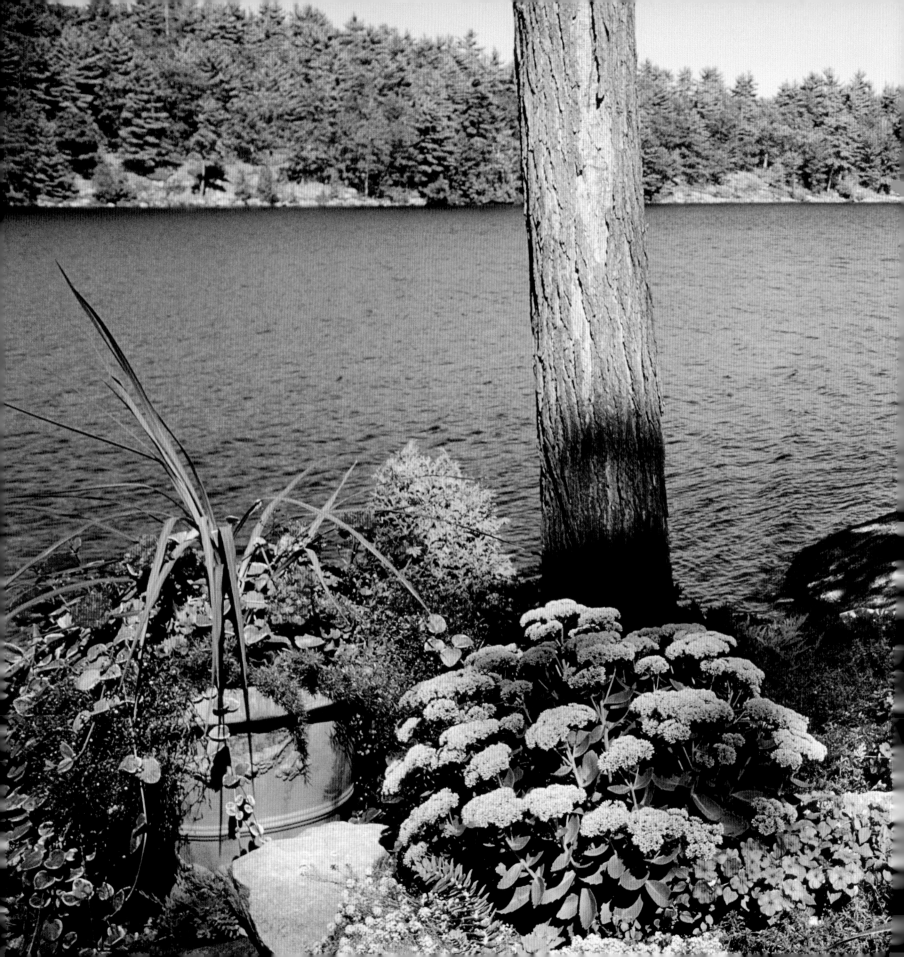

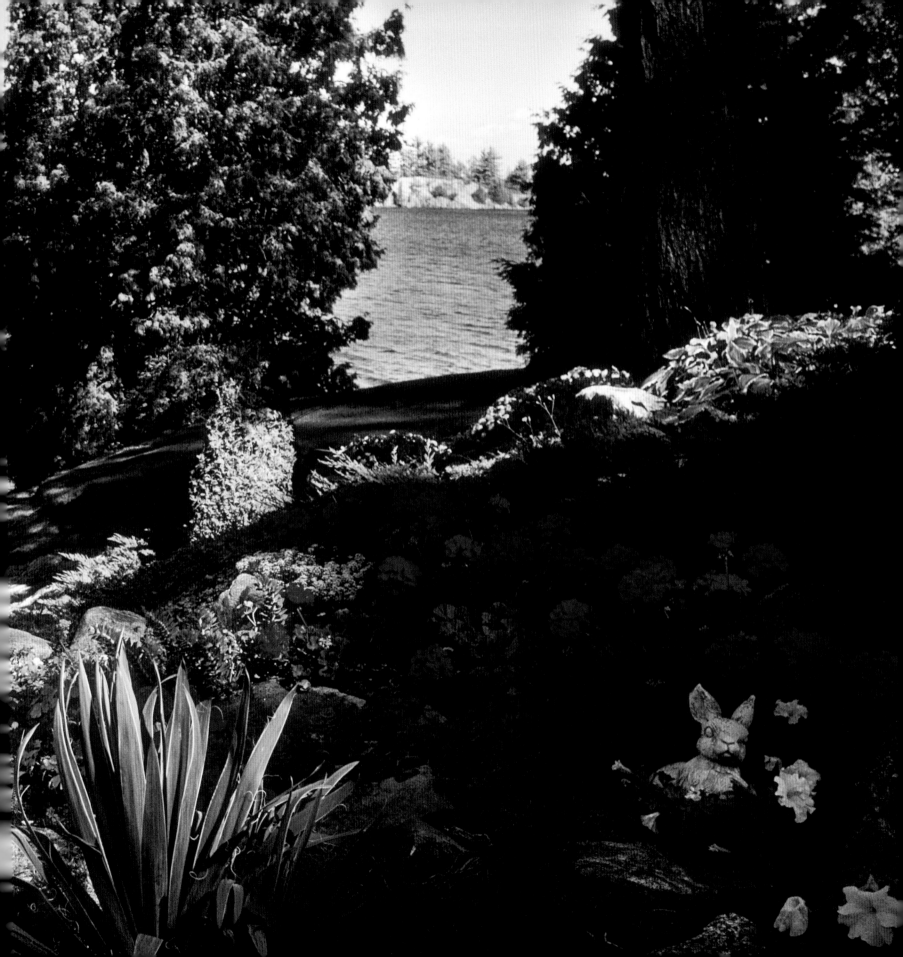

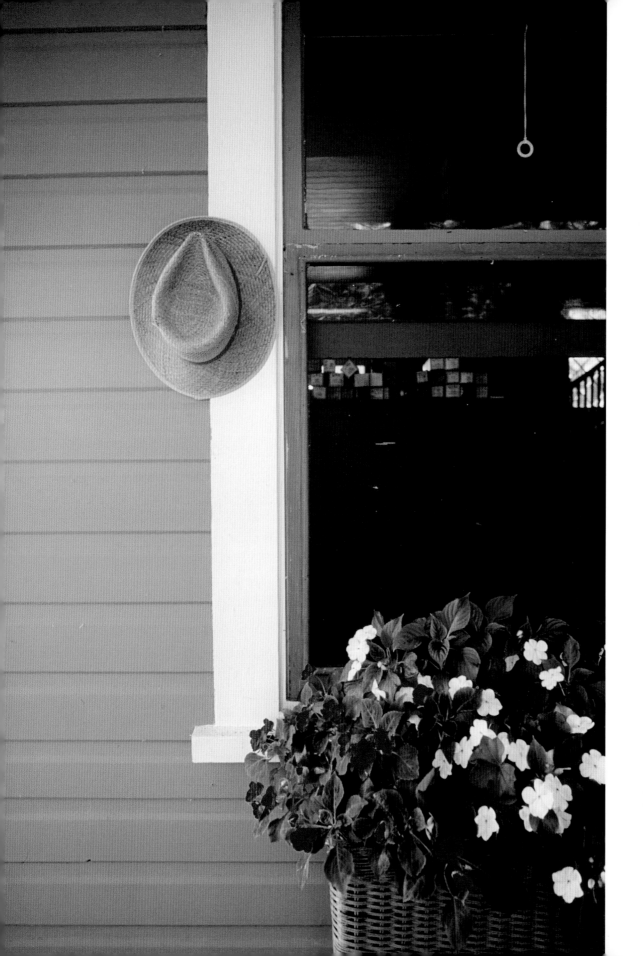

(left) The icons of summer — a beaten-up straw hat and a basket of impatiens.

(opposite) On properties where strong winds come roaring off the lake, gardeners must find protected nooks for grasses and planters to thrive.

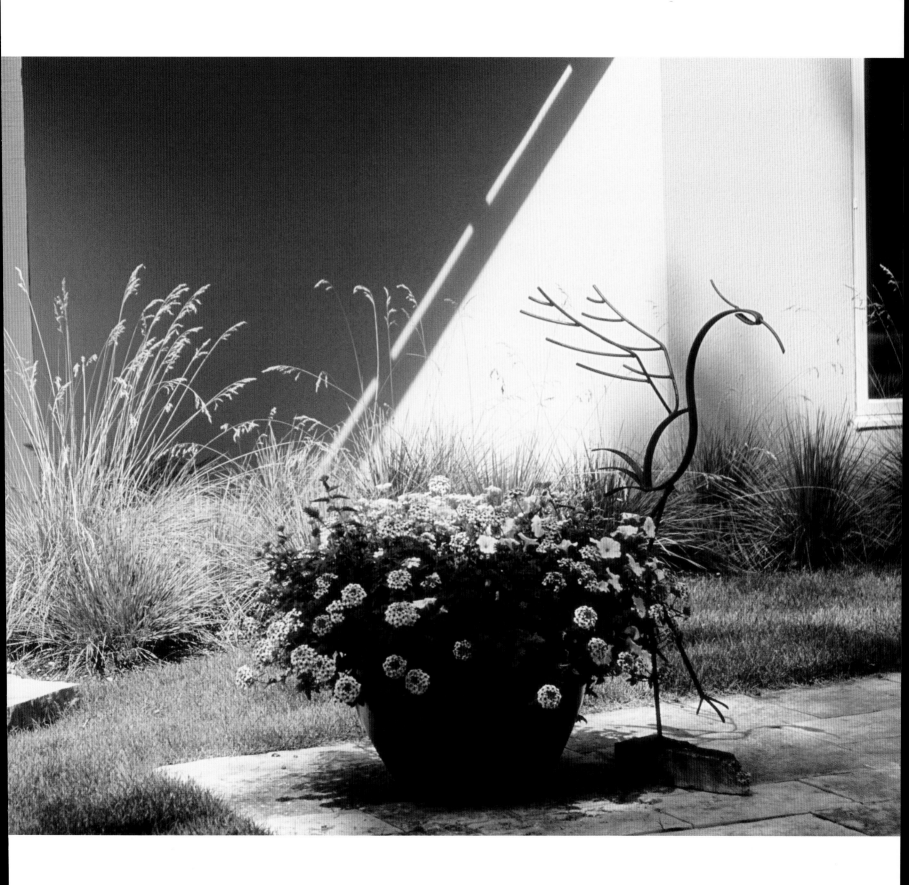

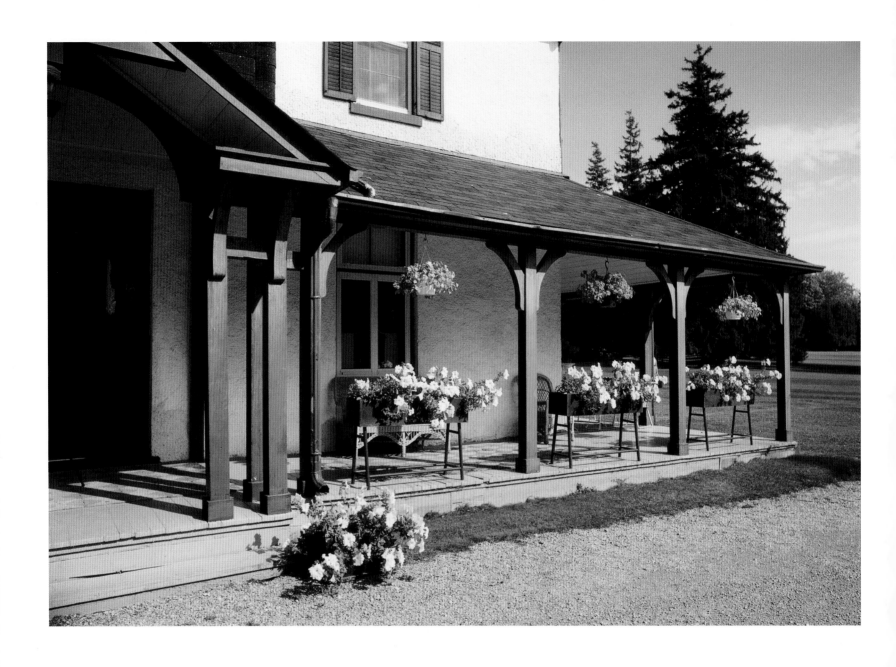

(above) A gracious lake house built in 1860 has gardens originally laid out by Frederick Law Olmsted, the landscape architect who designed, among other spaces, New York City's Central Park. The porch planters have always featured white petunias. "We're so bound by tradition," says the owner, "that I don't dare even change the color of the petunias."

(opposite) A view of meandering rock paths and well-established landscaping suggests a hardworking gardener.

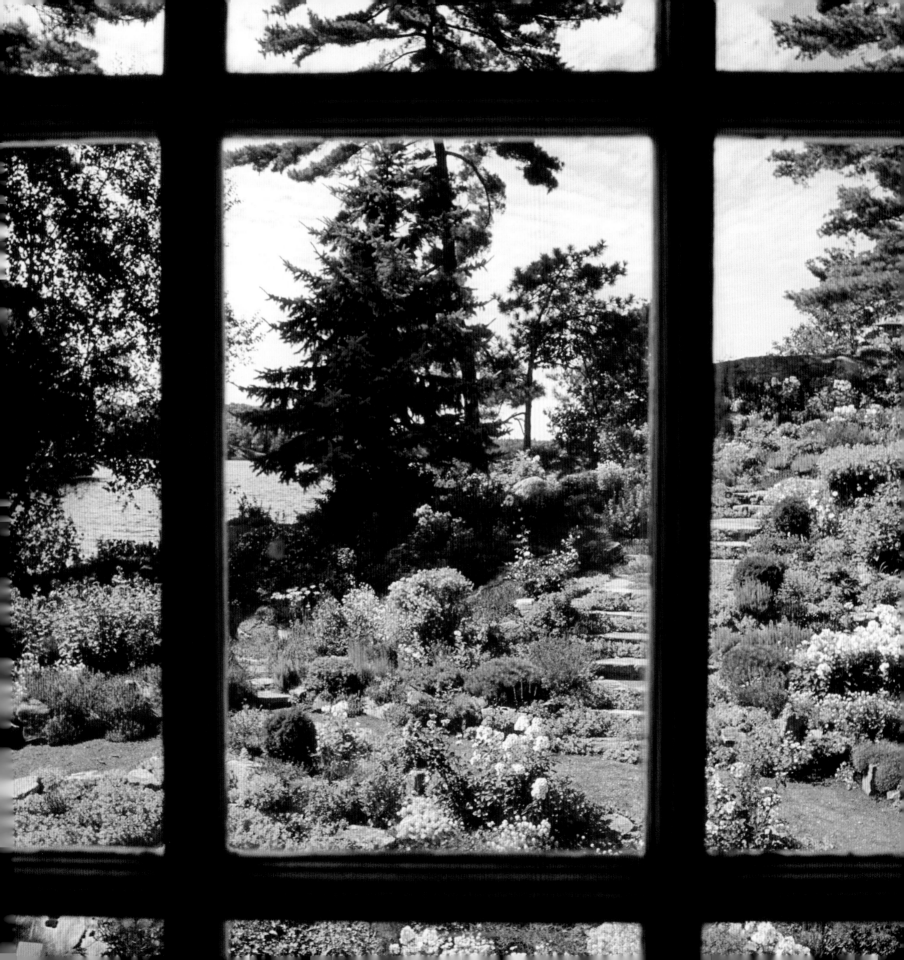

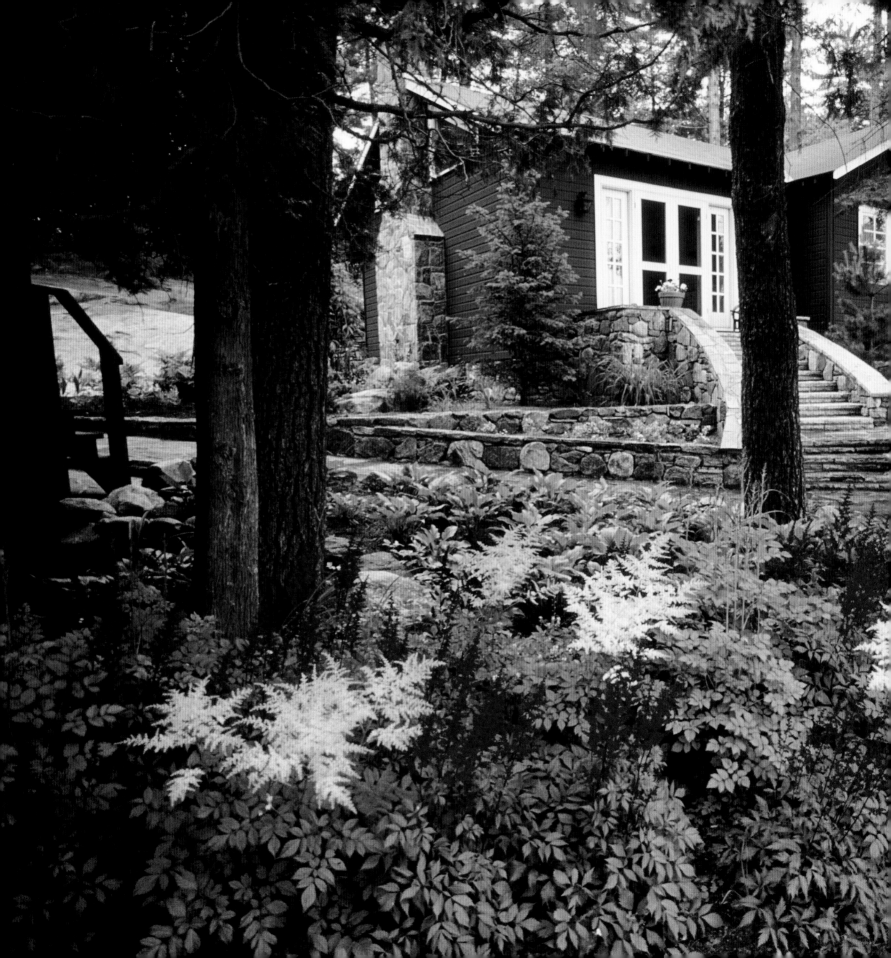

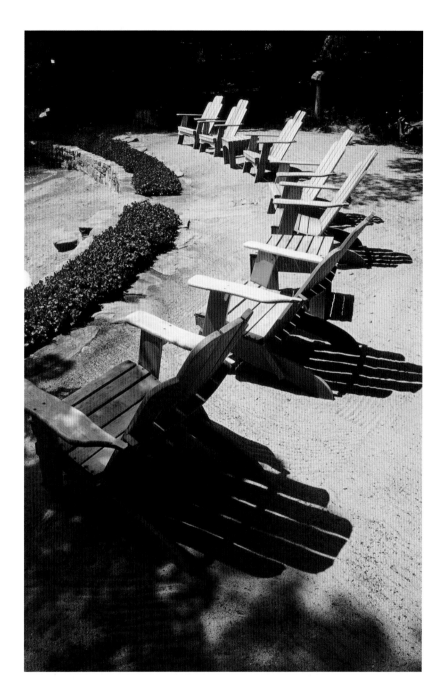

(above) Chairs lined up neatly on a well-raked beach.
A border of begonias separates the sand from the water.

(left) This cottage garden filled with spirea, bee balm, phlox and Shasta
daisies has been labored over by several generations of the same family.

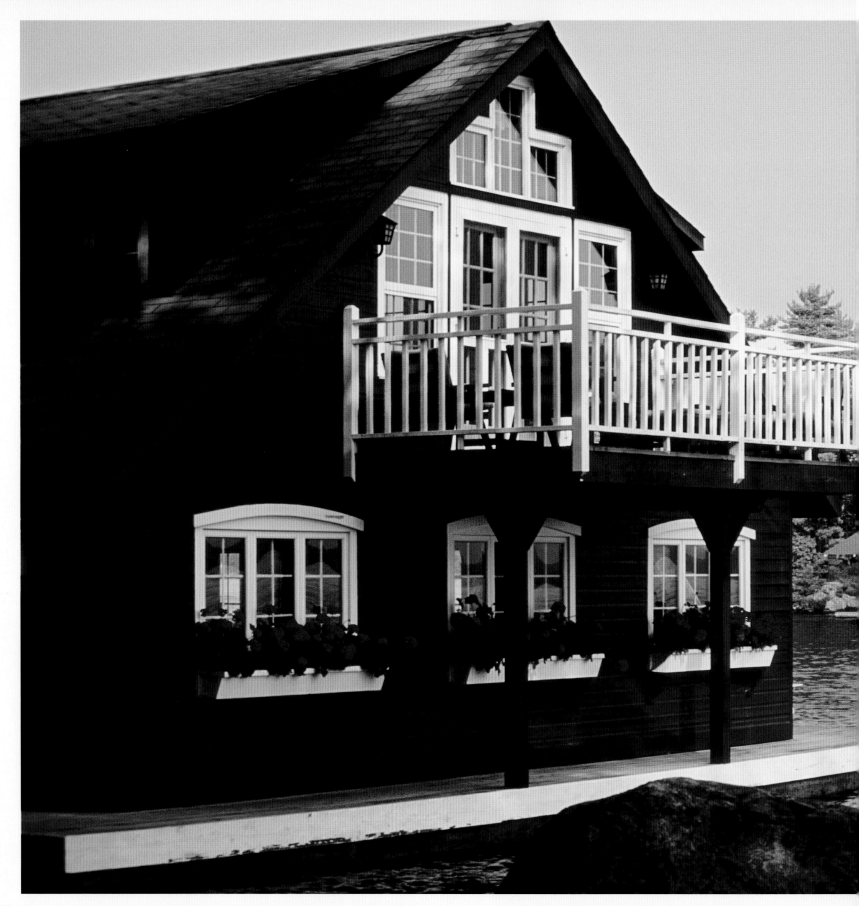

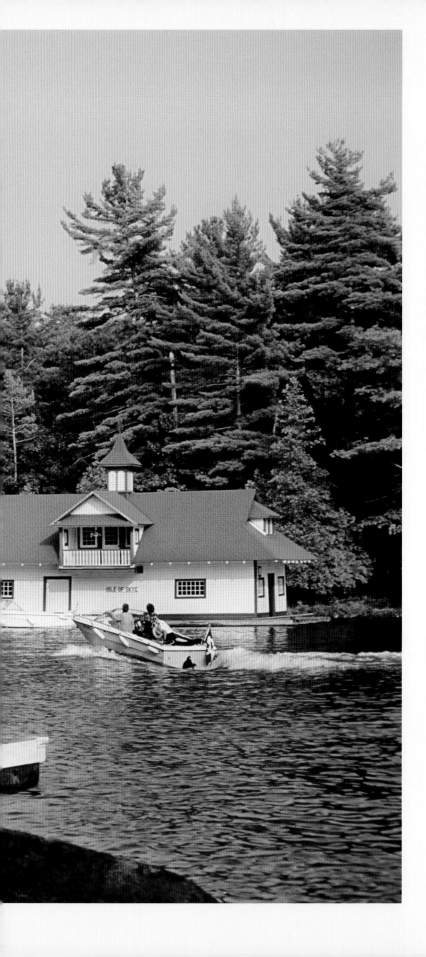

15

Summer's End

Summer's lease hath all too short a date.

WILLIAM SHAKESPEARE

And so, as the days shorten and cool hints of autumn fill the air, we begin our good-byes to the lake house. As always, the season has flown by, faster than passing clouds on a windy August day.

We leave with lingering regrets — for the many projects left undone, the visits with neighbors that didn't happen, the books that never got read. As we pack up our lakeside retreats to return to the busyness of other lives, we hang onto the good memories. For it is these memories that warm our hearts all winter long and keep us coming back, year after year, to the place we hold most dear.

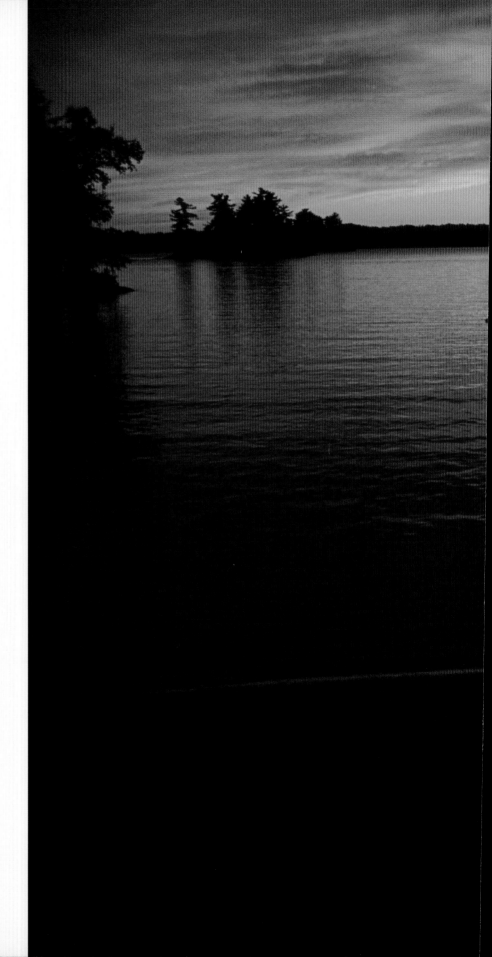

"Live in each

season as it passes;

breathe the air,

drink the drink,

taste the fruit,

and resign yourself

to the influences

of each."

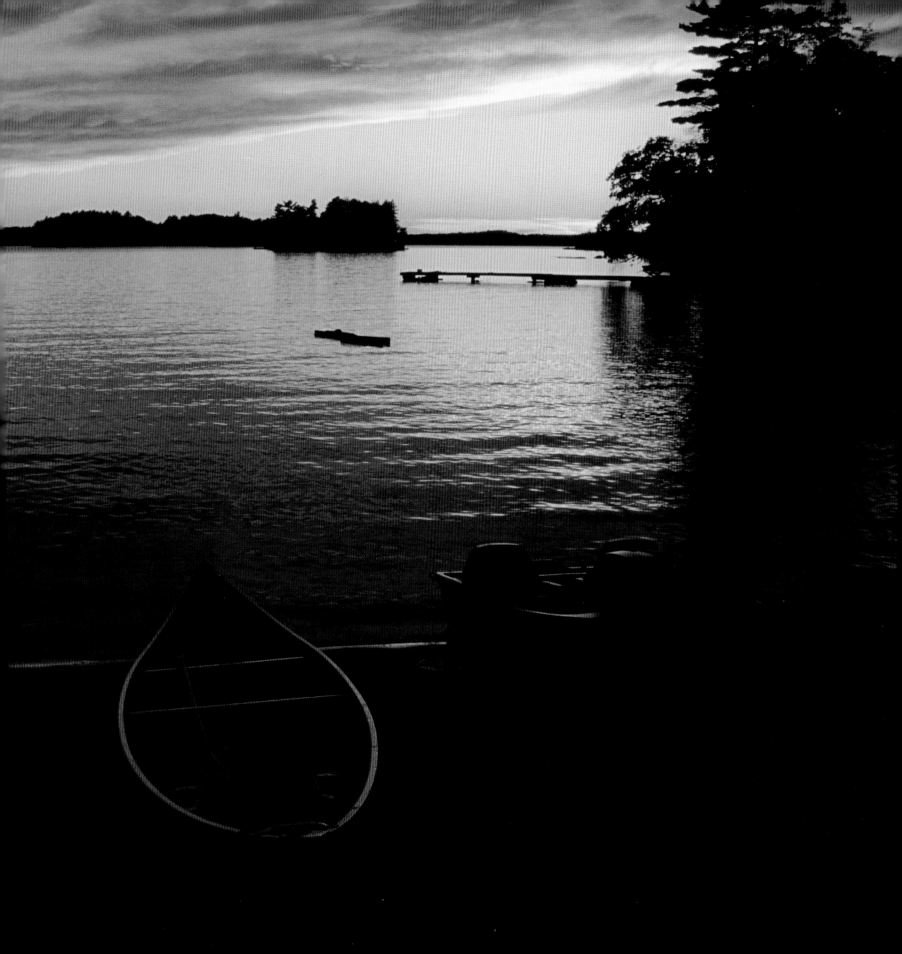

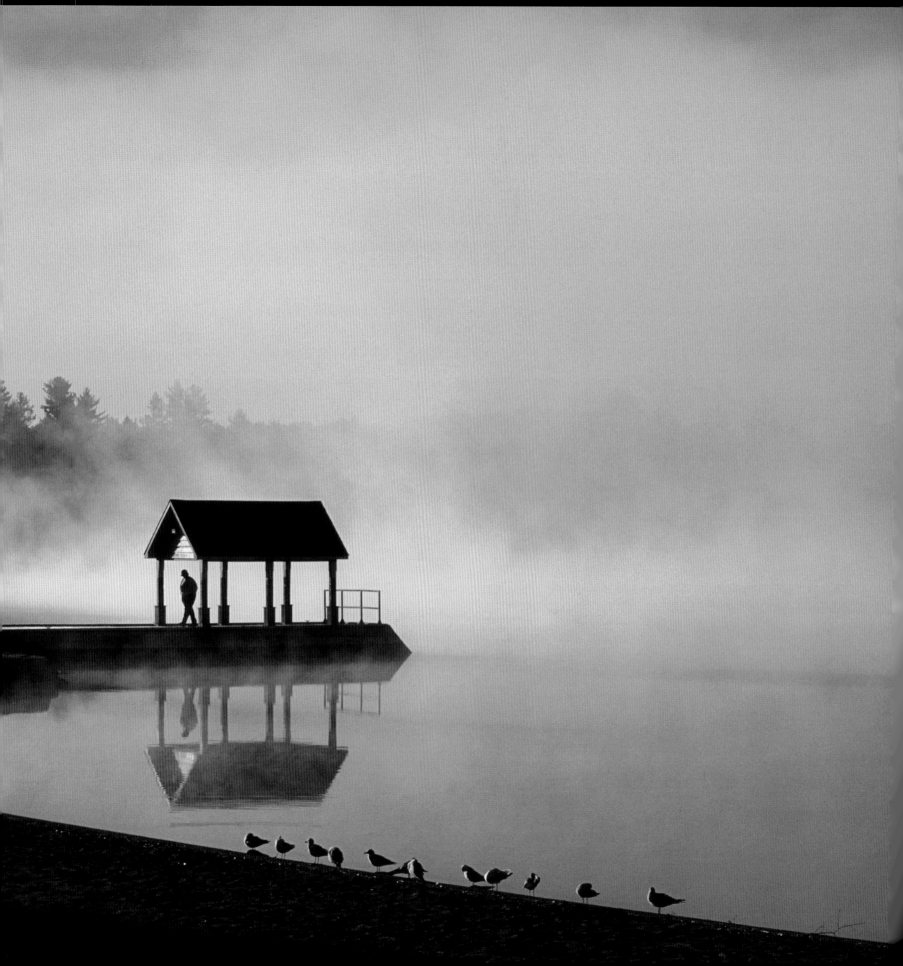